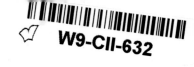

LIPCHITZ AND THE AVANT-GARDE
FROM PARIS TO NEW YORK

LIPCHITZ AND THE AVANT-GARDE
FROM PARIS TO NEW YORK

Edited by
Josef Helfenstein and Jordana Mendelson

Essays by
Jonathan Fineberg, Christopher Green, Jordana Mendelson,
David O'Brien, Cathy Pütz, Cecilia de Torres

Krannert Art Museum and Kinkead Pavilion
University of Illinois at Urbana-Champaign

Distributed by University of Washington Press

Published on the occasion of the exhibition
Lipchitz and the Avant-Garde: From Paris to New York
Krannert Art Museum and Kinkead Pavilion, University of Illinois at Urbana-Champaign,
September 22, 2001 - January 6, 2002

This exhibition and accompanying catalogue are made possible through the generous financial support of the following sponsors: Busey Bank, Illinois Arts Council, Jane Kelley, John and Alice Pfeffer, M. Gay Roberts, and Robert and Ruth Vogele.

Concept: Josef Helfenstein and Jordana Mendelson
Curatorial assistance: Sarah Eckhardt and Paula Braga
Project coordinators: Karen Hewitt, Sarah Eckhardt, and Cynthia Voelkl
Designer: John Havlik

Front cover: Jacques Lipchitz, *Untitled*, circa 1927-1929, charcoal on paper,
60.3 x 44.5 cm., Krannert Art Museum and Kinkead Pavilion, University of Illinois at Urbana-Champaign, Gift of Jacques and Yulla Lipchitz Foundation

Library of Congress Number 2001 135572
ISBN (hardcover edition) 0-295-98186-5
ISBN (paperback edition) 0-295-98187-3
"Towards the Monumental: The Dynamics of the Barnes Commission (1922-24)," by Cathy Pütz, published courtesy of The Barnes Foundation, Merion, Pennsylvania, USA.
"Lipschitz," by Gertrude Stein © The Estate of Gertrude Stein.
"Lipchitzmo," by Ramón Gómez de la Serna © Eduardo Alejandro Ghioldi.
"Lipchitz, le Sculpteur cosmogonique," by Joaquin Torres-García, published courtesy of The Getty Research Institute, Los Angeles, California and The Estate of Joaquin Torres- García.

Krannert Art Museum and Kinkead Pavilion
College of Fine and Applied Arts
University of Illinois at Urbana-Champaign
500 East Peabody Dr.
Champaign, IL 61820

CONTENTS

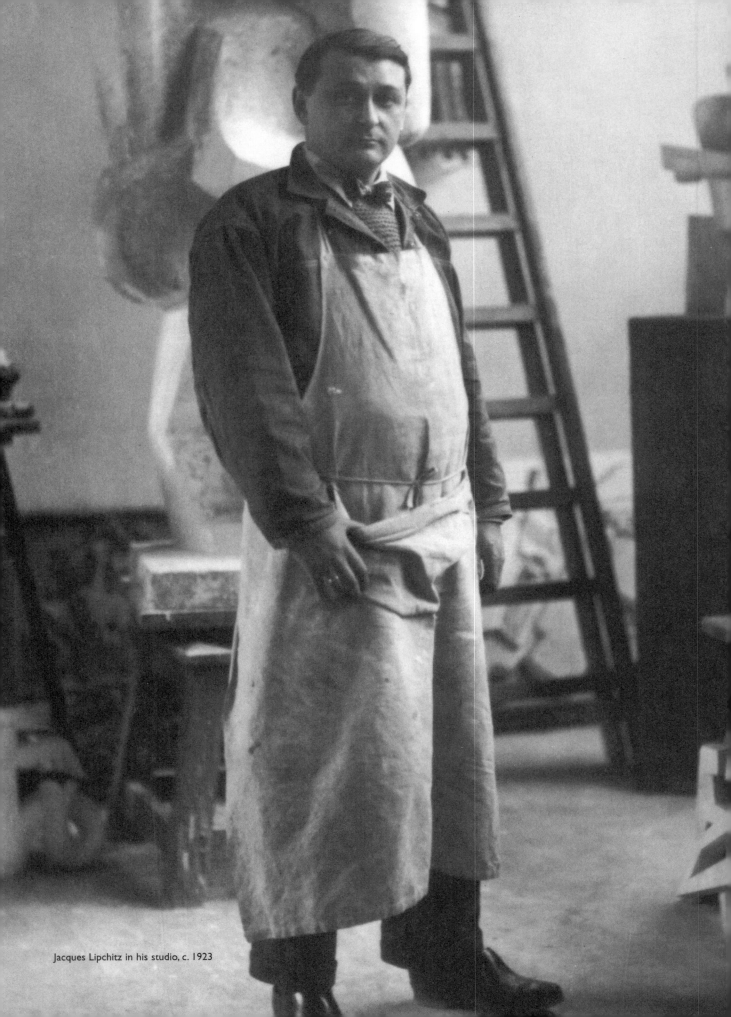

Jacques Lipchitz in his studio, c. 1923

Josef Helfenstein

INTRODUCTION

The idea for the exhibition *Lipchitz and the Avant-Garde: From Paris to New York* evolved from the significant gift of fifteen maquettes for sculptures, one drawing, and a set of prints from the Jacques and Yulla Lipchitz Foundation to the Krannert Art Museum. Highlighting this generous gift, this exhibition presents the innovations of Jacques Lipchitz in the context of his remarkable circle of friends. The fifty sculptures and forty drawings and paintings included in the show illustrate the range and evolution of Lipchitz's career. Seen side by side with paintings, drawings, and sculptures by his friends and contemporaries Juan Gris, Diego Rivera, Pablo Picasso, Amedeo Modigliani, Theodore Roszak, David Smith, George L. K. Morris, and others, the exhibition documents the collaborations that influenced a significant artistic career.

Jacques Lipchitz's working life spanned the years from his arrival in Paris in 1909 to his death in Italy in 1973. Born in Druskieniki, Lithuania in 1891, Lipchitz left for Paris at the age of 18 to study sculpture. The exhibition and accompanying book concentrate on the artistic and intellectual exchange between Lipchitz and his artist friends, beginning with the early years in France, when Lipchitz joined the Parisian avant-garde and closely followed the development of cubism. By 1916, he had met Picasso, Rivera, Gris, and other cubists. He played an active role in this group, becoming the first sculptor to apply the cubist vocabulary in a systematic way to three-dimensional forms. Cubism liberated Lipchitz from the figure and allowed him to concentrate on sculpture as an identity in itself rather than as an imitation of anything else. As our exhibition makes clear, the ongoing dialogue and exchange with artists like Picasso, Rivera, Gris, and Modigliani was fundamental to the development of Lipchitz's artistic ideas and practice. Other friends and colleagues included Henri Matisse, Henri Laurens, Jean Metzinger, Guillaume Apollinaire, Max Jacob, Jean Cocteau, and Blaise Cendrars. No sooner had he begun to contemplate form on its own terms, however, than he began to feel constrained by what he called the "iron rule of syntactical cubist sculpture." Lipchitz's formal innovations culminated in the *transparents*, open assemblages of flat and linear shapes cast into bronze that anticipate the aerated metal figures of Picasso and Julio González. In the 1930s, Lipchitz's work assumed an increasingly expressionist character, depicting contorted figures and dramatic themes reflecting the Depression and, with the rise of fascism in Europe, impending political catastrophe.

Along with thousands of other Jews, Lipchitz was forced to flee Paris as Hitler's troops enclosed the city in 1940. The next year, he and his first wife, the Russian poet Berthe Kitrosser, escaped to America, where he began his career again. After a brief

and disappointing trip to Paris, Lipchitz returned to America to stay in 1946 (now alone, as Berthe decided to remain in Europe). He established a studio in Hastings-on-Hudson, New York, and in 1948, married the sculptor Yulla Halberstadt. In America, his work became increasingly monumental in size, and he continued to use mythological and biblical themes. Lipchitz achieved wide recognition and received numerous commissions. In 1962, he began spending his summers in Pietrasanta, Italy, where he created his most monumental works. Lipchitz continued to produce sculpture until the last days of his life, when he died unexpectedly in Capri.

Acknowledgements

This exhibition celebrates the outstanding gift of fifteen maquettes for sculptures covering the span of Lipchitz's artistic career, one important drawing from the 1920s, and a set of prints from his late work. Krannert Art Museum is deeply grateful to the Jacques and Yulla Lipchitz Foundation. We are especially grateful for the generosity, enthusiasm, and support of Hanno Mott. Hanno Mott and the Jacques and Yulla Lipchitz Foundation have become part of the distinguished group of donors whose generosity have enriched the potential of our collection and the mission of our institution. Hanno Mott's friendship and the Foundation's gift have created a legacy that will continue to enrich the university, our community, and the art world. Through his advice and support, Hanno Mott has also been instrumental in helping us organize this ambitious exhibition.

From the beginning of my directorship, I have worked on this exhibition with my new colleagues here at the University of Illinois at Urbana-Champaign. For so generously sharing their knowledge and enthusiasm in shaping this exhibition and publication, I am indebted to Jonathan Fineberg, Jordana Mendelson, and David O'Brien, professors in the Department of Art History, and to the independent study group of art history graduate students organized by Jordana Mendelson: Sarah Eckhardt, Eun Young Jung, Amy Kuhl, Natasha Ritsma, Li-Lin Tseng, and Phoebe Wolfskill. The dedication, thoughtfulness, and enthusiasm of curatorial assistants Paula Braga, from August to December 2000, and Sarah Eckhardt, since January 2001, have been crucial, and I thank them for their invaluable contributions. I am also grateful to Guisela Latorre, Ph.D. candidate in art history, Stacy K. Smith, master's student in art history, Jane Kuntz, Ph.D. candidate in French, and John Wilcox, professor of Spanish at the University of Illinois at Urbana-Champaign. Jane Block, head librarian, and Christopher Quinn, assistant librarian of the Ricker Library of Architecture and Art, provided important support for the project through their assistance with research. Anita Glaze, professor emeritus of Art History and Richard Faletti, a major donor of African Art to the Krannert Art Museum, gave significant guidance in the selection of African pieces. For their participation in the special programs accompanying this exhibition, I am grateful to David Patterson, professor in the School of Music, Michael Shapiro and Gary Porton, director and associate director of the Drobny Program in Jewish Culture and Society, and Larry Schehr, professor of French. It is in large part due to the commitment and enthusiasm of each of these individuals at

the University of Illinois that the public in central Illinois has the opportunity to view the work of one of the most important sculptors of the twentieth century.

Likewise, my profound thanks go to the lenders and donors to the exhibition, both private and public. We are fortunate to be able to include key works by Diego Rivera, Juan Gris, Pablo Picasso, and Amedeo Modigliani. We are indebted to the following institutions and individuals for providing these loans: Adelheid M. Gealt, director, Anita Bracalente, registrar, and Kathleen A. Forster, curator of Western art after 1800, Indiana University Art Museum, Bloomington; Pierre Levai, director, and Pierre Sébastien, associate sales director, Marlborough Gallery, New York; William Lieberman, chief curator, Ida Balboul, research associate, and Jennifer Mock, administrative assistant, Modern Art Department of the Metropolitan Museum of Art, New York; Patrick Noon, Patrick and Aimee Butler Curator, and Christopher B. Monkhouse, James Ford Bell Curator, Minneapolis Institute of Art; Katya Kashkooli, director, Modernism Gallery, San Francisco; Kirk Varnedoe, chief curator, and Cora Rosavier, associate curator, Museum of Modern Art, New York; Anne d'Harnoncourt, director, Ann Temkin, Muriel and Philip Berman Curator of Modern and Contemporary Art, and Michael Taylor, assistant curator of modern and contemporary art, Philadelphia Museum of Art; Kimerly Rohrschach, director, Richard Born, senior curator, and Jennifer Widman, registrar, David and Alfred Smart Museum of Art at the University of Chicago; Brent R. Benjamin, director, Cornelia Homburg, curator of modern art, and Diane Mallow, registrar, St. Louis Museum of Art; Jock Reynolds, director, and Jennifer Gross, curator of European and contemporary art, Yale University Art Gallery, New Haven. For their individual loans and gifts, I thank: Jonathan Fineberg, Urbana; Yulla Lipchitz, New York; Hanno Mott, New York, representing the Jacques and Yulla Lipchitz Foundation; Robert Smith, Champaign; Bob Vogele, Chicago; and a private collector who wishes to remain anonymous.

The research, experience, and intellectual approach of the following individuals have greatly added to the concept of the exhibition and the art historical depth of this book. I would like to especially thank Cathy Pütz, exhibitions coordinator and collections registrar of the Courtauld Gallery, London, for providing us with important documents and photographs from the Tate Gallery's Jacques Lipchitz Archive in London. For their contributions to the research and content of the catalogue, I am very grateful to: Christopher Green, professor of art history at the Courtauld Institute of Art, and Cathy Pütz, Courtauld Gallery, London; Cecilia De Torres, owner, and Dan Pollock, gallery director, Cecilia De Torres, Ltd., New York; and Stephanie D'Alessandro, assistant curator, Art Institute of Chicago. I would also like to thank Bruce W. Bassett, president of Histor Systems, Inc., and producer of the 1977 film, *Jacques Lipchitz*, who is currently developing an interactive Lipchitz interview system. Last but certainly not least, I thank designer, John Havlik, and copy editor, Jane Hedges, for their creative and thorough work in putting together the catalogue and exhibition promotional materials.

The permission to translate and publish such important historical documents as Joaquin Torres-Garcia's *Lipchitz, Le Sculpteur cosmogonique,* Ramón Gómez de la Serna's "Lipchitzmo" *(Ismos, 1931),* and Gertrude Stein's "Lipschitz" *(Portraits and Prayer, 1934)* is due to the generosity of the following individuals and institutions: Thomas Crow, director, and Wim de Witt, head of Special Collections and Visual Resources and curator of Architectural Drawings, Getty Research Institute, Los Angeles; Cecilia de Torres, New York; Gladys D. Ghioldi, executor, Estate of Ramón Gómez de la Serna, Buenos Aires, Argentina; Calman Levin, executor, Estate of Gertrude Stein.

Finally, this exhibition was possible only through the hard work of the members of the Krannert Art Museum staff. I especially want to thank, again, Paula Braga and Sarah Eckhardt, curatorial assistants, for their commitment and their focus on this project. Of special importance has also been the presence of Karen Hewitt, associate director, who has coordinated many aspects of this project; Kathleen Jones, registrar, who was instrumental in coordinating loans and organizing the exhibition; Eric Lemme, exhibition designer, Lisa Costello, exhibition preparator, and John Cichon, master's student in sculpture, provided indispensible assistance in mounting the exhibition; Diane Schumacher, assistant to the director for public relations and special services, who coordinated events and programs and was responsible for public relations work; Debra Matier provided translations and correspondence in French and Spanish as well as editing and administrative support; Dorothy Horsch provided her clerical and logistical support for visitors. I also thank Gisele Atterberry, education coordinator; Mona Sherman-Dye, account technician; and Ann Rasmus, education director for the museum.

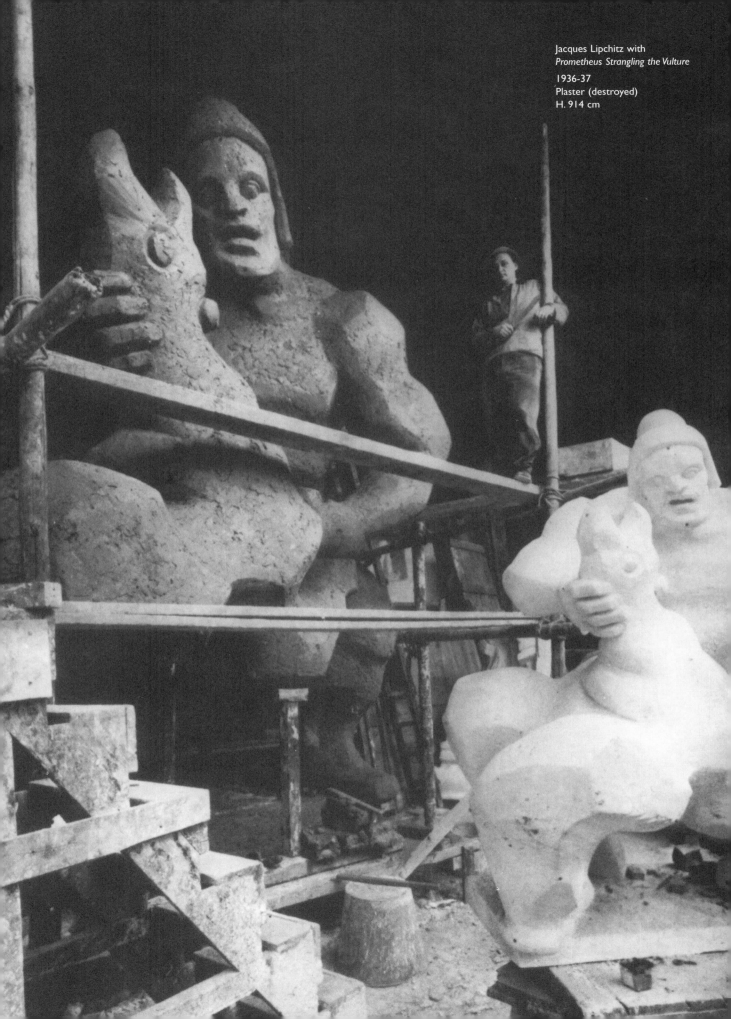

Jacques Lipchitz with
Prometheus Strangling the Vulture
1936-37
Plaster (destroyed)
H. 914 cm

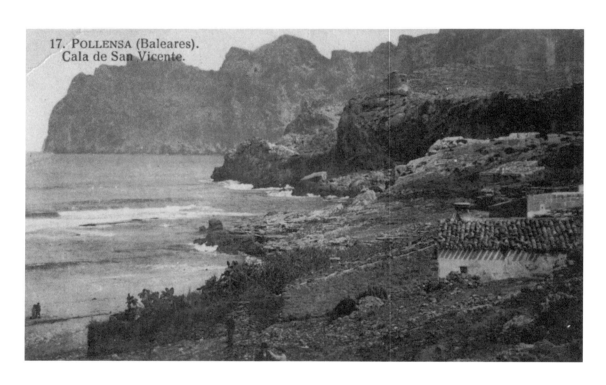

Figure 1. Postcard of Pollensa (Baleares). Cala de San Vincente. Tarjeta Postal, Fototipia J. Roig, Madrid.

Jordana Mendelson

SAILORS, BULLFIGHTERS AND DANCERS:
LIPCHITZ AND SPAIN

In 1914, Jacques Lipchitz took a trip to Spain at the invitation of his friend, the Mexican artist Diego Rivera. The contacts that Rivera had established among the literary and artistic communities in Madrid were key to Lipchitz's introduction to Spanish culture.[1] As many critics, historians, and Lipchitz himself have argued, this time in Spain marked the sculptor's transition from his earlier work to his experiments in cubism.[2] It was among the many foreign and national artists, writers, and performers that he explored the figures and forms that would lead him into a clearly articulated cubist style. What has not been adequately discussed is Lipchitz's use of advanced artistic styles to depict figures and types that were often folkloric, local, or traditional in subject. Moreover, he was not alone among modern artists in depicting the bullfighter or the typically dressed Spanish woman. The artists who accompanied Lipchitz and Rivera during their 1914 trip (Angelina Beloff and María Blanchard), those who were already in Spain (Marie Laurencin[3] and Robert and Sonia Delaunay[4]), and those who would live and work in Spain later in the teens (Olga Sacharoff, Otho Lloyd, and Francis Picabia[5]) were all attracted to the country's typical sites, sounds, and spectacles. When not representing what was typical, in the traditional sense, they were capturing what they considered exceptional or exotic: the characters and qualities that made Spain different from the rest of Europe. Lipchitz's cubist style developed in a context where the notion of the avant-garde—its origins and its practice—was intensely related to history, tradition, and popular culture.[6]

According to Beloff, who was Rivera's wife at the time, it was she who went ahead to find summer accommodations in Mallorca.[7] She left Paris with a few foreign friends and arrived on the island being the only one who could speak Spanish.[8] She found refuge for the group at Cala de San Vicente, about six kilometers from the small port city of Pollensa (fig. 1).[9] It was here that both Rivera and Lipchitz later joined Beloff. In her memoirs, she recounted that World War I was breaking out as Rivera left Paris with Lipchitz and his friend Gregoire Landau.[10] Irene Patai, in her elaborately narrated biography of the sculptor, indicates that Lipchitz had already been in Mallorca for two weeks when the war began and the group dispersed: Rivera and Beloff went to Barcelona, the others returned to their countries, and Lipchitz and Landau stayed on the island a bit longer before they also left for Barcelona and later Madrid.[11] In his own autobiography, Lipchitz was vague about the exact chronology but indicated that it was following their trip to Mallorca and Barcelona that "the First World War had started and we were trapped in Madrid for almost three months before I was able to get back."[12] Despite the differences in

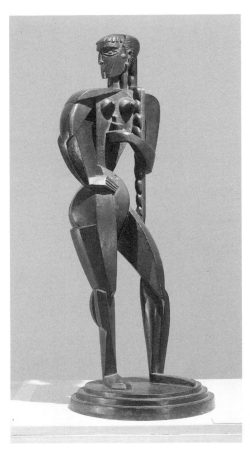

Figure 2. Jacques Lipchitz, *Girl with Braid*, 1914.
Bronze (edition of 7), H. 83.8 cm,
The Barnes Foundation, Merion, Pennsylvania.

accounts, the subtle rearrangements of sequence, and the varying degrees of detail, all these memoirs communicate the artists' deep fascination with the local scenery. According to both Rivera and Lipchitz, they pushed their artistic development during their time in Mallorca. Whereas for Rivera it was the infusion of dynamic color in his landscapes that offered a turn from the accepted modes of cubist experimentation, for Lipchitz it was the investigation of geometric forms and movement through the depiction of types that lead him toward a greater confidence in abstraction. Most interesting are the ways in which Lipchitz and Rivera simultaneously investigated similar subjects, while arriving at distinct solutions.

During World War I, Spain was a neutral country and became a key locale for the trade of black market goods and intelligence information. These wartime exchanges took place mainly in port cities like Barcelona and the islands in the Mediterranean. For the Parisian artists, their contact with this world of espionage and mystery took the form of a local sailor named Llampa. Both Beloff and Lipchitz offer accounts of this sailor, who played guitar and danced rhythmically before the young women of the town.[13] Patai elaborates further, making of Llampa a "customs officer," who had been dispatched by the government to investigate the local fishermen suspected of "dealing in contraband tobacco."[14] Perhaps it was the sailor's many sides—musician, spy, dancer—that fascinated these artists. It was not only in Mallorca that the sailor became a popular subject. In Barcelona too during this period and into the 1920s, the sailor filled the imagination of artists and writers alike.[15] Both literal and pictorial descriptions of sailors were accompanied by a sense of intrigue, travel, and cosmopolitanism. Both Rivera and Lipchitz created depictions of sailors that were open to multiple interpretations and yet recognizable by fellow artists and audiences.

Lipchitz's bronze sculpture of Llampa, titled *Sailor with Guitar*, was a significant departure from his earlier works (plate 11). He divided the subject's body and costume into geometric quadrants. The tilted oval of the hat forms a visual analogy to the rounded top and bottom of the guitar. The legs are stacked triangular blocks that play off the more curvilinear shapes of the torso, arms, and shoulders. The stripes of the sailor's shirt and the lines of his hands interrupt the stacked forms; their repeated pattern adds to the illusion of rhythm and music. The anecdotes about the sailor subside into the background when confronted with the visual reality of Lipchitz's composition. For Lipchitz, the sailor offered an opportunity:

> In the *Sailor with Guitar*, a subject which I studied first in drawings of many angles from various aspects, of a young sailor dancing around a pretty girl, I was finally building up the figure from its abstract forms, not merely simplifying and geometrizing a realistic figure. At the same time I would like to emphasize that I never lost sight of the gay young sailor who first suggested the subject. I think that the sculpture still retains much of the human quality that I found in him. I made clay and plaster models of the sailor in Madrid and brought them back with me to Paris.[16]

Rivera's portrait from the spring of 1914, *Sailor Eating and Drinking*, is striking when compared with Lipchitz's portrait of Llampa.[17] In both works, the artists have distilled some of the individual's principal features. In Lipchitz, it is the guitar, the sway of the body, and the strong forms of his subject's posture and costume. In Rivera, there is more play involved in capturing the subject's features. The sailor's moustache is visually disconnected from the body; it is outlined by a rectangular frame that appears to float above the sailor's other features. The hat, while similar in shape to Llampa's, is decorated with the clear sign of its French origin: *Patrie*. It is the formal similarities—the horizontal bands of the sailor's shirt and the curvilinear forms of the upper body and arm—that Lipchitz carries over into his own interpretation of the theme. But, whereas Lipchitz's sculpture is open in its abstractions, omitting from the figure those defining characteristics of language and geography, Rivera imbued the sailor with his own sense of French patriotism.[18]

If the theme of the sailor connected the work of Lipchitz and Rivera in 1914 to larger intrigues in the world of art and politics, their other work in Mallorca related more intimately to the sites and figures of the people and landscape of the island. As has already been mentioned, Rivera painted richly colored canvases of the Mallorcan landscape that were characterized by overlapping brushstrokes and a loosening of the boundaries between forms. Lipchitz, for his part, while observing in his autobiography the impact of the beautiful, natural scenery,[19] only translated into sculpture individual figures. In his *Girl with Braid*, Lipchitz transformed human anatomy into proto-cubist geometry (fig. 2). Stasis and the heavy weight of the sculptured mass are modulated just slightly with the feminine features of Lipchitz's subject and the slight indication of movement in her legs. According to Lipchitz, it was with this second sculpture that the forms were "even more fragmented cubistically" than in *Sailor with Guitar*.[20] He recalled that the subject of the sculpture was the "daughter of one of the fishermen who always wore her hair in a long braid with a cloth sewn over half of it, perhaps to protect her clothes from the oil she used in her hair."[21] Lipchitz's close observation of the girl's attire, her manners, and the potential rea-

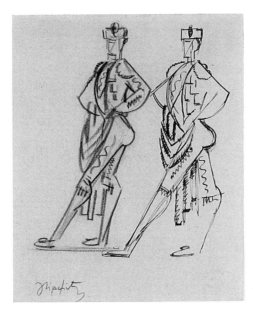

Figure 3. Jacques Lipchitz,
Studies for "Toreador" (the Matador),
1914. Charcoal and ink,
20.3 × 15.2 cm,
Art Gallery of Ontario
Signed lower left: Lipchitz.

sons for them is almost ethnographic in motivation. It is as if through close observation he might somehow see more deeply the essence of her character and translate it more thoroughly into abstracted forms that transcend the particularities of detail. As with his *Sailor with Guitar*, Lipchitz brings together in one form a multiplicity of intentions, both documentary and imaginative. In both cases, he unified a typical scene with his desire for artistic innovation.

Scared that her son was going to fight (and die) in World War I, Rivera's mother notified the artist of her immanent arrival in Barcelona.[22] Rivera and Beloff left for the Catalán port city almost immediately. Neither Beloff nor Rivera knew people in Barcelona. Once Rivera's mother returned to Mexico and Beloff received her pension, which had been delayed because of the war, Rivera and Beloff left for Madrid. In the interim, Lipchitz and Landau stayed in Mallorca. As Patai recounts, they experienced the island's *fiestas*, music, and rituals.[23] Perhaps it was during this time that both Lipchitz and Landau developed a taste for Spain's folkloric traditions, which they continued to explore in Madrid following a brief sojourn in Barcelona.[24] In Barcelona, Rivera showed them Antoni Gaudí's impressive *Sagrada Familia*, and on their way to Madrid they visited Toledo. Rivera had previously studied the work of El Greco and knew the paintings in Toledo well. Their dedication to the Spanish masters would expand further in Madrid, where they frequented the Museo del Prado. After finding affordable living quarters, the four quickly immersed themselves in the artistic life of the capital.[25] Even more than in Mallorca, it is in Madrid that we find Rivera and Lipchitz engaging with subjects in Spanish culture that were long considered part of its rich popular traditions: bullfighters, dancers, and cafés.

From his earlier trips to Madrid, Rivera was familiar with the artists and writers who frequented the literary gatherings at local cafés. In particular, during his earlier trips it was at the Café Levante where he had established ties with Spain's leading cultural personalities, many of whom were pivotal figures among the so-called Generation of '98: Pio and Ricardo Baroja, Darío de Regoyos, Ramón del Valle-Inclán, and Ignacio Zuloaga. The Generation of '98 was a term applied to a group of intellectuals who, troubled by recent events like the Spanish-American War, turned their attention away from the established culture of the royalty and aristoc-

Figure 4. Salvador Pascual Boldun, *Portrait of José Gómez Ortega (Joselito).* Figure 5. Salvador Pascual Boldun, *Portrait of Juan Belmonte.*

racy and toward the nation's folkloric traditions and rural areas. Darío de Regoyos had become one of the major figures associated with depicting *España Negra*, or dark Spain.[26] Many of the artists and writers of this generation found their subjects in the images of the poor, the gypsies, the border areas, and the encroaching industrialization. Rivera was influenced by many of them, some of whom turned toward what was called the lighter Spain, its scenes of breathtaking landscapes and captivating traditions. It was especially in the work of Ignacio Zuloaga that Rivera found inspiration. His *Los Viejos* (The Old Ones, 1912) shows a pronounced debt to the elongated figures and stylized lines that became Zuloaga's trademark, but that had their origin in El Greco.[27]

One of the dominant ideas to come out of the Generation of '98 was the formulation by Francisco Gíner de los Ríos of the past divided into *historia externa* and *historia interna*, external and internal history. Gíner de los Ríos considered "Spain's true historic reality to be the second of these."[28] This internal history was located in the traditions of Spain's rural populations who, in the words of Inman Fox, became "one of the most outstanding symbols of national values, representing the pure essence of the Spanish people."[29] For the Generation of '98, the peasant, rooted to the land, became the living witness to the nation's long history. Instead of the turmoil that characterized the turn of the century, Spain's *historia interna* offered the possibility for cultural redemption. Among the writers and artists at the Café Levante, Rivera would have been exposed to these ideas, albeit in modified or contested versions. The paintings of Zuloaga and José Gutiérrez Solana, who bridged the generation of '98 with those of the 20th century, were driven by the desire to uncover a Spanish reality that captured, in different ways, the traditions and practices of its people. Among the subjects treated by these two artists was the bullfighter, who filled the imagination of artists and writers alike during this period.

Rivera and Lipchitz were not immune from the excitement that surrounded the bravura and sacrifice of the bullfighter's art. Their studio on Goya Street was located near the newly constructed bullfighting ring on the outskirts of Madrid.[30] Rivera captured the building in all of its radiance in his *La Plaza de Toros* (1915). The main entrance was modeled after the Islamic influenced architecture of southern Spain. Rivera prominently featured the archway in his composition with the signage "Plaza

Figure 6. Jacques Lipchitz, *La Corrida*, 1914. Graphite, 13.4 × 10.5 cm, The Estate of Jacques Lipchitz represented by Marlborough Gallery.

de Toros" brilliantly written above. He tilted the circular form of the bull ring up to fill the central area of the canvas. It is an exuberant painting, at once documenting the excitement that the bullfight held for both artists and serving as a dynamic point of departure for Rivera's explorations in light and color.

The "golden age" of bullfighting lasted from about 1914 to 1920 and was largely fueled by the competition between two bullfighters: Joselito (fig. 4) and Juan Belmonte (fig. 5).[31] Artists, writers, and performers were dedicated fans of bullfighters who often championed their favorite contender in their works. Such was the case with Zuloaga, who painted a portrait of Belmonte in 1924 in which the bullfighter was depicted in front of an impromptu bull ring in rural Spain (fig. 7). The high contrast between the dark sky and deep tones of the background and the luminescence of Belmonte's costume capture Zuloaga's passion for the sport and his deep friendship with the bullfighter. Of the many portraits that Zuloaga painted of Belmote, in this version he immortalizes the details of Belmonte's facial expression and pose and the symbolic importance of his embodiment of a Spanish culture rooted in the character of the country's landscape and people.[32]

It is unknown whether Lipchitz saw any of Zuloaga's portraits of Belmonte. But he was similarly captivated by the spectacle of the bullfight. Zuloaga rendered homage to the bullfighter through his highly developed, almost baroque naturalism; Lipchitz used his own depictions of Belmonte's competitor as the basis for formal experimentation. Joselito was the model for his bronze sculpture *Toreador* (plate 10), and he made numerous sketches in preparation for the piece (fig. 3). In his autobiography, Lipchitz recounted the impression that Joselito made on him:

> In Madrid I met the great bullfighter Joselito, who was later killed, and my *Toreador* was inspired by him, although it is not in any sense a portrait. The bull-

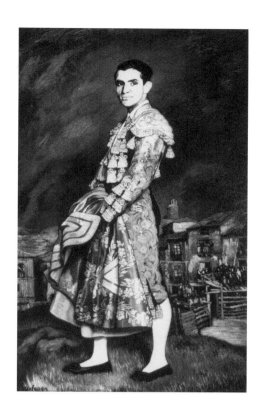

Figure 7. Ignacio Zuloaga, *Portrait of Belmonte in Silver*, 1924. Oil on canvas, 193 × 120 cm, Zuloaga Museum, Zumaya, Spain.

fights fascinated me, once I began to understand the ritual. I always had a strange sense of the toreador as a woman and the bull as a man whom this toreador charms and fascinates in order to kill.[33]

The competition between Joselito and Belmonte propelled critics to define the opposing stylistic attributes of classical bullfighting. Writers like José Bergamin contrasted the graceful movements of Joselito with the clumsiness of Belmonte.[34] It is clear from Lipchitz's description that he too observed in Joselito a certain elegance and femininity of style. More than in his preparatory drawings for the sculpture, the flowing lines of Joselito's movements were captured in Lipchitz's sketches of the bullfighter in action. His *La Corrida* (fig. 6) draws attention to the repeated curves of the bullfighter's cape and the flow of Joselito's body as it would have pulled back from the bull's approach. The final version of his sculpture is strikingly different. The pose is firm, with the bullfighter's left leg extended and the right placed slightly behind, rigidly perpendicular to the ground. The pose is typical. Any viewer familiar with *tauromaquía* would recognize it as the stance of the bullfighter, converting Lipchitz's sculpture of Joselito into an iconic representation of a general type. The ornamented costume, while highly feminine in its decorative details, is transformed into cubist armor. The angle of the thigh, the geometric form of the elbow, and the curved swell of the back—all of these features add to the stylization that Lipchitz made of the popular bullfighter. In his preparatory sketches and in the final bronze, Joselito's profile is divided along the sharply articulated bridge of his nose and cheek. In this, Lipchitz has captured the determined gaze and elegance that he observed while watching the bullfighter in action. Nonetheless, like his *Girl with Braid* and *Sailor with Guitar*, it is stasis above all else that creates an internal tension. The geometric lines reign in the figure's implied movement.

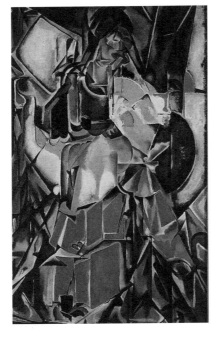

Figure 8. María Blanchard,
Mujer con abanico (*Woman with Fan*),
1916. Oil on canvas, 161 x 97 cm,
Museo Nacional Centro de Arte Reina Sofía, Madrid.

Patai gives a highly detailed account of the relationship between the sculptor and the bullfighter, illuminating the intersection between the world of the fine arts and that of mass spectacle that formed a constitutive part of the development of modern culture in Spain:

> Joselito had a carriage with a brace of horses and would invite Lipchitz to ride with him on his jaunts through Madrid. This caused a stir. News percolated swiftly by word of mouth and everywhere Lipchitz was honored for his association with the matador and referred to as the "Russian who rides in the coach of Joselito."[35]

Patai describes an incident in which the worlds of bullfighting and art further collided. Apparently, Joselito and his brother considered themselves art collectors. Although Lipchitz does not recount this story in his own autobiography, according to Patai, the brothers brought the sculptor to their home to see one of their greatest possessions, a painting that turned out to be "a kind of collage" made out of "decorative cigar rings."[36] Knowing Lipchitz's own talent as a connoisseur and collector, one can imagine that the bullfighters would have been keen to bring the artist into their home to see the collection for which they were so proud. What appears to be a scene taken from a comedic farse—a modern Russian sculptor who travels in a bullfighter's carriage and a bullfighter who considers himself an art collector—these are the particularities that made the world of art in Madrid something distinct from that of the cosmopolitan centers of modernity like Paris. It was in Spain that fortuitous collisions between tradition and the avant-garde took place. And yet, such collisions form a greater part of the anecdotal history of the avant-garde than they do an actual account of the trials and tribulations that artists faced when trying to pursue their careers in the country's capital.

Such is the case with María Blanchard, a Spanish painter who was a close friend of both Rivera and Beloff. Perhaps more than any other artist at the time, Blanchard comes closest to Lipchitz and Rivera in her blending of advanced pictorial forms and

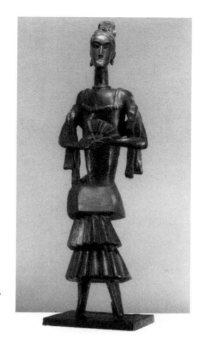

Figure 9. Jacques Lipchitz, *Spanish Dancer*, 1914. Bronze (edition of 7), H. 69.9 cm, The Estate of Jacques Lipchitz represented by Marlborough Gallery.

almost disarmingly typical subjects. Blanchard first met Beloff while studying with the Spanish painter Anglada Camarasa in Paris. Blanchard introduced Beloff to Rivera. Like the Mexican painter, Blanchard was also in Paris on a fellowship and the two maintained a constant friendship. Although her work is not as obviously folkloric in nature as some of the work that Rivera and Lipchitz undertook during their time in Madrid, she did dedicate a few of her works to typical figures and scenes. One piece in particular resonates with Lipchitz's drawings and sculptures, Blanchard's *Woman with Fan* (1916, fig. 8). Done two years after Lipchitz's colored drawing *Spanish Woman with Fan* (plate 8) and his bronze sculpture *Spanish Dancer*, (fig. 9) Blanchard's composition is markedly more dynamic and vibrant. (Her painting is closer in its treatment of the subject to Rivera's drawing from 1913, *Young Girl with Fans*, which demonstrates not only the close personal and artistic relationship between Blanchard and Rivera but also the preponderance of this theme during these years.) Blanchard fully develops the analysis of forms and the indication of simultaneity that is only hinted at in Lipchitz's 1914 works.

Lipchitz's sculpture of the spanish dancer is static. The arms form an inverted triangle with its pinnacle at the top of the dancer's head. Her frontal pose is rooted stiffly to the base, and the folds of her dress appear weighty, making of the dancer a formal exercise that drains much of the excitement of the spectacle from the figure. With her naturalistic features, the *Spanish Dancer* carries the mark of Lipchitz's earlier work. His drawing is much more experimental and has a great deal in common with Blanchard's later painting. The repeated pattern of the fan plays off the vertical folds of the woman's shawl. Her face is erased of specific features and is composed of sharp angles similar to those used in *Toreador*. Her scalloped neckline mirrors the semi-circular shapes of the veil that hangs over her hair, and the entire composition is pulled together through a balancing of light and dark tones.

Whereas Lipchitz's depictions appear incomplete in their formal development, Blanchard's composition demonstrates a masterful command over the manipulation

of form and color to communicate a subject both brilliant and restrained. In her painting, Blanchard too depicts the open fan, the geometric folds of the woman's skirt, and the slight turn of the woman's head as she poses for the artist. Movement and light are captured through her forceful brushwork and clean lines. (They also recall some aspects of Camarasa's paintings, which were often lush, colorful treatments of themes like Spanish dancers or scenes of Mallorca.) Unfortunately, Blanchard's paintings were totally misunderstood by the Spanish public, which identified neither with her interpretation of traditional subjects nor with her cubist experiments.[37]

In 1915, the *Exposición de Pintores Íntegros* opened in a galley called Arte Moderno on Madrid's Carmen Street.[38] The introductory text to the catalogue was written by Ramón Gómez de la Serna, one of the foremost supporters of the avant-garde in Madrid. Gómez de la Serna's *tertulia*, a regular meeting of artists, writers, philosophers, and performers at the Café Pombo, attracted foreign and national artists in Madrid during and after the war. It became the meeting place for the exchange of artistic and literary ideas, many of which were recorded in Gómez de la Serna's prolific output as an author. His *Pombo* (1918), *Ismos* (1931), and *Retratos Completos* (1963) all include descriptions of and anecdotes about Lipchitz, Rivera, Blanchard, Beloff, and many of the other artists who lived in, or passed through, Madrid during the early twentieth century. Though there has been some confusion about whether Lipchitz exhibited in *Pintores Íntegros* or not, it is most likely that his sculptures were not included.[39] Instead, it was Rivera and Blanchard whose work received the brunt of the critics' commentaries. Indeed, the clash between the modern ambitions of foreign and national painters in Spain and the conservatism of their public was manifested in the reception of paintings by both artists.[40]

The most scandalous work of the *Pintores Íntegros* exhibition was Rivera's portrait of Gómez de la Serna (see page 138), which hung in the gallery's front window display. In Gómez de la Serna's writings he praised Rivera and the portrait. He recounted that during the sessions in which Rivera worked he was free to continue reading, eating, and even get up for a walk; Rivera too sometimes turned away from his subject or read the newspaper while painting.[41] "What can I say! I am very pleased with this portrait."[42] He was clearly thrilled with the painter's ability to capture vividly his many sides and activities. Rivera combined profile and frontal views, used saturated primary colors, and played with different vantage points in the single composition. He painted Gómez de la Serna's right eye as if it were a solar eclipse, with radiating yellow rays emerging from a dark black circle. His one hand holds a pipe, which emerges from a mouth indicated with a simple X; his other hand adroitly holds a pen. On the table in front and on the surfaces behind, Gómez de la Serna's own books bear witness to the author's legendary productivity. The painting caused panic among the visitors to the gallery, massive numbers of people showed up to see the riotous spectacle, and the authorities were called in to convince the gallery director to remove the painting from its street-side location. The painting was interpreted as "a story about a crime, a crime that I had committed by killing my victim, whose head appeared behind my shoulder, with a Browning that I had at my side."[43] Indeed, in the painting a woman's head appears in the upper left corner and a pistol with its handle facing the author is depicted perpendicular to the bottom edge of the canvas. These elements, whether meant to be literal or metaphoric, sparked

the interest of the masses, who were probably more intrigued with the possible evidence of murder than they were with the revolutionary potential that these works held for Madrid's artistic community.[44]

Lipchitz left Spain at the beginning of 1915.[45] Upon his return to Paris, he finished the sculptures that he began in Mallorca and Madrid, all of which engaged the most typical of subjects: sailors, bullfighters, and dancers. Taking these types as a point of departure for formal experimentation, he paved the way for his future immersion into cubism. And yet, surprisingly, he did so in a way that embodied some of the complexities of the modern project in Spain: the use of progressive artistic styles to depict traditional, even folkloric, themes. The imprint that Spain made on Lipchitz's work is clear. He maintained friendships with Spanish artists and writers throughout his life and themes like the bull, which may have had its origin in his visits to Madrid's *Plaza de Toros*, recur in his oeuvre. The impact he made on Spanish culture, though more difficult to trace, is evident in the ephemera generated by those artists and writers who struggled during the early twentieth century for a Spanish avant-garde. Through the writings of Gómez de la Serna and the controversial reception of modern art in Spain—from the 1915 *Pintores Íntegros* exhibition in Madrid to the 1920 *Exposició d'Art francès d'Avanguarda* at the Galeries Dalmau in Barcelona, which did include his work[46]—Lipchitz became one of many artists whose name alone provoked a challenge to what some considered to be Spain's cultural bankruptcy.

Such was the case in 1928 when Lluis Montanyá, Sebastiá Gasch, and Salvador Dalí included Lipchitz in their *Manifest* as one of the "great artists of today." Accompanying him were other artists of "the most diverse tendencies and categories": Pablo Picasso, Joan Miró, Le Corbusier, André Breton, and Christian Zervos. This heterogeneous group of artists, writers, and critics represented a cross section of the international art scene as it was promoted in the late 1920s. Cubists, purists, and surrealists were enlisted by the young Catalans to differentiate themselves from what they perceived to be the closed world of local tastes and traditions. Like all manifestos, it was "anti" conventions and courtesies. Sent to all of the notable writers, artists, critics, newspapers, and cultural centers in Barcelona and throughout Spain,[47] the manifesto was an immediate, scandalous success, not unlike the *Exposición de Pintores Íntegros*, which nonetheless made disappointingly little real impact on the standing of avant-garde art in Spain. The manifesto endorsed clean-lined, machinist forms of modernity: anonymity, novelty, cinema, sports, and mechanical reproduction. They reproduced no illustrations of work by the artists they cited. Indeed, no direct connection was drawn between their choice of artists and the anti-artistic tendencies they advocated. This is certainly the case with their inclusion of Lipchitz. Had they been looking for inspiration, it probably would not have been in the proto-cubist works that he created in 1914-15, which were drawn from just the kind of typical subjects the authors were protesting. Clearly, they were not looking for models. As Joaquín Amigo remarked in the April 1928 edition of *Gallo*, the Catalán manifesto was not seeking to launch "one more ism."[48] In Madrid, just three years later, however, Ramón Gómez de la Serna would create new "isms," one of which was named after Lipchitz ("Lipchitzmo") and another after Rivera ("Riverismo"). Although they differed in their aims, both the Catalan artists and Gómez de la Serna embraced Lipchitz because, like other modern artists whose work was known through publications or legendary trips to Spain, invoking his name alone was a radical gesture.

I thank Guisela Latorre for her excellent research assistance with this article. I am also grateful to friends in Spain for locating sources, especially Juan Ángel López Mazanares, and to the graduate students who have worked on this project from the start. Their insights into the work of Jacques Lipchitz and their dedication to this exhibition were inspiring.

1. Rivera had been in Spain on numerous occasions before, both with and without Angelina Beloff. For more on his previous trips and his immersion in Spanish culture, see Luis Suárez, *Confesiones de Diego Rivera* (Mexico: Ediciones Era, 1962) and Angelina Beloff, *Memorías* (Mexico City: UNAM, 1986).

2. Jacques Lipchitz with H. H. Arnason, *My Life in Sculpture, Documents of Twentieth Century Art* (New York: Viking Press, 1972), 18; Lucía Ybarra, "Lipchitz in Spain," in *Lipchitz: A World Surprised in Space (Un mundo soprendido en el espacio)*, exhibition catalogue (Madrid and Valencia: Museo Nacional Centro de Arte Reina Sofía and IVAM, Centro Julio González, 1997), 224; and José Luis Barrio-Garay, "La escultura de Jacques Lipchitz," *Goya*, no. 96 (1970): 350.

3. See Marcelle Auclair, "El mundo de Marie Laurencin," *Revista de Occidente* 22 (October–December 1928): 68–90; Ramón Gómez de la Serna, "Ninfismo," *Ismos* (Madrid: Biblioteca Nueva, 1931), 241–46; Douglas Hyland and Heather McPherson, *Marie Laurencin: Artist and Muse* (Birmingham, Ala.: Birmingham Museum of Art, 1989); and Daniel Marchesseau, *Marie Laurencin: Cent oeuvres des collections du Musée Marie Laurencin au Japon* (Martigny, Switz.: Fondation Pierre Gianadda, 1993).

4. See Juan Manuel Bonet, "Los Delaunay y sus amigos españoles," in *Robert y Sonia Delaunay* (Madrid: Fundación Juan March, 1982), n.p.; Pascal Rousseau, *La aventura simultánea: Sonia y Robert Delaunay en Barcelona* (Barcelona: Universidad de Barcelona, 1995), and Guy Wheelen, "Los Delaunay en España y Portugal," *Goya*, no. 48 (1962): 420–29.

5. Glòria Bosch and Susanna Portell, *Complicitats: Olga Sacharoff i Otho Lloyd* (Tossa de Mar: Ajuntament de Tossa del Mar and Eumo Editorial, 1993); and *Francis Picabia: Máquinas y españolas* (Valencia: IVAM, 1995)

6. The existence of an avant-garde in Spain and the relation of Spanish modernity to that witnessed in the rest of Europe has been the subject of debate among scholars in and outside Spain. One of the most thought provoking examples of the current literature on the subject is Juan José Lahuerta, *Decir anti es decir pro: Escenas de la vanguardia en España* (Teruel: Museo de Teruel, 1999).

7. Beloff, *Memorias*, 42.

8. As Beloff recounts, she left for Mallorca with a Russian couple, an Englishman, and a French woman. Ibid.

9. Ibid., 43.

10. Ibid., 44.

11. Irene Patai, *Encounters: The Life of Jacques Lipchitz* (New York: Funk and Wagnalls, 1961), 136–40.

12. Lipchitz, *My Life in Sculpture*, 19.

13. Ibid., 18; and Beloff, *Memorias*, 44.

14. Patai, *Encounters*, 134.

15. See, for example, Salvador Dalí, *Venus and Sailor (Homage to Salvat-Papasseit)*, 1925, oil on canvas, Ikeda Museum of Twentieth-Century Art, Shizuoka-Ken, Japan.

16. Lipchitz, *My Life in Sculpture*, 18.

17. Diego Rivera and Gladys March, *My Art, My Life* (New York: Citadel Press, 1960), 104–5, cited in Ramón Favela, *Diego Rivera: The Cubist Years*, exhibition catalogue (Phoenix: Phoenix Art Museum, 1984), 79–80. Ramón Gómez de la Serna included a reproduction of this painting in the chapter that he dedicated to Rivera, "Riverismo," in his *Ismos* (Madrid: Biblioteca Nueva, 1931), 342.

18. Ramón Favela, *Diego Rivera: The Cubist Years*, exhibition catalogue (Phoenix: Phoenix Art Museum, 1984), 91.

19. "I had not gone intending to work and for a while I principally mediated, observed the rocks and flowers, and drew continually. I could see from the mountains to the ocean, and in this austere and beautiful landscape, filled with contrasts, many of my ideas about cubism were clarified." Lipchitz, *My Life in Sculpture*, 18.

20. Ibid., 19.

21. Ibid.

22. Beloff, *Memorías*, 45.

23. Patai, *Encounters*, 137.

24. In his book *Pombo* of 1918, Ramón Gómez de la Serna described Landau as a young Russian who was studying in Berlin and who came to Spain during the war and frequented his *tertulía* at the Pombo café. Gómez de la Serna also commented that Landau mastered Spanish and became almost Andalusian in his manners, knew all of the bullfighters, and frequently visited Madrid's flea market, *el rastro*. Ramón Gómez de la Serna, *Pombo* (Madrid, 1918), n.p.

25. Beloff, *Memorías*, 46; Lipchitz, *My Life in Sculpture*, 19; and Patai, *Encounters*, 140–41.

26. Darío de Regoyos illustrated Emile Verhaeren's *España negra* (1899), which came to symbolize an entire approach to presenting the remote areas and rituals of rural Spain. For more on the role of the visual arts in the Generation of '98, see *Paisaje y figura del 98*, exhibition catalogue (Madrid: Fundación Central Hispano, 1997).

27. Favela, *Diego Rivera*, 32–33.

28. Inman Fox, *La invención de España: Nacionalismo liberal e identidad cultural* (Madrid: Cátedra, 1997), 48–49.

29. Ibid., 172.

30. Favela, *Diego Rivera*, 92; and Patai, *Encounters*, 143.

31. Agustín Díaz Yanes, "Joselito el Gallo: El último torero clasico," in *Arte y tauromaquia* (Madrid: Ediciones Turner, 1983), 225–26. Also see Timothy Mitchell, "Beauty from Barbarity: The Intellectual Redemption of Tauromachy in Bergamin, Lorca, and Pérez de Ayala," *Hispanic Journal* 8, no. 2 (Spring 1987): 87–99.

32. *Ignacio Zuloaga, 1870–1945*, exhibition catalogue (Houston: The Meadows Museum, 1990), 220.

33. Lipchitz, *My Life in Sculpture*, 19.

34. My account of Bergamín's book *El arte de birlibirloque* (1930) is based on Mitchell's discussion of Bergamín and Pérez de Ayala in his "Beauty from Barbarity," 94.

35. Patai, *Encounters*, 143.

36. Ibid., 143.

37. Although Blanchard was able to secure a teaching position in a provincial school, she felt isolated there without the support of the Parisian art community. She returned to Paris, though was never able to profit from her unique style of cubism.

38. *Íntegros* means complete or whole. In titling the exhibition in this way, Gómez de la Serna was creating a new term meant to signal a variation on cubism, even though historians consider many of the works proto-cubist. The exhibition was the first of its kind in Madrid. In Barcelona, the Galeries Dalmau held the first exhibition of cubism in Spain with its *Exposició d'Art Cubista*.

39. For contrasting accounts of Lipchitz's participation in the exhibition, see José Luis Barrio-Garray, "La escultura de Jacques Lipchitz," *Goya*, no. 96 (1970): 350; and Francisco Calvo Serraller, "Sísmicos Istmos," in *Istmos: Vanguardias españolas 1915–1936*, exhibition catalogue (Madrid: Fundación Caja Madrid, 1998), 21–24.

40. Among the works on exhibit were Rivera's paintings of Mallorca.

41. The portrait is not mentioned in Gómez de la Serna's 1918 *Pombo*, but in his 1931 *Ismos* he devoted almost ten pages to it.

42. Gómez de la Serna, *Ismos*, 339.

43. Ibid., 343.

44. One of the more serious reviews of the exhibition was written by José Francés, who observed the difficult reception of cubism in Spain and his own incomprehension of the works' meaning, while at the same time giving serious attention to the accomplishments of both Rivera and Blanchard. José Francés, "Los pintores 'íntegros,'" *El año artístico (1915)* (Madrid: Editorial "Mundo Latino," 1916), 50–54.

45. Ybarra, "Lipchitz in Spain," 224.

46. I thank Robert Lubar for generously sharing his research on this exhibition, which included works by Blanchard, Lipchitz, and Rivera. A full discussion of this and other exhibitions held at the Galeries Dalmau in Barcelona is beyond the scope of this paper. It is important to note, however, that Josep Dalmau was the leading promoter of the avant-garde in Barcelona. See *Exposició d'Art francès d'Avantguarda. Catàlog*, exhibition catalogue (Barcelona: Galeries Dalmau, 1920). For a review of exhibitions held in Barcelona during this period, see Francesc Fontbona and Francesc Miralles, *Del modernisme al noucentisme, 1888–1917* (Barcelona: Edicions 62, 1985), 202–5, 246–49.

47. Sebastiá Gasch, "Un 'manifest' i un 'full groc,'" *Serra d'or*, no. 107 (August 10, 1968): 29.

48. Joaquín Amigo, "El manifesto antiartístico Catalán," *Gallo*, no. 2 (April 1928): 18.

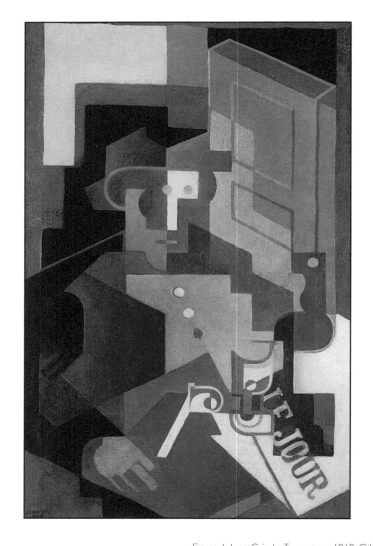

Figure 1. Juan Gris, *Le Tourangeau*, 1918. Oil on canvas, 100 × 65 cm, Musée National d'Art Moderne, Centre Georges Pompidou, Paris, France.

Christopher Green

LIPCHITZ AND GRIS:
THE CUBISMS OF A SCULPTOR AND A PAINTER

In the spring and summer of 1918, Jacques Lipchitz and Juan Gris lived in close association in the little Touraine commune of Beaulieu-lès-Loches. Every day, they worked together in Gris's studio in the spacious manor he rented with his wife, Josette, at Ferrières-sur-Beaulieu.[1] The two of them were at the core of a small group of artists escaping the bombardment of Paris in the last months of the Great War; María Blanchard was there for most of the time, Jean Metzinger more briefly.[2] This is how Lipchitz recalled the working relationship within this group to Deborah Stott over fifty years later: "What you have to understand is that this part of our production is a collective work. It was only after, when we were forced to be separated, that we started to speak for ourselves . . . So you can't really talk about influences; it's something different. A collective mind was working so each was influenced by the other."[3]

The friendship between Juan Gris and Jacques Lipchitz was also a collaboration. As such it was part of a wider cubist collaboration, held together by the dealer Léonce Rosenberg, encouraged by the writers Paul Dermée, Vicente Huidobro, and Pierre Reverdy, and brought to a climax by a series of exhibitions in Rosenberg's Galerie de l'Effort Moderne in 1919–20 and, early in 1920, by the showing of the cubists at the Salon des Indépendants.[4] Except for a temporary breakdown in their friendship in 1923, Lipchitz and Gris remained close until Gris's death in 1927, but the years 1916–20 saw their greatest intimacy both as friends and as artists.[5] This period will therefore be the focus of this essay. Discipline and order characterized the work that emerged from their wartime collaboration; these are words that invoke the values of rational control represented by a military commander like Maréchal Foch, who was indeed held up by Rosenberg as an example to all his artists.[6] Lipchitz's *La Liseuse II* and *Pierrot à la clarinette* (1919) or Gris's *Guitare, livre et journal* (1920), which were among their contributions to the Indépendants (1920), can appear the disciplined products of a collective enterprise, one that included Metzinger and Blanchard too—what has been called a "Call to Order."[7] Their work represented the most rigorously controlled cubism produced in the rigorously controlled commercial and cultural environment centered on Rosenberg's Galerie de l'Effort Moderne.[8] Yet, the closeness of their relationship and the way they released creative energy in one another between 1916 and 1920 sets them apart: it was above all they, the youngest of the cubists, who gave vitality to the Effort Moderne's "Call to Order".[9]

They were closest of all that summer of 1918 at Beaulieu-lès-Loches, but by the early months of 1917 there is clear evidence of the intimacy of their collaboration.

In January, Gris writes to Rosenberg: "Je vois souvent Lipchitz. Nous sommes très bien ensemble et je l'aime beaucoup."[10] In February, he writes: "Je vais souvent à Montparnasse chez Lipchitz. Nous sommes devenus très amis. Il me plaît vraiment ce garçon."[11] And then in April: "Je ne vois pas beaucoup de monde. Tous les dimanches je vais à Montparnasse chez Lipchitz et là je vois quelques amis."[12] Many came to Lipchitz's "Sundays" in 1917—including Pablo Picasso, Metzinger, and Blanchard—but at their core was the vibrant friendship of the expatriate Lithuanian and the expatriate Spaniard.[13] It is most of all the energy mutually released in them that Lipchitz recalls when, in 1957, he sums up their relationship in his otherwise dissenting response to D.-H. Kahnweiler's monograph on Gris: "Rien ne deminnera la gloire pure de Gris si l'on constate que les années 1916–1919 qui étaient créatives pour nos deux, étaient fécondées par nos énergies enthousiastes fraternellement entremêlées."[14]

As Deborah Stott was the first to recognize, this was a working relationship, which operated at a profound level in both theory and practice.[15] Famously, in 1921 Gris claimed for his painting a purity guaranteed in effect by what he called his "deductive" method. Instead of starting from figures or objects in the composition of his paintings, he asserted that he started from the arrangement of colored planes—abstract elements. He did not make a cylinder from a bottle, but a bottle from a cylinder.[16] The year before, Paul Dermée made precisely the same claims for "purity" and what can be described as a deductive method in the sculpture of Lipchitz, and he made them, we know (thanks to Stott), prompted by the sculptor. He set this way of working against what he called "stylization," by which he meant the practice of abstracting from things seen. To construct with volumes in light and then so to relate and inflect them that they "became" figures or objects was to produce, wrote Dermée, "la *sculpture pure*."[17]

In conversation with Deborah Stott, Lipchitz himself suggested that his own move from "stylization" to a method whose starting point was in the abstract occurred after his architectural works of 1915–16, which he said, were still stylized.[18] As we shall see, for Lipchitz and Gris together, the key transitional period toward a cubism that could be presented thus and as an orderly art disciplined in the collective terms of the wartime "Call to Order" was 1916–17, the period when their friendship was cemented.[19]

Both Stott and I have demonstrated that the working processes involved were neither as consistent nor as simple as they were made to appear, but between 1916 and 1920 Lipchitz and Gris together developed a practice that gave an initiating role to the proportional division of the block or canvas using the Golden Section triangle and a key role to formal rhymes in the elaboration of ideas.[20] Geometric armatures based on the Golden Section triangle were used as springboards for ideas in drawing; these were then elaborated and enriched in figurative or still-life terms. Both D.-H. Kahnweiler in his witness account of Gris's practice, and Lipchitz in his account of his own practice at the time, stress the openness and spontaneity of the process of elaboration.[21] Crucial to it was the formal rhyme, which followed from the simplicity of Gris's and Lipchitz's formal vocabularies: a single formal combination could be made to denote quite different things and so did not need to be given a definitive meaning (referent) to begin with. Thus, in Gris's *Tourangeau* (fig. 1) paint-

ed at Beaulieu in 1918, the construction of the head is almost repeated, though inverted, in the head and shoulders of the bottle, while the head of Lipchitz's *L'homme à la guitare*, modeled before his departure for Beaulieu, is almost repeated in the head of the bottle in his *Bas-Relief I*, executed at Beaulieu. One particular combination of elements is not necessarily either a head or bottle; and by 1918 this is as true of Lipchitz's as of Gris's practice. Complex and open the processes of elaboration might have been, but one simple point can be made: between 1917 and 1920 Lipchitz's and Gris's shared aspiration was to work from the abstract to the concrete, from form to "motif," and for both an idealized image of their working method went with an idealized image of the result—in Lipchitz's case, "*sculpture pure*."

And yet it has to be emphasized that neither Lipchitz nor Gris thought of their practice as idealist. The use of Platonic language in relation especially to Gris's "Call to Order" has tended to leave the impression of a search for some fixed, ideal essence. In fact, Gris himself, writing in April 1920, made a point of distancing his "deductive" method from the idealism he associated with Greek art, and the critics who supported Gris and Lipchitz in 1920–21 were careful to do likewise for such a practice in general.[22] Indeed, their friend Maurice Raynal specifically used their work to argue for the personal character of postwar cubism altogether. Raynal's short 1920 monograph on Lipchitz starts with a comprehensive rejection of the inductive method (stylization) precisely because it idealizes, reducing everything to some impersonal essence (the "thing in itself," the noumenon). What Raynal wants—and finds in Lipchitz's sculpture—is a vision of things shaped by the personal "loves" of the artist: that to which he is drawn.[23] In 1921, writing on Gris, he phrases it thus: "Chaque homme crée son beau particulier, le beau qu'il aime, plus simplement ce qu'il aime tout court et non ce qu'aime autrui." He argues from the example of Gris's cubism for the infinite, the "sublime" in "sensibilité." "Notre sensibilité, je le disais, est infinie comme le ciel, ce prototype du sublime suivant la conception philosophique."[24] For both Dermée and Raynal, who to some extent shaped theory in relation to the work of Gris and Lipchitz, the "pure" cubism, which their painting and sculpture represented, was nonetheless based always on their individual "sensibilités" —on their personal experience of the world. It was fundamentally because of this, the theory said, that they worked back to the world (deductively) and not away from it (inductively) —to retie the link. And it was fundamentally because of this that the sculpture of Jacques Lipchitz would be consistently held up by sympathetic critics *against* the idealism of Constantin Brancusi in the early 1920s. As André Salmon put it, contrasting Brancusi's *Princess X* against Lipchitz's sculptures at the Indépendants of 1920: "Il [Brancusi] est hanté, dominé, dévasté par la passion des formes pures. Il est damné, exalté d'une mathématique qui réduirait la perfection mathématique à la pureté du zéro. O . . . C'est en effet une perfection. Hélas!"[25]

In the light of this discourse, with its stress on the personal and experiential, Lipchitz's and Gris's work invites an analysis that not simply brings out the way it illuminates the "collective" move towards the "Call to Order" of 1916–20 but that also highlights the distinctiveness of two individual achievements. Certainly theirs was a collective production between 1916 and 1920, but it was individual as well—the result of two different yet complementary sensibilities developing alongside one another.[26]

Lipchitz himself dated his meeting with Gris to "the beginning of 1916."[27] There is an indication in Gris's correspondence that they knew each other by July 1916, and it is certainly possible that they were introduced around the date that they signed contracts with Léonce Rosenberg (Gris, April 18; Lipchitz, May 5, 1916).[28] But throughout 1916, Lipchitz's correspondence suggests that his circle revolved around his friendship with Diego Rivera. Picasso, Henri Matisse, Henri Laurens, and María Blanchard are all mentioned, but not Gris.[29] In fact, their friendship is not referred to in the correspondence of either of them until Gris writes to Rosenberg about it early in 1917, and then he writes as if their intimacy is something new: "Nous sommes devenus très amis."[30]

A look at Lipchitz's work, alongside his correspondence with Rosenberg (now accessible thanks to the work of Christian Derouet),[31] identifies the later months of 1916 and especially the turn of 1916–17 as crucial both for his "Call to Order" in collaboration with Gris and for the assertion of his own individual "sensibilité" as a sculptor. In conversation with Deborah Stott and in *My Life*, Lipchitz himself consistently gave the impression that his engagement with multimaterial construction in the "demountables" and with "stylization" in the "architectural" sculptures was confined to 1915 in the former case and to early 1916 in the latter. A letter of March 2, 1916, mentions a "pierre" almost finished, and identifies it by using a "V" motif which can almost certainly be identified with the "shoulder-blade" feature central to the tall "architectural" *Personnage debout* in the Guggenheim Museum; the letter also refers to a *Tête* in progress, which is probably the *Tête* usually dated 1915.[32] A letter of April 28, 1916, tells Rosenberg: "le violonceliste est en train de sècher [sic] et je compte de pouvoir le livrer dimanche vers 2 1/2–3h."[33] The sculpture in question is clearly the polychromatic demountable, *Le Violonceliste*. Receipts in March and letters in May corroborate this evidence that Lipchitz was engaged in polychromatic and multimaterial construction that spring.[34] Just at the moment, therefore, when he probably met Gris, Lipchitz was still working both in the multimaterial polychromatic mode opened up by Piccasso's prewar constructions, and in the "stylized" synthetic mode opened up by Picasso's most austere cubist figure paintings of 1915, above all the New York *Arlequin* and the sombre *L'Homme accoudé sur une table*. His architectural stone pieces had little to do with Gris, and a demountable like *Le Violonceliste* looked more to the Gris of 1913—of *Le Torero* and *Le Fumeur*—than to the Gris of 1915–16. The correspondence dateable to the last six months of 1916 is not so helpful in establishing exactly when particular pieces were made, but it does establish that Lipchitz himself was aware during these months of an important shift in his position, one that clearly situated him more decisively as an individual and a sculptor. The first sign of this is a letter dated June 20, 1916, where Lipchitz simultaneously differentiates himself from Laurens, with whom he was, however, on good terms, and writes of clarifying his own "vision": "Je suis arrivé à un point ou [sic] ma vision commence à s'éclaircir. Il me faut fixer absolument dans la matière définive mes sensations et de ça ne fait que gagner l'oeuvre car elle garde toute la fraicheur d'émotions."[35] The key evidence of his shift comes in a letter dateable to December 1916, and the key themes he brings out here are the distinctiveness of sculpture, its antipathy as an art to polychromy, and its proximity to architecture.

La sculpture—l'Art le plus grand (pour moi). Aussi subtile que la peinture mais plus sévère—est tombée dans une execive [sic] politesse. / J'étais aussi entrainé par un courant très malsain—la sculpture polychromée—C'est pas ça du tout. / Evidenment [sic] c'est faciliter sa tache parce que c'est obtenir par les couleurs des choses qu'on devrait obtenir par la forme pure. / Ça rend la chose plus aimable, plus plaisant mais c'est pa [sic] ça la sculpture! L'architecture est une sculpture en grande proportion accomodée à quelque besogne. La sculpture il faut la faire comme on fait l'architecture. C'est comme ça d'ailleurs que l'ont fait les anciens aussi bien que les egyptiens comme les assyriens comme aussi les français de la cathédrale de Chartres.[36]

This talk of "les anciens" echoed both Léonce Rosenberg's desire to link modern art to pre-Renaissance art and Gris's explicit referencing of "Tradition" in the paintings he brought back in autumn 1916 from his first stay at Beaulieu-lès-Loches, among them the Corotesque *Portrait de Josette*. Altogether, in fact, Lipchitz's rejection of the "aimable" and the "plaisant" in polychromy and his commitment to "la forme pure" and to the constructive coherence of "architecture" within an idea of "Tradition" precisely paralleled Gris's moves as a painter between the spring and autumn of 1916. If one compares Lipchitz's *L'Homme à la mandoline*, which he dates to the end of 1916 with the polychrome *Violonceliste*, the shift to the severe and the "pure" is obvious enough.[37] Games not only with solid and void, but with significations are a feature of *Le Violonceliste*, games sanctioned by Picasso: the head, shoulders, and bow-tied upper torso of the figure is an angular variant on the head, neck, and body of the curvilinear cello; the figure's left arm is turned like a chair leg, the chair legs themselves are not; the cello bow is not a straight line, it ripples like the sound waves it would produce. Such games with the relationship between forms and meanings are gone in *L'Homme à la mandoline*, but not the games with solid and void. The interaction of solid and void, however, has been redirected: they are now an integral part of the key architectural theme of cohesion, something much less playful. This stress on the interaction of solid and void within the theme of architectural cohesion precisely parallels the interaction of figure and ground (form and space) in Gris's painting of spring-autumn 1916. The parallel is worth looking at more closely. Given the importance of the architectural analogy to Lipchitz's new sculpture of the turn of 1916–17, it is clearly more in the "architectural" stone pieces of 1915–16 than in the polychromatic demountables that continuities can be seen.[38] Structural wholeness is a feature of a piece like the Guggenheim *Standing Personnage* or the Tate's *Sculpture* as much as *L'Homme à la mandoline*. In all these pieces, the intersecting edges of planes can seem to generate a web-like geometry that expands into the space around the piece, engaging that space. This was an effect that was to continue in Lipchitz's work right through his cubist period; his drawings often show it to follow from his use of geometry in the initiation and development of ideas, a geometry drawn out on the sheet which articulates both the projected sculpture and the space around it.[39] At this stage, however, the mass of the pieces and their spatial envelope can be felt as two quite distinct properties, integrated only in formal abstract terms. This twofoldness is stated quite literally in one of the "architectural" pieces of 1915–16, the obelisk-like sculpture, where the obelisk as such is a solidification of the space around the stylized female figure as a core, giving that space a monumental presence.[40] Here palpably both figure and space are integrat-

ed and yet kept separate. An echo of this solidification of a structured "space" is found in *L'Homme à la mandoline*, where Lipchitz explained the double figure as a man and a shadow, but here the space of the shadow is brought within the figure as a flat yet solid element. Lipchitz himself linked his attempt to fuse the figure and its shadow to painting, and from the spring of 1916 there is no doubt that the painting of shadows was a central preoccupation of Gris's.[41] Elsewhere I have shown how a work like *Le Siphon* of May 1916 is pulled together by its geometric "organizing lines" but retains a clear twofoldness in its representation of objects and space.[42] Here, as in Lipchitz's *L'Homme à la mandoline*, the shadow functions as an intermediary between the two. Yet, it should be stressed that Lipchitz's use of the shadow produces a distinct and individual *sculptural* solution. His sculptural shadow is a flat sign gripped within the three-dimensional embrace of the figure; it is a fully sculptural conceit that yet signals a relationship with painting. The insistence on an explicitly *sculptural* articulation of space contrasts with Gris's explicitly two-dimensional approach to the problem, but for both the problem to be resolved is the same: the integration of figure or object and space to make it whole.

By the spring of 1917, Lipchitz and Gris had more fully resolved that problem, the one in an emphatically sculptural and the other in an emphatically pictorial way: together, and yet in ways that further separated a sculptural from a pictorial sensibility. In Gris's case a key work is the tiny *Carafe et bol* of May 1917; in Lipchitz's case a key work is *Baigneuse assise* of early that year.[43] For both of them, these were important works too in the development of their deductive methods. In Gris's painting, one can no longer talk about a twofoldness, so completely are figure and ground fused within the structure of "organizing lines." The objects could not be more crisply delineated, yet it is impossible to say definitively just what is figure and what is ground. Things and their setting, solid and space, flow together, however tightly contained by structure, everything represented by flat areas of brown, green, and white relief modeling is kept to a minimum.[44] In Lipchitz's sculpture, there remains a powerful sense of the figure as a weighty mass in space, but space is made a property of the sculpture itself and thereby becomes an integral part of it, fusing the two together as in Gris's painting, yet so utterly differently. The bather's right thigh is depicted by a curved plane sliced out of stone; it is an absence, a space. Such an inversion was, of course, a feature of Picasso's, Aleksandr Archipenko's, and Laurens's earlier polychromatic work, but here solid and void are not dematerialized by the pictorial effects of color, they are unequivocal physical presences. The space that Lipchitz was to integrate into his freestanding sculptures from later 1916 was always to be actual, never pictorial.

Briefly, at the end of 1917, Lipchitz and Gris were tempted by a more dynamic and equivocal figuration (found, for instance, in Lipchitz's *Baigneuse III*) but stability, clarity, and wholeness returned as basic requirements early in 1918 with works like Lipchitz's *L'Homme assis à la guitare* and Gris's *Guitare* (fig. 2), both finished just before their departure for Beaulieu-lès-Loches.[45] The principles applied in the integration of figure and ground and solid and space have not changed here, but they are applied more elaborately, and in Lipchitz's case with both greater compactness (economy) and with a fuller awareness of the positive potential of voids within sculpture. Perhaps the most telling passage is the sequence of transitions from the flat silhouette of head and shoulders to the projecting and convex upper torso. The

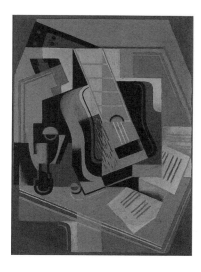 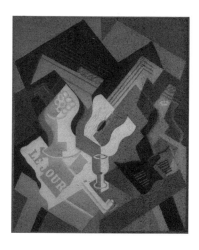

Figure 2. Juan Gris, *Guitare*,
1918. Oil on canvas, 81 × 59.5 cm,
Museo Nacional Centro
de Arte Reina Sofía, Madrid.

Figure 3. Juan Gris, *Guitare et compotier*
(*Guitar and Fruit Dish*),
1919. Oil on canvas, 92 × 73.5 cm,
Henie-Onstad Art Center, Norway.

mass of the head is represented by a flat cutout shape and a negative volume, whose positive signification is enhanced by the contrast with the actual positive volume of the torso. Once again, space is actively integrated into the piece and once again as successfully as in Gris's painting, but without a hint of the pictorial. The only concession to the pictorial in Lipchitz's sculpture is the use of framing rectangular planes, which echo Gris's use of framing devices, and which give it a dominant frontality.

There were rhymes in Lipchitz's and Gris's work long before 1918, but it was in 1918–19 that rhyming became a highly developed and visible feature. A look at how they each used it brings out further both the closeness of their collective enterprise and the distinctiveness of their individual contributions, the one engaging a decisively sculptural, the other a decisively pictorial sensibility.

Gris ties together his *Guitare et compotier* (fig. 3) of July 1919 by means of rhymes as well as "organizing lines." The sound hole of the guitar and the mouth of the glass are simple rhymes; the fruit bowl with its bunch of grapes and the guitar as a whole are more complex, structural rhymes.[46] Lipchitz, similarly, ties together his *Pierrot à la clarinette* probably of very late 1919 by the use of rhymes.[47] The clarinet's aperture, its sound holes, and the Pierrot's buttons join with the face, hat, and ruff to develop a theme based on the circle, but here every rhyming relationship is a relationship of solid and void as well, conceived and realized in three dimensions. Hat and face are cylinders, which interpenetrate; on the concave surface of the face (a negative standing for a positive convexity), the eyes are protrusions that echo the protruding holes of the instrument (positives standing for negatives). These are not mere echoes between one shape and another; they are tangible relationships in three dimensions, which incorporate and intrude upon space. What I have tried to bring out in this analysis is the emergence in Lipchitz of a particular kind of sculptural "sensibilité," distinct from Gris's pictorial "sensibilité" within a development which remains so close as to invite the epithet, collective. The distance between them, even as their work converged, is perhaps most strikingly brought out by their respective attempts to cross over between media, both of them in my opinion failures. Lipchitz was certainly alone responsible for his sole "finished" oil painting,

Nature-morte au compotier, which he acknowledged was "inspired by the works of my friend Juan Gris."[48] It totally lacks the capacity to "make" space and mass in two-dimensions which is so striking a feature of even the simplest and flattest of the paintings by Gris to which it relates, for instance his *Carafe et bol* of May 1917. Gris's only ambitious attempt at sculpture, his painted plaster *Arlequin* also of 1917, was made with Lipchitz's technical help, but was otherwise Gris's own invention.[49] It entirely lacks that grasp of the relationship between the different aspects of the piece when seen in the round, so often a feature of Lipchitz's free-standing sculptures of 1916–20, and the side views lack the compact cohesion of the front and back views. Behind these failures convincingly to cross over into the other medium, lie not merely different working experiences, but sharply contrasting sensibilities.

When Paul Dermée and Maurice Raynal came to write the first important texts on Lipchitz in 1920 and 1921, it was the distinctiveness of his *sculptural* achievement that they stressed. For both of them, this came of a special sensitivity to light as creator of form, and an especially tight control of sculpture as construction. Raynal wrote of the architectural sculptures of 1915–16 as "fontaines lumineuses de sa sensibilité" and of Lipchitz's modulation of light across surfaces as "le colorement de l'ombre."[50] Dermée recalled Lipchitz's formation as "fils d'un entrepreneur en construction" and claimed for his work exemplary status as a demonstration of all that was sculptural in sculpture against the heresies of multimaterial polychromy.[51] Years later, when in May 1947 Lipchitz himself wrote to Kahnweiler to challenge his monograph on Gris, it was not the dealer's representation of their relationship that he opposed, but his rejection of the idea that anything significant had been achieved by sculptors as sculptors in cubism, and thus of Lipchitz's importance in the development of cubist sculpture.[52]

In their insistence on the separateness of sculpture as an art, Lipchitz and his supporters protested too much. Picasso and Archipenko had made the first moves in the opening out of an entirely new kind of sculpture, one that engaged the pictorial but was no less sculptural for that, one that had a long future in the twentieth century. Ultimately, by rejecting multimaterial polychromy in 1916, Lipchitz did not make a statement about the essential nature of sculpture as such, he made possible the development in his own work of a particular sculptural *sensibilité*, one so excited by the actualities of mass, weight, and space and so gripped by the order of built structures that it could not accept the games-playing arbitrariness of cubist construction. The convergence of his art with that of Gris was underwritten by an increasingly clear insistence on the separateness of the media, which echoes their poet-friend Pierre Reverdy's insistence on the fundamental separateness of literature from visual art.[53] It was, in part, therefore, a shared set of values that helped Lipchitz jettison polychromy and develop his cubism in the way he did alongside Gris. I would argue, however, that what is above all brought out by looking at his work in the context of Gris's cubism is a highly individual *sensibilité*, one that is revealed most distinctively in everything about his sculpture that denies painting, including the painting of Juan Gris.[54]

1. Gris and his wife, Josette, arrived in Beaulieu-lès-Loches on April 2, 1918; Lipchitz and his wife, Berthe, were installed there by April 20. Lipchitz and Berthe returned to Paris on September 24; Gris nearly two months later on November 12. See Christian Derouet, ed., *Juan Gris: Correspondance, Dessins 1915–1921* (Valencia and Paris: IVAM Centre Julio González and Centre Georges Pompidou, Paris, 1990–91), letters 22 and 24; and Douglas Cooper, ed., *Letters of Juan Gris (1913–1927)* (London, 1956), letters LXXII and LXXV. The Lipchitzes lived with Gris and his wife on arrival but soon moved out to live separately in lodgings found for them by Josette, who came from Beaulieu. Jacques Lipchitz with H. H. Arnason, *My Life in Sculpture* (London: Thames and Hudson, 1972), 51, and information from an interview with Josette Gris, July 20, 1977.

2. Derouet notes that Metzinger was installed in lodgings at Beaulieu from June 21, 1918, but returned to Paris on July 31. Blanchard was still there at the end of October, when Gris and Josette nursed her through flu. See Derouet, ed., *Juan Gris*, letters 45 and 46 and p. 83.

3. Deborah A. Stott, *Jacques Lipchitz and Cubism* (New York and London, 1978), 147–48.

4. Also important for the cubists early in 1920 was the revived Salon de la Section d'Or and the exhibition organized by Rosenberg at the Galerie Moos in Geneva. For an account of this, see Christopher Green, *Cubism and Its Enemies: Modern Movements and Reaction in French Art, 1916–1928* (New Haven: Yale University Press, 1987), 25–37.

5. Lipchitz refers to the breakdown in their friendship in Lipchitz, *My Life in Sculpture*, 69–70. Lipchitz was one of the four chief mourners at Gris's funeral on May 13, 1927.

6. Rosenberg wrote to Gris in August 1918 recommending Foch's *Des principes de la guerre*; he also recommended it to Fernand Legér and Theo van Doesburg. See Derouet, ed., *Juan Gris*, 83.

7. Lipchitz also showed *Arlequin à l'acordéon* (1919).

8. Just how rigorously Rosenberg attempted to control his cubists is emerging with the publication by Christian Derouet of the correspondence between the dealer and his artists and other documentation concerning Léonce Rosenberg. See for instance Derouet, ed., *Juan Gris*; Derouet, "Juan Gris: A Correspondence Restored," in Christopher Green, *Juan Gris*, exhibition catalogue (London: Whitechapel Art Gallery, 1992), 286ff.; and Derouet, "Exposition Henri Laurens, Décembre 1918," in *Henri Laurens*, exhibition catalogue (Villeneuf d'Ascq: Musée d'Art Moderne, 1992–93), 38–53. This is to be added to by the publication of the correspondence between Fernand Léger and Léonce Rosenberg. Not only Rosenberg's strategies of control as a dealer, but the basic factual material relating to the production of his artists can now be far more accurately understood as a result of Derouet's gathering of this material for the Service de Documentation of the Musée National d'Art Moderne, Centre Georges Pompidou, Paris. In particular Derouet's projected correlation of information from Rosenberg's stockbooks and from the correspondence holds out the hope of a more precise picture of what the artists produced, when, and under what circumstances than we have for any other important phase in the history of modernism. This article is much indebted to Christian Derouet's help and support. I also wish to acknowledge the help of Monsieur Oddos, the director of the Service de Documentation, and his staff, especially Madame Tépéneag and Madame Brégeger.

9. In 1916 when they met, Gris was twenty-nine and Lipchitz twenty-six. Though Blanchard too was a recruit to cubism, she was significantly older.

10. Letter from Gris to Léonce Rosenberg, January 29, 1917; Service de Documentation of the Musée National d'Art Moderne, Centre Georges Pompidou, Paris.

11. Letter from Gris to Léonce Rosenberg, February 22, 1917; Service de Documentation of the Musée National d'Art Moderne, Centre Georges Pompidou, Paris.

12. Letter from Gris to Léonce Rosenberg, April 19, 1917; Service de Documentation of the Musée National d'Art Moderne, Centre Georges Pompidou, Paris.

13. Patai dates Lipchitz's "Sundays" to 1916–17 and names Picasso, Rivera, Gris, Matisse, Modigliani, Metzinger, Reverdy, Salmon, Jacob, and Cendrars as among those who came. See Irene Patai, *Encounters: The Life of Jacques Lipchitz* (New York: Funk and Wagnalls, 1962). Lipchitz names Gris, Hayden, Laurens, Lhote, and Severini as among those who came. See Stott, *Jacques Lipchiz and Cubism*, 15. Lipchitz also recalls discussions in Gris's studio, naming "the mathematician Princet, the poets Reverdy, Jacob, and Huidobro" as present. Lipchitz, *My Life in Sculpture*, 39.

14. Letter from Jacques Lipchitz to D.-H. Kahnweiler, May 27, 1947; Tate Gallery Archive, London. The first to have drawn attention to this important document was Cathy Pütz, who reproduced and discussed it in Pütz, "Cubism in the Work of Jacques Lipchitz (1914–1922)" (M.A. diss., Courtauld Institute, University of London, 1995). I am grateful to Cathy Pütz for her invaluable introduction to the material in the Tate Gallery Archive.

15. Stott's is a searching analysis based on first-hand evidence from Lipchitz. See Stott, *Jacques Lipchitz and Cubism*.

16. Juan Gris (signed "Vauvrecy," the pseudonym of Amédée Ozenfant), Statement, *L'Esprit nouveau*, no. 5 (Paris, February 1921): 533–34.

17. Dermée puts it thus: "Le cubiste constructeur ne travaille pas sous l'émotion immédiate que lui donne l'objet le motif . . . Au premier stade de la création artistique il n'a que des intentions plastiques pures . . . Puis vient la découverte du *motif* . . ." Paul Dermée, "Lipchitz," *L'Esprit nouveau*, no. 2 (Paris, November 1920): 169–82.

18. Stott, *Jacques Lipchitz and Cubism*, 17, 27–37, 116–17.

19. I have argued for the importance of 1916–17 in the development of Gris's "deductive" practice in Christopher Green, "Synthesis and the Synthetic Process in the Painting of Juan Gris," *Art History* 5, no. 1 (London, March 1982): 87–105.

20. Stott, *Jacques Lipchitz and Cubism*; and Green, *Juan Gris*, and "Synthesis and the Synthesic Process in the Painting of Juan Gris."

21. Kahnweiler in D.-H. Kahnweiler, *Juan Gris, His Life and Work* (London and Stuttgart, 1968–69); Lipchitz in Lipchitz, *My Life in Sculpture*.

22. For Gris on the point, see Juan Gris, Statement (in answer to an *enquête on "art nègre"*), Action, no. 3 (Paris, April 1920); translated into English in Kahnweiler, *Juan Gris, His Life and Work*, 24. Dermée makes a point of connecting the sense of the permanent in Lipchitz's sculpture not to a universal ideal but to "l'ensemble des émotions et des impressions de toute sa vie c'est-a-dire son humanité." Dermée, "Lipchitz," 171.

23. Maurice Raynal, *Lipchitz* (Paris, 1920), n.p.

24. Maurice Raynal, "Juan Gris," *L'Esprit nouveau*, no. 5 (Paris, February 1921): 534–55.

25. André Salmon, "Aux Independants (II)—Le Bonnat du Cercle Volnay," *L'Europe nouveau*, no. 6 (Paris, February 7, 1920): 233. For a later instance of this kind of comparison between Lipchitz and Brancusi, see Waldemar George, "Sculpture, quelques aspects de la sculpture moderne," *La Vie des lettres* (Paris, April 1923), 22.

26. My account, based on the new evidence of the Lipchitz-Roseberg correspondence collected together by Christian Derouet and made available by the Service de Documentation of the Musée National d'Art Moderne, Centre Georges Pompidou, Paris, reorders the chronology of Lipchitz's work expecially in 1915–16. I do not wish to imply that the artist intentionally misled later commentators. Clearly he later tended to think of the demountables as prior to the architectural sculptures because they are obviously less related to his later cubist work, an understandable failure of memory. A particularly clear account of Lipchitz's development between 1916 and 1920, as it was understood from Lipchitz's later recollections, is found in Alan G. Wilkinson, *Jacques Lipchitz: A Life in Sculpture*, exhibition catalogue (Toronto: Art Gallery of Ontario, 1989).

27. See Jacques Lipchitz, Preface, *Juan Gris—Jacques Lipchitz: A Friendship*, exhibition catalogue (New York: M. Knoedler and Co., 1959), n.p.

28. Rosenberg writes to Gris (July 3, 1916): "Lipchitz m'a écrit que A. Kann est venu le voir . . ." Gris must therefore know who Lipchitz is, and we can assume that he probably knows him personally.

29. See the Lipchitz-Rosenberg corresondence, in the Service de Documentation, Musée National d'Art Moderne, Centre Georges Pompidou, Paris. Obviously, Gris and Lipchitz could not have been in close touch in September and October 1916, when Gris was at Beaulieu.

30. Letter from Juan Gris to Léonce Rosenberg, February 22, 1917; Service de Documentation, Musée National d'Art Moderne, Centre Georges Pompidou, Paris.

31. See note 8.

32. Letter from Jacques Lipchitz to Léonce Rosenberg, "Vendredi le 2 mars," 1916; Service de Documentation, Musée National d'Art Moderne, Centre Georges Pompidou, Paris. That the date is 1916 is confirmed by checking the day that corresponds to Friday, March 2, in the calendar for 1916.

33. Letter from Jacques Lipchitz to Léonce Rosenberg, "Paris, le 28 avril," 1916. Service de Documentation, Musée National d'Art Moderne, Centre Georges Pompidou, Paris. Reference to other pieces using wood and other materials in letters securely dateable to May 1916 confirm that the date is 1916.

34. A receipt dated March 22, 1916, refers to a plaster "intitulée La Danseuse" and cedes Rosenberg the right to have three "exemplaires" constructed using ebony and aluminium (it seems that aluminium proved impossible to find in wartime Paris, although Lipchitz did search for it). This may refer either to the *Danseuse* later dated by Lipchitz to early 1915, just after his return from Majorca, or to the most architectural of the demountables, the *Danseuse* in the collection of Yulla Lipchitz, usually dated 1915. Letters dated "Dimanche 14 mai," and "Jeudi, le 18 mai," both confirmed from the calendar to be 1916, refer to a wooden piece "de 95 cm. De hauteur en bois de poligendre, bois de roses, de hêtre, piche pin, verve, cuivre et peinte."

35. Letter from Jacques Lipchitz to Léonce Rosenberg, "Paris, le 20 juin 1916"; Service de Documentation, Musée National d'Art Moderne, Centre Georges Pompidou, Paris. Of Laurens he writes: "Laurence [sic] c'est autre chose il a une vision toute autre que la mienne."

36. Letter from Jacques Lipchitz to Léonce Rosenberg, "Mardi." The letter is dateable to December 1916 because of its reference to Rosenberg's request for drawings for a house he planned to build, which refers back to a letter from Lipchitz requesting details of the terrain, etc., dated "Paris, VIII/XII 1916." Rosenberg appears to have replied to the points about polychromy in the sculpture of the past, because this is referred to in a letter from Lipschitz dated "Paris le 19 Décembre 1916"; Service de Documentation, Musée National d'Art Moderne, Centre Georges Pompidou, Paris.

37. Here I accept the dating suggested by Lipchitz in Lipchitz, *My Life in Sculpture*. It is especially in his memory of the dating of the demountables that he seems to have been mistaken. Neither stylistic evidence nor the Lipchitz-Rosenberg correspondence indicate that his dating of the later 1916 and the 1917 pieces is mistaken.

38. The importance of the architectural analogy is underlined by Lipchitz's involvement in Rosenberg's project to build himself a house. See note 36.

39. Drawings from the Tate Gallery notebook of 1916–17, discussed in this catalogue by Cathy Pütz, offer good instances.

40. This piece is dated by Wilkinson to 1915, on the basis of Lipchitz's recollection of works related "to an Egyptian obelisk." See Wilkinson, *Jacques Lipchitz*, 75.

41. Stott claims that Lipchitz "described this piece as an attempt to emulate painting by including the man and his shadow in the sculpture." Stott, Jacques Lipchitz and Cubism, 125

42. Green, "Synthesis and Synthesic Process," 60–61.

43. Again I follow Lipchitz's dating. See *Lipchitz, My Life in Sculpture*, 45–46.

44. For a discussion of this work integrated into a consideration of Gris and his development of the deductive method, see Green, *Juan Gris*, 60–61.

45. For the dating of Lipchitz's *L'Homme assis à la guitare*, see Lipchitz, *My Life in Sculpture*, 50. I discuss *Baigneuse III* and Gris's equally dynamic and equivocal *Compotier, pipe et journal and Nature-morte à la plaque* (of November and December 1917) in Green, *Cubism and Its Enemies*, 28–29. Lipchitz spent a period in June and July 1917 at Le Piquey on the Bassin d'Arcachon. He was back in Paris by August 7, when he wrote to Rosenberg about employing a workman as practicien in the studio. Lipchitz-Rosenberg correspondence, Service de Documentation, Musée National d'Art Moderne, Centre Georges Pompidou, Paris. He and Gris were certainly both in Paris through the autumn.

46. I first discussed this work in terms of its rhymes in Green, "Synthesis and Synthesic Process." For a discussion of rhyming in terms of metaphor and the Reverdian notion of the image, see Green, *Juan Gris*, 63–67.

47. As indicated to me by Christian Derouet, Rosenberg's stockbooks can be helpful in dating certain pieces. *Pierrot à la clarinette* was one of the pieces shown at the Indépendants, which opened in February 1920. It may well be referred to in the stockbook entry for no. 6637, 1919, "Lipchitz, Pierrot, sculpture pierre h. 79," whose arrival in Rosenberg's stock is dated January 5, 1920. If so, this indicates a very late 1919 date for its completion.

48. Lipchitz, *My Life in Sculpture*, 50.

49. In 1959, Lipchitz was specific when writing of Gris's *Arlequin* on show in New York: "I am happy to see that the only real sculpture he ever made, late in 1917, is here. I helped him make it. Of course, not the creative part, for that he did not need me. Only the technical one. He has built it so carefully, using triangles of the golden rule, which he had cut out as patterns of cardboard, and constantly verifying his work with these patterns in order not to allow himself any mistakes in his construction or in his proportions." Lipchitz, Preface, *Juan Gris—Jacques Lipchitz*, n.p. A late (autumn) 1917 date is confirmed by a letter of January 25, 1918, where Gris informs Rosenberg that "la sculpture" is to be taken "domain matin" so that a mold can be made from which two terra-cotta casts may be produced.

50. Raynal, *Lipchitz*, n.p.

51. "Lipchitz a défendu la sculpture pure contre les tendances de sculpteurs modernes qui voulaient l'abâtardir en y introduisant les procédés de la peinture: matieres heteroclites (tôle, verre, papier-pâte, etc.), couleurs, etc.,croyant par la matière vivifier la sculpture." Dermée, "Lipchitz," 171.

52. Lipchitz to Kahnweiler; see note 13.

53. As Etienne-Alain Hubert was the first to point out, Reverdy's fundamental theoretical statement on cubism of March 1917, his article "Sur le cubisme," was prefaced by an attack on the notion of a merger between visual art and literature, something he saw threatened by the combination of word and image found on the covers of Francis Picabia's periodical *391*. See Pierre Reverdy, "Sur le cubisme," *Nord-Sud*, no. 1 (Paris, March 15, 1917), in Reverdy, *Oeuvres completes, Nord-Sud, Self-Defence et autres écrits sur l'art et la poésie*, 1917–1926, ed. Etienne-Alain Hubert (Paris, 1975), 16, 238–39.

54. My decision to focus on the fundamental distinctions between Lipchitz's and Gris's cubisms, as well as their shared values, necessarily diverts attention away from the political and social meanings of their collective "Call to Order." I have explored these in my essays on Gris's painting of the figure and still life in Green, *Juan Gris*. A study of Lipchitz's subjects would also be fruitful. The shift from multimaterial polychrome construction and "stylization" went with a move towards a more limited range of subjects, dominated by the nude (bather), the still life (in the reliefs), and the Commedia dell'Arte.

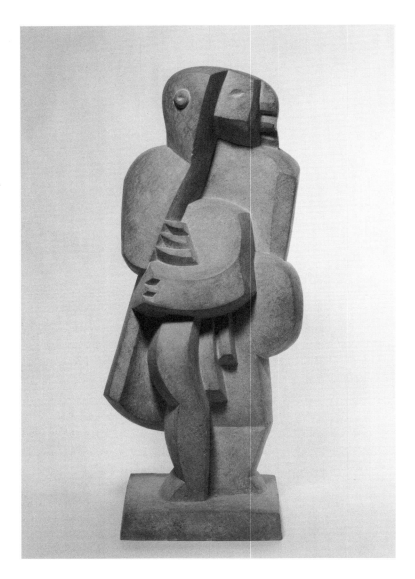

Figure 1. Jacques Lipchitz, *Bather*, 1924. Limestone, H. 68.8 cm,
Fogg Art Museum, The Harvard University Art Museums, Cambridge, Massachusetts,
Gift of Lois Orswell.

Cathy Pütz

TOWARDS THE MONUMENTAL:
THE DYNAMICS OF THE BARNES COMMISSION (1922–24)

As a widely traveled polyglot and cultural eclectic who, by the end of his life, was as proud to count himself French as he was Lithuanian or American by nationality, Jacques Lipchitz may in retrospect have found it hard to pinpoint exactly when his relationship with America began. It is a relationship that undoubtedly describes the most publicly fêted and commercially successful part of his career. When we now draw from a rich reserve of neglected archival material to look for its beginnings, we find them appropriately at the moment when, in 1920s Paris, Lipchitz's financial fortunes took a sudden upturn. This was the moment when he first met the formidable American collector Dr. Albert C. Barnes. For Lipchitz, the introduction and subsequent commission marked a critical turning point with repercussions for his sculptural technique and motifs even more far-reaching than the considerable financial benefits.

The introduction to Barnes in late 1922 came interestingly through Lipchitz's contact with the French dealer Paul Guillaume and the mutual interest Lipchitz and Guillaume shared in collecting African and Oceanic artifacts. It came too at a time when the American connection was beginning to develop for avant-garde sculpture more generally through discreet but significant channels. One of these was the renewed contact made with his homeland by Lipchitz's friend, the artist John Storrs, who acquired Lipchitz's *Man with Mandolin* (1916–17)[1] in November 1922 on behalf of the newly founded, American-based, Société Anonyme. This society gave crucial exposure to avant-garde artists relatively unknown in America, like Lipchitz and Alexander Archipenko, during the 1920s.[2] Another new avenue came through a Hungarian dealer, Joseph Brummer, like Lipchitz an émigré in Paris who moved his business to New York, making significant inroads there for Lipchitz, Henri Laurens, and Ossip Zadkine between 1925 and 1930.[3]

In France during this period, the market for avant-garde sculptors was perceptibly shifting, and the Barnes-Lipchitz relationship, as elaborated through their unpublished correspondence, is a prime example of the way one or two key contacts directed artists to major new commissions, freeing them from the emotional and economic ties of exclusive dealer-contracts.[4] Out of the heady mood of the early 1920s three discreet markets emerged: the aristocracy, to which friends like Jean Cocteau enjoyed privileged access, and one important new client of Lipchitz's, Charles de Noailles; American buyers coming through Guillaume, also directly through visits to Paris; and the professions and the thriving industry of the decorative arts, which embraced Jacques Doucet and Coco Chanel, both keen patrons of Lipchitz.

With this postwar revivification of the art markets, the opportunities to be exploited were many, especially for those such as Paul Guillaume who had the necessary social standing and requisite *sens du luxe.* Guillaume was considered the most Parisian of Parisian dealers, an *homme de goût* and a *connaisseur d'ancien,* whose gallery in the rue la Boëtie was the treasure trove that drew the wealthiest international collectors, grandly dubbed "(le) palais des princes mécènes."[5] Guillaume's reputation as the specialist dealer in *art nègre* not only associated him with the avant-garde but was also widely held to be the reason for his first contact with the "prince des princes mécènes," Albert Barnes, for whom Guillaume became the Parisian "agent" in 1922 (going under the title of Barnes's "Foreign Secretary").[6] By this time, Guillaume had frequently had occasion to discuss *art nègre* with Lipchitz, who was often called upon for advice by friends who appreciated his considerable connoisseurship. Correspondence between Guillaume and Lipchitz suggests that the thing these two very different men had most in common was the passion for collecting. Their letters discuss possible purchases for and loans from Lipchitz's own extensive collection and Guillaume keeps Lipchitz up-to-date with lectures he may be interested in at the Barnes Foundation in Merion, mentioning one for example on "Primitive Negro Sculpture" when he writes on April 6, 1926.[7] Interestingly, a few months later, on July 13, Guillaume writes again with a special request: "Mon cher ami, Puisque vous avez eu la gentillesse d'accepter, je vous adresse ce bronze de Picasso pour que vous lui fassiez les honneurs de la patine dont vous avez le secret. Prenez votre temps . . ."[8] His respect for Lipchitz was evidently considerable.

It would, then, have been quite natural for Guillaume to introduce Barnes to Lipchitz as one enthusiast collector to another. Archive material suggests too that Lipchitz's very wide artistic and philosophic interests were what propelled the relationship with Barnes, prompting many joint visits to the Louvre and extended discussions on the educational value of art.[9] Again indicating the degree of esteem in which he was held, Lipchitz was one of the first artists to whom Guillaume introduced Barnes when Barnes visited on a major buying trip for the Foundation in Pennsylvania that was under construction, a project in which the American took the most personal interest. It is one of the striking features of his relationship with Lipchitz that Barnes was not prepared to leave the task of commissioning the artist in all its detail to a third party, quite the contrary. Lipchitz became for him, as we shall see, a very personal *cause célèbre.*

Lipchitz would relate to Deborah Stott the amusing circumstances of his initial meeting with Barnes—his failure to realize the identity or importance of this man and thus his treatment of Barnes as just another prying tourist (the same mistake Lipchitz made, several years later, with Alfred Barr).[10] The meeting came at a time when Lipchitz's finances were in a desperate state. He had scraped together, with the help of friends, all that he could to buy back his works from his former dealer, Léonce Rosenberg. That in itself was fortuitous, for Barnes was not only interested in commissioning new work from Lipchitz; he scrutinized the sculptures he found in Lipchitz's studio, and those shown in Maurice Raynal's 1920 monograph on the artist, selecting eight works ranging from 1917 through 1920.[11] His enthusiasm for Lipchitz's work is evident from this immediate and extensive purchase, and, with Guillaume's help, it communicated itself to other American buyers and collectors visiting Paris, who as a consequence made unscheduled visits to Lipchitz's studio.[12]

On the basis of what he saw in the studio, Barnes decided to order further work from Lipchitz for the exterior walls of the Foundation. He was clearly particularly inspired by the *Still Life* with musical instruments (1918, plate 25), commissioning two musical instrument reliefs of a similar nature and going into great detail in his subsequent correspondence with Lipchitz regarding their format. The sculptures specifically commissioned for Merion finally numbered seven reliefs, a vase designed to fit an exterior niche, and a standing figure, a bather, which eventually took its position on the lawns adjacent to the building. One key point emerging from the archival correspondence is its insight into the real financial impact of this transaction for Lipchitz—indeed, the proceeds would enable him to have his friend Le Corbusier design and have built for him a new house in Boulogne-sur-Seine.[13] We know from Lipchitz's wartime notebook (covering circa 1915 to 1920, and held in the Tate archive, London) that the Rosenberg contract had provided Lipchitz with on average 1,000 francs a month and that the most Rosenberg envisaged having to pay for any individual sculpture was 1,100 francs. Lipchitz projected that by 1921–27 he should be charging 1,700 francs for a stone up to a meter high. Lipchitz's first quotation to Barnes is 30,000 francs for the figure and 60,000 francs for five bas-reliefs, which Barnes finds reasonable, given a hoped-for 15 percent discount. They finally agree on $6,000 for bas-reliefs and figure. Lipchitz's circumstances were truly transformed.

At an early stage, Barnes put Lipchitz in direct contact with the Foundation's architect, Paul Philippe Cret. In practice, the working relationship between client, sculptor, and architect was clearly difficult, and Lipchitz found himself caught in the middle of a distinctly awkward triangle. One major reason for Barnes's close involvement with the fundamentals of the project, from the type of stone to be used to the exact way it should be cut, was his surprisingly evident distrust of his architect's proficiency. Lipchitz might as a consequence receive any number of differing specifications from each of them.[14] Given Barnes's perfectionism here, the fact that he and Lipchitz continued to get on so well says much for Lipchitz's professionalism and ability. On August 10, 1923, Barnes writes: "Je pense souvent aux nombreuses et profitables conversations intimes sur l'art et sur d'autres questions que nous avons eu ensemble. Je voudrais pouvoir vous voir plus souvent . . ." Again, on February 6, 1924, Barnes comments: "Je suis encore dans le charme de nos bonnes conversation [*sic*] et de nos balades au Louvre et je pense souvent au beau Lorrain et Greco qui vous avez eu la chance de découvrir." The correspondence reveals that Barnes often discussed his purchases for the Foundation with Lipchitz, as he does in what appears to be his fourth (undated) letter to the sculptor where he writes that he has acquired "the big Rousseau" and the portrait of Mme. Cézanne which they had seen, adding: "I need a big ship to carry all that I have bought." On December 26, 1923, Barnes writes: "Cher Lipchitz, J'ai acheté quelques sculptures Grecs et Egyptiens qui sont maintenant chez Paul Guillaume. Quand vous avez le temps, allez et les voir, s.v.p.," prizing Lipchitz's opinion. As a mark of respect for their friendship, Barnes was clearly at pains to be as fair and reasonable with Lipchitz as possible in their business dealings. He writes with extreme care, for example, on February 15, 1924, to explain his preference for the bather to be designed as free-standing, out

of the niche for which he had at first planned it: "Toutefois vous comprenez, naturellement, que le changement est proposé seulement s'il ne vous dérange pas du tout."

The two men shared not only the interests of connoisseurship, but also, as is evident here, a similar multilingual capacity, and Barnes, who begins his correspondence with Lipchitz in German, rapidly progresses to French, while teasingly offering Lipchitz his first English lesson.[15] From the outset, Barnes reiterates his respect for Lipchitz and his work and is effusive in his compliments, seeing the requirements of his patronage as being to encourage and protect artistic genius—at this stage Lipchitz in particular, whose work, Barnes writes in early 1923, is so little known in America—from the ravages of the critics of whom he is bitterly scathing. After taking receipt in Merion in March 1923 of the works he selected from the Raynal catalogue, Barnes writes on April 10:

Figure 2. Jacques Lipchitz, *Musical Instruments with Bunch of Grapes*, 1922. Bronze (edition of 7), 81.9 × 107.3 cm, Marlborough International Fine Art. Stone version (unique) at the Barnes Foundation, Merion, Pennsylvania.

> Cher Lipchitz—Je veux vous dire combien je suis heureux d'avoir vos statues qui sont arrivées il y a quinze jours . . . Elles sont réelles, fortes, pleines de rhythme, de mouvement, de grace, de charme, de caractère, de vie. Elles sont pour moi une expérience nouvelle qui a enrichi ma vie. Je les ai preté à l'Académie des Beaux Arts de Pennsylvanie . . . Nous nous attendons à une vive excitation avec beaucoup—naturellement—de critiques adverses et des académiciens et de leurs stupides amis. Mais je suis prêt à analyser at à répondre à toutes les critiques publiées.

For Barnes, Lipchitz becomes a comrade in arms, a fellow pioneer working towards Barnes's educating, liberating goals—certainly through his sculpture, also through the ideas they share on the "democratization" of the arts. On November 2, 1923, Barnes writes to say how delighted he is to hear that the commissioned reliefs are almost finished. He continues:

> Je suis d'accord avec l'idée centrale de vos affirmations sur les bases philosophiques, plastiques et representatives d'une oeuvre d'art satisfaisante. La difficulté dans toute discussion de ce genre est de trouver exactement ce qu'on veut dire par des mots comme "philosophie," "morale" etc.

Barnes goes on to say how much these words can betray no more than an instinctive or habitual reaction to works of art; that unless an individual has had the advantage of wide reading, broad experience, and training in the scientific method they tend to translate what is basically a personal opinion into general principles. The aim of his Foundation is to redress the balance, providing for every interested individual the groundwork of training in an analytic, scientific approach to art:

> Je crois que les principes d'art peuvent être expliqués en termes si simples qu'ils peuvent être compris de tous ceux qui veulent prendre la peine d'obtenir les connaissances nécessaires dans les branches que la science moderne de l'éducation nous a montré être indispensables. C'est pour cela que j'ai commencé la Fondation.

Artists, he believes, can only benefit from this prerogative, noting in the same letter: "Si nous réussions, tous les artistes qui sont vraiment des créateurs n'auront rien à craindre des critiques ignorants, quelques proeminants ou réputes qu'ils soient." The

Figure 3. Jacques Lipchitz,
Reclining Figure with Guitar,
1923.
Stone (unique),
114 x 232 cm,
The Barnes Foundation,
Merion, Pennsylvania.

single point of disagreement between Barnes and Lipchitz, until they fell out under rather mysterious circumstances, was over Barnes's request that the sculptor send him drawings that would "explain" the exterior reliefs to the educational parties visiting the Foundation. Understandably Lipchitz is loath to do anything so literal but he does finally give in.[16]

Moving on to look more closely at the commission in its formal dynamics, Barnes himself set Lipchitz's work in his own mind against the background of a cubism that had grown out of Paul Cézanne's discoveries, and an evolution in modern sculpture that had begun with Auguste Rodin. In *Les Arts à Paris* in 1924 Barnes wrote, "En philosophie, nous avons évolué de la métaphysique hégélienne et kantienne à l'évolution créatrice de Bergson et au pragmatisme de Dewey; dans les arts plastiques, nous avons dépassé Monet et Rodin pour réjoindre Matisse et Lipchitz," casting Lipchitz as Rodin's natural successor. It was indeed as such that Lipchitz came to see himself.[17] Lipchitz's own historic reference points were certainly far-ranging—the motifs of musical instruments in his reliefs evoked images he admired from the French eighteenth-century.[18]

In beginning to grasp Lipchitz's sculptural thinking at this point, we find most revealing a comparison of the relief that Barnes selected from Lipchitz's previous work, the *Still Life* (1918, plate 25), with the four principal motifs devised specifically by Lipchitz for Barnes: *Musical Instruments with Bunch of Grapes* (1922, fig. 2), *Reclining Figure with Guitar* (1923, fig. 3), *Figures with Musical Instruments* (1923, fig. 4) and *Pastorale* (1923, fig. 5). Just as Lipchitz had effected a softening of his geometric cubist practice in his work for Coco Chanel (1921, CR1.122 & 123), combining pared-down, schematic organization with warmer, anthropocentric forms, so, in the work for Barnes, he developed a more vibrant feel for the figurative by suggesting continuous metamorphosis between the human and the inanimate. In the *Musical*

Figure 4. Jacques Lipchitz,
*Figures with Musical
Instruments*, 1923.
Stone (unique),
exact dimensions unknown,
The Barnes Foundation,
Merion, Pennsylvania.

Instruments with Bunch of Grapes, we can see a clear continuity with the 1918 relief, but in 1922 Lipchitz no longer feels the need to center the piece so carefully around the firmly rooted, vertical guitar. By 1922, the strings, clarinet, and "compotier" float freely over what is literally depicted as a ground of ebbing water. By the time of *Pastorale* in 1923, the subject has been completely opened up, as though loosened, "aerated," brought out-of-doors altogether. The figures do more than resemble the instruments they play; their principal body parts have become those of the guitar with which they are depicted in figure 4. Cubist simile, its cerebral visual rhyme, has been replaced by a more mellifluous metamorphosis.

The introduction of "air" and a more dynamic space into the way his sculpture was conceived was in part due to its being envisaged as needing to function in an integrated way with an exterior architecture. It is this relationship of sculpture with architecture that constituted the crux of the aesthetic debate into which the work for Barnes was drawn. This is also key to much of the formal innovation in Lipchitz's sculpture of the 1920s. Significantly, when Lipchitz in later life came to review the formal lessons he learned through the Barnes commission, he extrapolated four principles: the synthesis of angular and curved forms achieved through a more literal integration of objects such as guitar and figure; the way of taking into account an architectural context by deeper undercutting of the sculpted forms; how one might use a pedestal to better understand the nature of free-standing sculpture; and the evolution of sculpture fitting more "organic" contexts (interestingly the niches of the Foundation walls were designed to incorporate plants as well as Lipchitz's sculptures)—in all cases, so as to suggest a more satisfactory harmony between architecture and its wider human environment.[19]

Some of the most pertinent reviews of Lipchitz's work in the period were produced for architectural magazines. One such appeared in the Spring 1925 issue of

Figure 5. Jacques Lipchitz, *Pastorale*, 1923. Stone, exact dimensions unknown, The Barnes Foundation, Merion, Pennsylvania.

L'Architecture vivante, written by Lipchitz's friend Amédée Ozenfant with input from the magazine's editor, the architect Jean Badovici. This issue considered Lipchitz's *sculpture architecturale* using illustrations that included one of the Barnes reliefs (misdated 1921, in fact 1923, fig. 4) in a strongly lit photograph emphasizing its deep undercutting. The article declared the work a success for the way it functioned as an organic part of the overall architecture, one component in an open, "airy" structure of strong, simple lines. The flatness of its planes and depth of its intervals had been exaggerated to use light most expressively. Ozenfant stressed: "toute l'architecture est là: dans cette respiration de volumes." Lipchitz's quasi-scientific approach was emphasized, Ozenfant continued: "il a cherché dans une analyse impitoyable de la réalité et des exigences de la raison moderne les conditions de l'art nouveau." Light became substantial as it played in the hollows of Lipchitz's reliefs:

> dans les creux se joue une symphonie de lumière comme d'une matière à travers laquelle il exprima ses émotions et sa vision, de cette lumière qu'il avait d'abord étudiée et traduite en elle-même … il créa cette sculpture qui exprime en un language nouveau d'une matière synthétique et rationnelle l'essence de l'objet.

Lipchitz's work for Barnes was used then as an example of successful architectural sculpture. Moreover, the fact of his being a cubist sculptor was thought to single him out as fundamentally architectural by inclination. Within his immediate circle, Lipchitz's forebear here was taken to be the sculptor-architect Raymond Duchamp-Villon, whose career had been brutally cut short by World War I. In 1920 the critic André Salmon had visualized Lipchitz and Duchamp-Villon as the ideal artistic partnership.[20] Interest in Duchamp-Villon's work was revived in 1924 with the publication in Paris of a major monograph of his sculpture, written by Walter Pach. Its appearance served to reignite the existing enthusiasms of the influential Christian

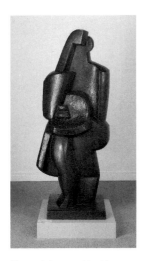

Figure 6. Jacques Lipchitz, *Bather*, 1923–25. Bronze (edition of 7), H.196.9 cm, Dallas Museum of Art.

Zervos, editor of *Cahiers d'art*, and Guillaume Janneau, keeper at the Musée des Arts Décoratifs and author of the important *L'Art cubiste, théories et réalisations, étude critique* (1929). In this text Janneau situated Lipchitz's work of the mid-1920s in direct relation to Duchamp-Villon, of whom he noted:

> celui-ci discerna d'emblée le caractère éminemment décoratif des volumes géométriques ordonnées. Les compositions dans lesquelles il indiqua son conception d'un style ornemental qui retournât au classicisme par des voies nouvelles . . . constituent les premiers essaies, mieux, les premiers exemples de la formule décorative qui règne aujourd'hui.[21]

Janneau uses Duchamp-Villon's work as proof of the decorative and architectural bases of cubist sculpture. Lipchitz himself would of course always recall with some pride the significance of the role his father played in these dynamics of his work. In an introduction to Louis G. Redstone's *Art in Architecture* he noted: "Louis, As you know, my father was a building contractor; in reality, a very able architect without a diploma," recounting how as a young man he had been encouraged by his father to become an architect himself. "Later on in Paris, having difficulties with my art, I started to think about my father's sermons and began to study architecture . . . I vividly remember my arguments with Le Corbusier . . . around 1924 . . . we were at Place St. Augustin in Paris discussing, as always, architecture." Lipchitz recounts his own position—that sculpture gave to architecture its humanity, its human scale, that without it a building was simply "housing."[22]

Lipchitz's commission attracted wide press attention beyond the specialist publications so far mentioned. The breadth of coverage focusing exclusively on his reliefs reminds us that these were what Lipchitz was exhibiting at the time, showing the Barnes plasters, for example, at the 1924 Salon des artistes décorateurs. The writer Géo Charles had been prompted to comment in *Montparnasse* in February 1923: "Je ne puis passer sous silence Lipchitz que la notoriété dans le monde des revues impose à l'attention." Lipchitz was a strong self-publicist, securing the attentions of the most prominent personalities, with reviews appearing in the 1920s by such as Gertrude Stein and Jean Cocteau. What fascinated his reviewers in this period was the combination of his status as "sole surviving cubist" and the aplomb with which his new work achieved a balance of cubist rigor and imaginative expansiveness in its revitalized engagement with the figurative. In a review of Lipchitz's exhibits at the 1925 Salon des artistes décorateurs, an anonymous contributor to *Le Jour* noted:

> dans les salles de peintures, nous retrouvons encore plusieurs artistes fort intéressants et d'abord Jacques Lipchitz, qui est peut-être le seul artiste d'aujourd'hui qui aît su rester dans la grande tradition cubiste. Lipchitz sait assembler des éléments, organiser des formes, son bas-relief est une des rares oeuvres de ce Salon qui évite à la fois l'abstraction et le réalisme.[23]

The equally significant element of the Barnes commission, not covered by the press, was the free-standing *Bather*. This was the largest figure Lipchitz had executed thus far, and a version of it appeared in front of Le Corbusier's *Pavillon de l'esprit nouveau* at the 1925 *Exposition des arts décoratifs*. The formal evolution of the Barnes *Bather*, which went through various stages from 1923–24 (fig. 1) through to its final state in 1925 (fig. 6), should be understood in the context of the works Barnes selected

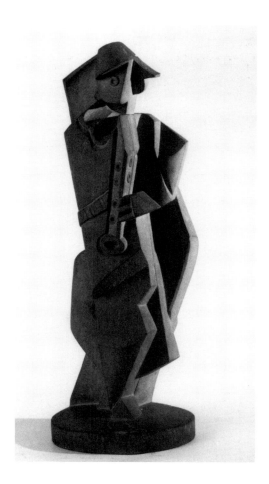

Figure 7. Jacques Lipchitz, *Harlequin with Clarinet*, 1919.
Stone (unique), H. 75.6 cm,
The Barnes Foundation, Merion, Pennsylvania.

from Lipchitz's previous production—a *Harlequin with Mandolin* (1920, plate 31) and the *Harlequin with Clarinet* (1919, fig. 7) to which Barnes fondly referred in a letter of early 1924 as "mon joueur de flute," requesting at this point one (or two) large free-standing figure(s) along similar lines.[24] Seen side-by-side, it becomes clear that the *Bather* shares especially the 1920 figure's disposition of body parts: the full curve of thigh and hip, the arch of shoulder blade and upper arm which echoes the sweep of a knee-length cape, and the way the face is split to create a sense of two figures in one. Lipchitz is here developing a concept for monumental sculpture that he had arrived at well before meeting Barnes. We can see that a sense of imposing scale is being created by more than actual size; it emerges through simplification, balance, and centeredness. An unusual series of ink sketches for Lipchitz's *Man with Guitar* (1920, fig. 8) reinforces this fact, with the fully worked-out pedestal (fig. 9) establishing that Lipchitz had already had a wider, presentational context in mind for his sculpture. The sketch also reveals how two separate figures become interlocked to form another integrated figure in a way unique to Lipchitz.

We can say then that Lipchitz's ideas by 1920 on figurative metamorphosis and the mechanics of monumental sculpture were crystallized through his work on the Barnes commission. Ozenfant, as we recall from his comments in *L'Architecture vivante*, talked about the interpenetration of light and space and the ability to express emotion in a concentrated form as key elements to this carefully honed understanding. He also described Lipchitz's technique as the expression of the essence of an object through combining preexisting forms to create a new language of sculpture and a new landscape of imagery. In 1919 Maurice Raynal had used similar terms to encapsulate cubism's prerogatives; and again in 1926 André Salmon

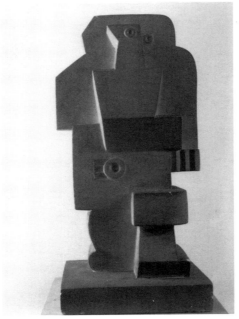

Figure 8. Jacques Lipchitz, *Man with Guitar*, 1920.
Artificial stone (unique), H. 53.5 cm,
Oeffentliche Kunstsammlung, Basel, Kunstmuseum,
Gift of Raoul La Roche, 1963.

Figure 9. Jacques Lipchitz,
Study for Seated Man with Guitar, 1920.
Ink and graphite, 28.4 × 19.5 cm,
Marlborough International Fine Art.

used these terms to connect Lipchitz's understanding of the monumental with Rodin's insight into the way a crude reality could be transposed to communicate perennial values: "Jacques Lipchitz introduisait d'un seul coup . . . tous les signes littéralement aimables d'une humanité supérieure. L'artiste le plus audacieusement approché du signe intégral, de la pureté réduite à son essence, tenait joyeusement aux plus solides beautés terrestres."[25] This very humanistic concept of the monumental would continue to be the central tenet of Lipchitz's process for the rest of his career. It operated in an energized space, a new space created by Lipchitz that we have observed evolving in the Barnes reliefs and that played with light and volume with sufficient confidence for the work to hold its ground out-of-doors. This confidence involved the manipulation and distortion of form to a degree that its interaction with natural light remained vigorous, catalytic, and the space around and within the sculpted object appeared to vibrate with potential movement. If we plot Lipchitz's 1920s' work in terms of this increasingly vibrant space, the Barnes commission sits naturally at a crossroads between an earlier, refined work of a modest scale whose measured elegance, balance, and restraint fit well within highly decorative interiors such as Coco Chanel's; moving through the *transparents*, a new process realized at the end of 1924, where the conversation between form and space became more animated; through to Lipchitz's first truly monumental work—to *Ploumanach* (1926), *Figure* (1926–30), and *Joie de vivre* (1927)—each taking a particular landscape and the motif of intertwined figures into their conception. From the intimate private arena, Lipchitz was moving into broader social contexts, from a fashionable early 1920s' cubism to a socially engaged cubism driven by a humanistic imperative that in Lipchitz's case was communicated through powerfully expres-

sive, telluric forms. The urgency of this imperative he shared with Albert Barnes—a proselytizing, value-driven aesthetic, which, as we have begun to see, the Barnes Foundation promoted and which, when the relationship between Barnes and Lipchitz was at its strongest, formed the cementing link between these two highly volatile and exacting personalities.

Published Courtesy of The Barnes Foundation, Merion, Pennsylvania, USA.

1. Alan G. Wilkinson, *The Sculpture of Jacques Lipchitz: A Catalogue Raisonné*, vol. 1 (New York and London: Thames and Hudson, 1996), catalogue no. 53 (further references will cite CR1 plus catalogue number).

2. See Robert L. Herbert, Eleanor S. Apter, and Elise K. Kenney, eds., *The Société Anonyme and the Dreier Bequest at Yale University: A Catalogue Raisonné* (New Haven and London: Yale University Press, 1984), Lipchitz appears at 410–13. The Société hosted Archipenko's first American exhibition, in New York, during February and March 1921.

3. Ossip Zadkine, *Le Maillet et le ciseau: Souvenirs de ma vie* (Paris: Albin Michel, 1968), 122–24.

4. The correspondence between Albert Barnes and Lipchitz from this period (1923–26) is held in the archive of the Musée d'Art et d'Histoire du Judaïsme in Paris, France (MAHJ). This contains thirty letters by Barnes, and twenty-four letters in reply by Lipchitz.

5. Maurice Sachs, *La Décade de l'Illusion*, written 1932 (Paris: Gallimard, 1950), 47–48. English translations of all French citations are provided in Annex 2.

6. The job title Guillaume used on his personal letterhead in correspondence held at MAHJ.

7. The unpublished Guillaume-Lipchitz correspondence is split between the MAHJ archive and the Tate, London, archive (file A15). The London material dates from 1926, the Paris material from January 1923 through 1926.

8. Letter from Guillaume to Lipchitz, July 13, 1926, held at MAHJ.

9. Lipchitz's personal collection of books and catalogues in the Tate archive, London, bears witness to mutual areas of interest with Barnes: it includes copies of the *Journal of the Barnes Foundation* issues that feature Barnes's own writing on Paul Cézanne, and a copy of the Foundation's publication by Mary Mullen, *An Approach to Art* (1923), among other items (archive file E).

10. The original manuscripts from Deborah Stott's interviews with Lipchitz are held in the Tate archive, London; reference here is made to interview no. 24, September 6, 1968.

11. A list of the works Barnes bought from Lipchitz is provided in the Annex following this essay.

12. Lipchitz outlined the way he made many other sales as a direct consequence of his standing with Barnes (Stott interview no. 135, September 5, 1969, and Irene Patai *Encounters: The Life of Jacques Lipchitz* (New York: Funk and Wagnalls, 1961), 231. To Stott, Lipchitz describes a whole cascade of resulting commissions, from the de Noailles' to Mme. de Mandrot's, Doucet's, Pierre David-Weill's and Comte André de Fels's.

13. Construction began on Lipchitz's new property in May–June 1924; it was completed in spring 1925, and Lipchitz moved in more or less immediately. Tim Benton, *The Villas of Le Corbusier: 1920–1930* (New Haven and London: Yale University Press, 1987), 85ff.

14. The MAHJ holds six letters to Lipchitz from Cret, written between January 15 and April 24, 1923. In connection with this correspondence, a letter from Barnes dated September 14, 1923, states that, following a visit Cret has paid to Lipchitz's studio, Lipchitz should follow whatever Barnes advises and disregard Cret's views. Similarly, on the subject of the precise measurements of the space allocated to Lipchitz's reliefs, Barnes himself takes a tape measure to it, writing on January 26, 1926: " . . . je me méfie de l'exactitude de son (Cret's) travail . . ."

15. Barnes's fourth letter to Lipchitz is in German with parallel English translation, "votre premier leçon en Anglais."

16. Lipchitz says that he and Barnes parted ways in 1925. See Jacques Lipchitz with H. H. Arnason, *My Life in Sculpture* (London: Thames and Hudson, 1972), 94. Both Stott and Patai record the same sequence of events without being precise about the dates: some time after Barnes's return to America in 1925, during which period some resentment festered within Barnes regarding an artist Lipchitz had "forced" on him by recommendation, Barnes revisits Lipchitz's studio in a rage, which is the last Lipchitz ever sees of him. See Patai, *Encounters*, 216; Stott interview transcript no. 24. From the Guillaume-Lipchitz correspondence at MAHJ it is clear that Barnes was still seeing Lipchitz early in 1926; the breakup appears to have occurred sometime during that year.

17. Albert Barnes, "Le Temple," *Les Arts à Paris*, no. 10 (November 1924): 11–12; Lipchitz to Stott, interview no. 56, November 7, 1968: "He said, if you examine a child in the womb, almost ready to be born, and then after he's born, there is not that big difference, and this is the same situation as with him and Rodin. They are the same, but they have a different life."

18. Lipchitz, *My Life in Sculpture*, 57.

19. Ibid., 73.

20. André Salmon, "Des Indépendants au Louvre," *L'Ere nouvelle*, February 14, 1920. Duchamp-Villon had of course constructed the model for the maison cubiste, which appeared in the 1912 Salon d'automne decorative arts section to considerable public interest.

21. Guillaume Janneau, *L'Art cubiste: Théories et réalisations, étude critique* (Paris, 1929), 20.

22. J. Lipchitz, introduction to Louis G. Redstone FAIA, *Art in Architecture* (London: McGraw-Hill Book Company, 1968), vi.

23. Review of the Salon for *Le Jour*, May 26, 1925. A bronze musical instrument relief of Lipchitz's appeared in the room-set designed by Pierre Chareau, the 1923 sculpture CR1, no. 164.

24. Barnes letter to Lipchitz dated February 15, 1924. In a letter of January 8, 1923, Barnes indicated that the free-standing figure(s) need not be ready as soon as the reliefs, specifying spring or summer 1924. In a later letter of March 14, 1924, Barnes opts to have just the one large free-standing figure instead of two smaller ones.

25. André Salmon, "Jacques Lipchitz," *Art d'aujourd'hui* 3, no. 10 (1926): 21–23. Compare this with Maurice Raynal's 1919 essay "Quelques intentions du cubisme," reproduced in the January through March issues of the first year of Léonce Rosenberg's *Bulletin de l'effort moderne* (especially no. 2 [February 1924]: 2–3): "Concevoir un objet est, en effet, vouloir le connaître dans son essence, le représenter dans l'esprit, c'est-à-dire, dans son but, le plus purement possible, à l'état de signe, de totem, si l'on veut."

Annex 1

Work bought from Lipchitz by Albert Barnes

References are to the *Jacques Lipchitz Catalogue Raisonné, Volume 1* (CR1), 1996.

1. Purchases from Lipchitz's previous production.

i) *Bather III*, 1917 (CR1.61)

ii) *Bather*, 1917 (CR1.63)

iii) *Bather*, 1917 (CR1.65)

iv) *Still Life*, 1918 (CR1.79)

v) *Harlequin with Clarinet*, 1919 (CR1.89)

vi) *Reader II*, 1919 (CR1.96)

vii) *Bather*, 1919 (CR1.100)

viii) *Harlequin with Mandolin*, 1920 (CR1.109)

2. Work produced for the Barnes Foundation, Merion, Pennsylvania (Literature: Jacques Lipchitz with H. H. Arnason, *My Life in Sculpture*, Documents of Twentieth Century Art [New York: Viking Press, 1972], 70 ff.; Musée d'Art et d'Histoire du Judaïsme, Paris, photographic archive, inventaire No. P01 and Barnes-Lipchitz correspondence).

i) Seven reliefs:

* *Musical Instruments with Bunch of Grapes*, 1922–24 (CR1.144)

* *Musical Instruments with Basket of Fruit and Grapes*, 1922–24 (CR1.146)

* *Musical Instruments*, 1923 (CR1.163)

* *Reclining Figure with Guitar*, 1923 (CR1.152)

* *Figures with Musical Instruments*, 1923 (CR1.156)

* *Pastorale*, 1923 (CR1.157)

* *Harlequin with Mandolin in Oval*, 1923 (CR1.158)

ii) *Vase*, 1923

* Bronze study for this (CR1.148) A photograph of the finished piece appears in Maurice Raynal, *Jacques Lipchitz* (Paris, 1947).

iii) *Standing Figure/Bather*, 1924 (CR1.169 and 170)

Lipchitz mentions making several versions of this figure (*My Life in Sculpture*, 74), choosing to present CR1.169, 1923–25, as the culmination of the project.

Annex 2

Author's English translations of French text

1. Maurice Sachs quotations, 1932: Guillaume was considered . . . "a man of taste" and "a connoisseur of the Old Masters," whose gallery . . . was dubbed "the palace of the greatest benefactors."

2. Guillaume letter to Lipchitz, July 13, 1926: "My dear friend, Since you have had the graciousness to agree, I am sending you Picasso's bronze for you to honor it with the application of your own secret patina. Do take your time . . ."

3. In note 14, Barnes on January 26, 1926: "I have my doubts as to the exactitude of his work."

4. Barnes letter August 10, 1923: "I often think of the many worthwhile, intense discussions we have had about art and much besides. I wish I could see more of you."

5. Barnes letter February 6, 1924: "I am still in thrall to our wonderful conversations and our visits to the Louvre. I often think about your fortuitous discovery of the beautiful Claude Lorrain and the El Greco."

6. Barnes letter December 26, 1923: "Dear Lipchitz, I have recently bought some Greek and Egyptian sculptures which are currently in Paul Guillaume's possession. Do please call in to take a look at them when you get a moment."

7. Barnes letter February 15, 1924: "In any case you must of course understand that I'm only proposing this change of plan if it poses absolutely no inconvenience to you."

8. Barnes letter April 10, 1923: "My dear Lipchitz—I should like you to know how very happy I am to have your sculptures here. They arrived two weeks ago. They are vital, strong, full of rhythm, movement, grace, charm, character, life. To me they are quite a new experience, one that has enriched my life. I have lent them to the Pennsylvania Academy . . . We can expect a bit of a stir, and (it goes without saying) the attentions of antagonistic critics and academics and all their idiotic coterie. But I am braced to take on whatever critical analysis comes our way."

9. Barnes letter November 2, 1923: "I concur with the central tenet of your assertions as regards the philosophic, plastic, and representative bases of an efficacious work of art. The problem with any discussion along these lines is to tie down exactly what we mean by words such as 'philosophy,' 'morality,' and so on.

"I believe that the principles of art can be explained in terms so straightforward that they can be understood by all those who are prepared to take the trouble to acquire the groundwork they need in the aspects of educational theory which the latest research has shown to be indispensable (i.e., psychology). This is the very reason why I started the Foundation."

"If we succeed, all truly creative artists will have nothing to fear from ignorant critics however prominent or respected they might be."

10. Barnes in *Les Arts à Paris* 1924: "In philosophy we have progressed from Hegel's and Kant's metaphysics to Bergson's ideas on the development of creativity and Dewey's pragmatism. In the plastic arts we have moved on from Monet and Rodin only to join Matisse and Lipchitz."

11. Ozenfant in Spring 1925: "Here lie the essentials of architecture—in this aeration of volumes."

"Lipchitz has ruthlessly scrutinized experiential reality and the demands of contemporaneity in order to better understand the true condition of modern art."

"A symphony of light plays in the hollows of his sculpture as though light were a tangible material, molded by the artist to express his sensibility and his vision. With this substantial light, whose nature he has carefully studied and understood, Lipchitz has constructed a new sculpture, a sculpture that uses a language of its own, one of synthesis and logic, to express the essence of the object."

12. Janneau in 1929: "Duchamp-Villon immediately understood the essentially decorative quality of geometrically arranged forms. His concept of a decorative style that used new means to recall a timeless classicism was expressed through work that constituted the first attempts at, or rather the first achievement of, today's most potent decorative notations."

13. Géo Charles in February 1923: "I cannot but mention Lipchitz, whose notoriety in the press forces us to take his work into account."

14. 1925 review for *Le Jour*: "Among the painting displays several very interesting artists are to be found, preeminent among them, Jacques Lipchitz, who is perhaps the only contemporary artist who has managed to continue working within the vein of traditional Cubism. Lipchitz understands how to combine and order diverse forms such that the relief he exhibits stands as one of the very rare works in this Salon which successfully avoids both extremes of abstraction and realism."

15. André Salmon in 1926: "Jacques Lipchitz at a single stroke drew down into his art all those familiar archaic indices that invest humanity with an eternal dimension. As an artist who is perhaps the most courageous in his espousal of the notion of "pure sign," demonstrating a clarity of purpose in seeking the purest form of expression, Lipchitz is equally enthusiastic in embracing the most earthy, temporal beauties."

16. In note 24, Raynal in 1919: "To create a new object is in effect to seek to know an object in its most essential form, to communicate its spirit, to express in the purest possible way its purpose as Sign, or perhaps one should say, as Totem.

Figure 1. Jacques Lipchitz, *The Lovers* (*Le Couple*), 1934.
Bronze (edition of 7), H. 16.2 cm,
Stedelijk Museum, Amsterdam.

David O'Brien

LIPCHITZ AND GÉRICAULT

In 1933 Jacques Lipchitz produced five different bronze maquettes of the head of the French Romantic artist Théodore Géricault.[1] Lipchitz repeatedly professed his admiration for Géricault,[2] and he possessed nine canvases thought to be by the painter.[3] His deep interest in the artist reveals much about the direction in which his sculpture was turning in the 1930s, but it has received no comment within the art historical literature.

Figure 2. Anonymous, *Death Mask of Géricault*. Plaster, 30 × 19 × 17 cm Musée Fabre, Montpellier.

Lipchitz referred to his portraits of Géricault in his autobiography as follows:

> I have always been a great admirer of this painter, a genius who died young, and I have some paintings of his. There exists a death mask of Géricault of which I acquired a cast. I wanted to make a portrait as realistic as possible, so I checked documents and existing portraits of him. This was my homage to a great artist whom I loved very much.[4]

The portraits do indeed draw directly on the abundant iconography of Géricault, and these sources tell us something about Géricault's significance for Lipchitz.

On January 27, 1824, the day following Géricault's death, his friends had a death mask made to preserve his features (fig. 2). This cast has since become one of the best known images of the artist. "There is hardly a studio today," Charles Blanc noted in 1842, "without the plaster mask of Géricault."[5] The Goncourt brothers, in describing the studio of Coriolis in *Manette Salomon*, noted a "mask of Géricault, on which was draped a felt clown's hat with rooster feathers."[6] By the end of the century the masks adorned innumerable artists' studios.[7]

Almost as soon as Géricault's friends had made the mask, however, they had second thoughts. Léon Cogniet decided to enlist two of his colleagues, Achille Devéria and Alexandre-Marie Colin, in a project to create three lithographic portraits of the artist that would recall his "force and energy" and be placed in projected volumes of facsimiles of Géricault's works.[8] These portraits, like the death mask, became canonical images of Géricault. Cogniet's prints were particularly influential, as they introduced the trademark Greek cap (a sort of skullcap with tassel) into the iconography of Géricault. These lithographs were followed by a great many other portraits, printed, sculpted, and painted, by such Romantic luminaries as Horace Vernet, Ary Scheffer, and David D'Angers.[9]

When the late Romantic sculptor Antoine Etex won a contest for the commission for Géricault's tomb in Père Lachaise cemetery in 1839, he returned to the imagery

developed by Cogniet. For the life-size figure that sat atop the tomb, completed in 1841, he chose to portray Géricault on his deathbed, painting to the end, wearing the now standard skullcap with tassel. For a bust created for another tomb design, Etex referred more overtly to the death mask, portraying Géricault with sunken cheeks and eyes and a bony nose and skull.[10]

The death mask and the busts by Cogniet and Etex formed the essential iconography to which Lipchitz turned in his own portait of Géricault. The deeply sunken eye sockets and pronounced cheekbones and nose derive from the death mask. It is hardly surprising that the sculptor turned to the object bearing the most immediate physical trace of Géricault's features, for he believed that portraiture should develop out of a direct reaction to its subject. Lipchitz once remarked that "the portrait is rooted in my observation and impression of a specific individual, and, although it is necessary to transform that individual into a work of sculpture, the subject can never be lost sight of."[11] The inclusion of the Greek cap, on the other hand, alludes to the many portraits of the artist produced by the Romantic generation. Lipchitz no doubt intended to retain the associations that had grown up around this imagery: Géricault as a suffering, accursed artist, devoted to his art, but tragically cut down in the prime of life.

Figure 3. Théodore Géricualt, *Embracing Couple*, n.d. Pen and brown ink, red wash, heightened with white, on blue paper. Musée Bonnat, Bayonne, France.

Yet Lipchitz's interest in Géricault extended beyond the well-worn mythology surrounding the artist's persona. Géricault served as an important inspiration, both formally and thematically, for the direction in which Lipchitz was moving his art around 1930, when he began to replace the hard edges and geometric patterns of his earlier, cubist work with fuller, more rounded forms and fluid lines. Spurred on especially by the rise of fascism in Europe, Lipchitz wanted to find an allegorical language that could address pressing social and cultural issues. In contrast to the highly formal experiments of his cubist years, his art began to include a more narrative element and addressed such broadly significant themes as passionate love and the fight between good and evil. He introduced generic or mythological figures with muscular, more naturalistic anatomies involved in dramatic activities: love-making, violent struggle, and battles between man and beast. In all these respects, his work from the 1930s resembles Géricault's own experiments with classicism at the beginning of the nineteenth century.

For Géricault, working with the nude allowed him to express his thoughts in a language that was supposedly timeless and universal: all viewers, regardless of their particular social group or historical situation, could, in theory, recognize their own plight in the image of an idealized body stripped of the markers of class, wealth, or nation. Similarly, Lipchitz was searching for a language that could have a broad appeal without being identified with a particular group or nation. He wanted to make general statements about an elemental struggle between right and wrong. Yet Lipchitz, again like Géricault, could not keep himself from referring directly at times to his own specific experiences. Lipchitz's many sculptures from 1933 of the fight between David and Goliath look very much like Géricault's scenes of strangulation, but Lipchitz placed a swastika on one version to make his message explicit.[12] The artist's desire to address urgent political problems superceded his desire to maintain the distance of classical metaphor.

Many comparisons may be drawn between individual works by the two artists. Perhaps Lipchitz had some knowledge of Géricault's modest sculpture entitled *Satyr and Nymph* (Musée des Beaux-Arts, Rouen) when he undertook his own *Embrace* (1934, private collection). Both works unabashedly depict massive, anonymous bodies engaged in richly physical love. But it is the broader affinity between Lipchitz's work of the years around 1933 and Géricault's drawings and paintings that seems significant. Thus, Lipchitz's *Man on Horseback Fighting a Bull* of 1932 (Israel Museum, Jerusalem) might be compared to Géricault's drawings of bull tamers, while the former's *Lovers* (1934; fig. 1) might be compared to the latter's *Embracing Couple* (fig. 3). In all of these works, tangled, abstracted human forms engaged in acts of brutality or sensuality speak to the viewer in the most open-ended terms.

The clay head of Géricault in the Krannert collection (fig. plate 52) was the model for the third of the four bronze maquettes (fig. 4). There exists a clear progression in the maquettes, with the later versions increasingly acquiring the bony, emaciated qualities of the death mask. A fifth bust is more than twice as large as the maquettes and possesses the most severe features. It is probably the culmination of Lipchitz's experiments with Gérciault's likeness. Géricault's famous paintings of decollated heads may well have been on Lipchitz's mind when he executed this series. With no indication given of shoulders or a torso, the maquettes appear like so many disembodied heads. Terminating abruptly at the neck, the Krannert head possesses this disturbing quality to a high degree and recalls how the portrait appeared to Lipchitz before he cast it on a base.

Figure 4. Jacques Lipchitz, *Géricault Maquette No. 3*, 1933. Bronze (edition of 7), H. 28.6 cm.

1. Five bronze busts of Géricault are included in Alan Wilkinson, *The Sculpture of Jacques Lipchitz : a Catalogue Raisonné* (London and New York: Thames and Hudson, 1996), 103-4. A sixth bronze maquette, apparently identical to the second work in the catalogue raisonné except for its base, was included in Alan Wilkinson, *Jacques Lipchitz: A Life in Sulpture*, exh. cat. (Toronto: Art Gallery of Ontario, 1989), 123.

2. Jacques Lipchitz with H. H. Arnason, *My Life in Sculpture*, (New York: Viking Press, 1972), 31 and 128.

3. We know that Lipchitz possessed nine paintings supposedly by Géricault, but today only one of these, a copy of Mola's *Vision of Saint Bruno*, is accepted as authentic. See Jacques Thuillier and Philippe Grunchec, *Tout l'oeuvre peint de Géricault* (Paris: Flammarion, 1978), 157.

4. Lipchitz, *My Life in Sculpture*, 10.

5. Charles Blanc, *Histoire des peintres français au dix-neivième siècle* (Paris: Cauville frères 1845), 433.

6. Edmond and Jules Goncourt, *Manette Salomon* (Paris: Bibliothue Charpentier, 1906), 133.

7. For an extended discussion of the prominence of the mask in French artistic life of the nineteenth and twentieth centuries, see Bruno Chenique, "Géricault posthume," in R. Michel, ed., *Géricault* (Paris: La Documentation française, 1996), 2:937–59.

8. See ibid., 2:939–40.

9. On these portraits, see Chenique, "Géricault posthume," and Germain Bazin, *Théodore Géricault: Etude critique, documents et catalogue raisonné*, vol. 1, *L'Homme: Biographie, témoignages et documents* (Paris: Bibliothèque des arts, 1987), 201–29.

10. On Etex's tomb, see Bruno Chenique, "Le tombeau de Géricault," in Michel, ed., *Géricault*, 2:721–58; and Bazin, *Théodore Géricault*, 189–99.

11. Lipchitz, *My Life in Sculpture*, 10.

12. Compare the sculptures of David and Goliath in Wilkinson, *The Sculpture of Jacques Lipchitz : a Catalogue Raisonné*, 102-103, with Géricault's *Scene of Torture* (Musée Bonnat, Bayonne). The swastika appears on the *David and Goliath* on page 103, figure 310.

Photo Credits:

Figure 1, photograph, courtesy, Stedelijk Museum, Amsterdam.

Figure 2, photograph by Cliché Frédéric Jaulmes, © Musée Fabre, Montpellier.

Figure 3, photograph, courtesy, Réunion de Musées Nationaux/ Art Resource.

Figure 4, © Estate of Jacques Lipchitz, courtesy, Marlborough Gallery, New York.

Figure 1. Photograph taken on the occasion of the exhibition *Artists in Exile*, Pierre Matisse Gallery, New York, March 1942. Left to right, front row: Matta, Ossip Zadkine, Yves Tanguy, Max Ernst, Marc Chagall, Fernand Léger; back row: André Breton, Piet Mondrian, André Masson, Amédée Ozenfant, Jacques Lipchitz, Pavel Tchelitchev, Kurt Seligmann, Eugene Berman.

Jonathan Fineberg

LIPCHITZ IN AMERICA

With the invasion of Poland and the entry of the French and British into World War II in September 1939, the artistic vanguard of Paris began streaming out of the city. Jacques Lipchitz and his wife, Berthe, left in May 1940 for Toulouse and then New York, where they arrived June 13, 1941. Within six months on either side of their arrival, André Breton, Salvador Dalí, Max Ernst, André Masson, Matta, Kurt Seligmann, and Yves Tanguy among the surrealists, as well as Marcel Duchamp, Fernand Léger, Piet Mondrian, Marc Chagall, Ossip Zadkine, and Amédée Ozenfant had all fled Paris for New York (fig. 1). This mass relocation of so much of the "gravitas" of recent European modernism (augmented by the presence of such artists from Germany as Josef and Anni Albers, Lyonel Feininger, and George Grosz, who had all come to New York, too) almost instantaneously made New York the center of the art world. But this was a transformation by *fiat*, a dramatic appropriation of European modernism into the aesthetic culture of New York (which already had some remarkable artists in its own right along with advanced aesthetic ideas that stood apart from the paradigms of European modernism).

However accidental this act of appropriation, it was entirely coherent with the indigenous American tendency toward commodification and had the curious effect of dislocating modernism conceptually as much as it had been dislocated physically. In effect, European modernism came to New York as a detached symbol, a recombinable element in the perpetually reconfiguring collage of American culture. The American artist Stuart Davis, for example, had already appropriated references to European modernism into his canvases right alongside road signs, bottles of cleaning fluid, and the label on a package of Lucky Strike cigarettes; in the same way, Jackson Pollock would lift the principle of surrealist automatism like a prefabricated object into his methods, giving it a meaning that had little to do with what a Masson or Ernst had in mind.

So Lipchitz landed in New York as "one of France's new old masters"[1] (to use the words of *Art Digest* in 1950), and, as such, he had an emblematic significance to young American artists but relatively little deep and direct interaction with them. Moreover, Lipchitz told James Johnson Sweeney in a 1945 interview for *The Partisan Review* that "for me the center is still France and I believe it will remain France for some time to come."[2] Lipchitz did not come looking for inspiration in the American scene, only a safe haven. And yet, Lipchitz went on to spend the next twenty-eight years—nearly half his career—in New York, making some of his best known works there.

Figure 2. Jacques Lipchitz, *Acrobat on a Ball*, 1926. Bronze (unique), H. 43.8 cm, whereabouts unknown.

Albert Elsen noted, in his landmark book on *Modern European Sculpture 1918–1945*, that Lipchitz "restored to modern sculpture the expressiveness of gestures, purposeful action, and narrative that had been absent since Rodin's death in 1917."[3] This gestural expressionism in Lipchitz's sculpture is principally an American oeuvre, though it began around 1930 in Paris. A contemporary and close friend of Pablo Picasso and Juan Gris from the early teens, Lipchitz was, already by 1920, thoroughly identified with cubism; indeed, he was one of the leading masters of cubist sculpture from 1915 into the early 1920s. Christopher Green talks about his work of that time as occupied with an austerity and purity of formal structure.[4] Maurice Raynal, in his 1920 monograph on the artist, argues that Lipchitz gave cubism a more personal character, humanizing it; but he nonetheless places Lipchitz squarely in a cubist métier.[5]

Both are certainly correct. But, as J. F. Yvars has pointed out, to see this artist only in terms of cubism ignores the last forty years of his career! For no sooner had Lipchitz begun to contemplate the form in sculpture on its own terms (as he himself described the hallmark of his cubism) than he began to feel constrained by what he called the "iron rule of syntactical cubist discipline."[6] At the end of the 1920s, he turned to myth and biblical subjects in an increasingly expressive language of gesture and narration.

"When I am asked, as I frequently have been," Lipchitz said in his late autobiography, "when I ceased to be a cubist, my answer is invariably, 'Never!'"[7] Yet by 1941, when he arrived in New York, cubism had come to mean, for him, not an adherence to a set of fixed stylistic protocols or even a formalist orientation, but rather an underlying and more general sense of formal structure in the service of his expressive ambitions. Cubism liberated Lipchitz from the figure in the teens and allowed him to concentrate, as he explained, on "the sculpture as an identity in itself rather than as an imitation of anything else."[8] This formal focus even led him toward abstraction, though only for a moment, around 1913; yet he quickly recognized his own inalienable connection to bodily reality; "I want to make organic life," he said, and he realized that every abstract form in his work gravitated towards the vital.[9]

Lipchitz's so-called *transparents* of the middle 1920s (works like *Acrobat with a Ball*, [1926, fig 2.]; *Acrobat on a Horse*, 1927; and *Woman with a Guitar*, 1927) introduced a sense of gestural wire drawing into his work — leading during and after 1929 — to more volumetrically gestural works like *Reclining Figure* (1929, plate 47), *Return of the Prodigal Son* (1930), *The Rape* (1933, plate 53), and *The Embrace* (1933–34). This gestural tendency mutated into an almost "painterly" expressionism in the manipulation of flowing sculptural mass and of "touch" in the surface modeling of Lipchitz's work.

Because of the increasingly direct, emotional manner, one might have expected Lipchitz to turn to direct carving and to a more "primitive" and simplified style, such as that of Constantin Brancusi or his friend Amedeo Modigliani. Moreover, Lipchitz had a deep admiration for tribal art and a remarkable eye for it as a collector and connoisseur. Yet he saw his own work as centered in a tradition of classical modeling, as descended from Auguste Rodin. "I am, in a manner of speaking an adversary of direct cutting. For a sculptor today I regard modeling the more adequate tech-

nique. I feel that the advocacy of direct cutting which has been so widespread during the last thirty years is, like the interest in 'primitivism' and collective production, just another indication of the tendency toward self-imposed technical regression."[10]

Unlike the acrobats, harlequins, nudes, and still-life objects that dominated his cubist period and his *transparents* of the 1920s, the subjects to which Lipchitz largely turned after 1929 originated in ancient myth and in the Bible. He also sought to define a style of baroque, maximal elaboration in composition as well as in gesture and in the complexity of the narration, rather than seeking a formal reduction, as in "primitivism." The use of bronze further affirmed this atavistic content, lending a sense of timelessness even to radically new forms. (Except for the experiments with construction and carving in the early cubist years, with assistants doing the roughing-in of the block, Lipchitz remained faithful to the technique of modeling and casting in bronze for his entire career.) Yvars aptly described Lipchitz's stylistic shift in the 1930s as an updating of classical mythology to the imaginative urgency of the moment.[11] Although baroque in energy, the tradition of modeling and the mythological and biblical subjects were a classical practice, put here in the service of an increasingly direct expressionism.

Lipchitz's new work of the 1930s and 1940s responded directly to the flood of emotion and energy he was experiencing in the now rapidly shifting events of life around him. First, there were the political events against which Lipchitz registered his protest in such sculptures as *Towards a New World* (1934), *David and Goliath* (1933, with a swastika on the chest of Goliath), *Prometheus Strangling the Vulture* (1936, commissioned for the Paris World's Fair of 1937), *The Terrified One* (1936), and *Scene of Civil War* (1936). Lipchitz linked the emancipation of the individual with creative liberty. "My life has been spent in creating Utopias,"[12] he told Bruce Bassett in the filmed interviews of the late 1960s, and he talked about how hard one has to work to be free, to overcome one's resistance to any encounter with the unknown, and to allow the subject matter to evolve unhindered.[13]

The mutation of themes like the *Rape of Europa* (1938–41, plate 57 and fig. 3) into a series with an entirely new thrust in 1969–72 (plates 71 and 72), the *Prometheus Strangling the Vulture* [see page 11] (conceived in 1936 for the monumental but temporary plaster of 1937 and then rethought in 1943–44 toward the large bronze of 1949–53), *Hagar* (1948–49) which looks back to the 1929 *Figure* and is later revisited in 1969–71, all speak to a kind of expressive and thematic fluidity in Lipchitz's process. Speaking of the 1938 *Rape of Europa*, Lipchitz said that "the general forms of the bull and Europa probably derive from the earlier bull and condor [1932], although, as is so frequently the case with my sculpture, the conflict and terror of the earlier version is here transformed into erotic love."[14] Then in 1941 he recreated the *Rape of Europa* again "in a quite different context, the Europa as a symbol for Europe and the bull as Hitler, with Europe killing Hitler with a dagger."[15]

The artist himself described the new stylistic departure of his work in the 1930s and 1940s—referring specifically to the example of his 1940 sculpture *Flight*—as ". . . very free and baroque in its organization, representing not only my emotions at this moment when I was fleeing with my family, but also a new and open expres-

Figure 3. Jacques Lipchitz, *Rape of Europa*, 1941.
Bronze (edition of 7), H. 33.5 cm,
The Estate of Jacques Lipchitz represented by
Marlborough Gallery

sionist type of composition."[16] *Arrival* (1941, fig. 4) is the autobiographical pendant to *Flight* and, whereas the latter seems helplessly frenzied, turning around itself in space, *Arrival* has an exhuberant and directional energy.

Lipchitz's sculpture in New York became more introspective and personal. In part, the expulsion from Paris in which he left everything behind and then a major studio fire in 1952 in New York (in which much of the older work still in his possession was lost) encouraged an already present impulse to return to past work. After thirty years of bronze casting, he had also acquired a high level of technical self-assurance by the 1940s that freed him to work more spontaneously than ever before. As part of this characteristic, ongoing return to the past and bringing it relevantly back into the present, explicitly Jewish subjects moved to the fore in the early 1940s, reconnecting Lipchitz with the world of his childhood. *The Prayer* (1943) shows a hooded figure holding "the cock of expiation over his head, prepared for the sacrifice," he explained. "I know that the later, completed sculptures had a particular significance for me, related to the Second World War. . . . it was one of the earliest complete narrative subject themes . . . [and] it was the first attempt I can recall at a specifically Jewish theme."[17] *Our Tree of Life*, concerning Abraham and the genealogy of Judaism, occupied him until his death in 1973—it was his last monumental public commission. (The maquettes for Study for a Monument of 1934 [plate 51] may already point toward *Our Tree of Life*.)

Lipchitz also returned to mother and child themes in the first half of the 1940s and here too we find precedents around 1933-34 in works such as *Rescue of a Child* (plate 50). With regard to the large *Mother and Child II* (1941 fig. 5), he recounted "a curious history which I did not realize until after the fact. In 1935 I was in Russia and one night, when it was dark and raining, I heard the sound of a pathetic song. I tried to trace it and came to a railroad station where there was a beggar woman, a cripple without legs, on a cart, who was singing, her hair all lose and her arms outstretched. . . . when I made the *Mother and Child* . . . this image . . . emerged from my

Figure 4. Jacques Lipchitz, *Arrival*,
1941. Bronze (edition of 7), H. 53.3 cm,
Minnesota Museum of American Art, St. Paul, Minnesota.

Figure 5. Jacques Lipchitz, *Mother and Child II*,
1941. Bronze (edition of 7), H.127 cm,
Art Gallery of Ontario.

subconscious."[18] The increasingly direct access to the flow of unconscious imagery—indicated in this anecdote, not only by the nature of the source material itself but by the manner in which he discussed unconscious memory—became a common feature of the work of Lipchitz's New York period.

Another important expression of the growing spontaneity in Lipchitz's work after 1940 was in 1942, when the artist had a sudden "nostalgia to do transparents such as I had done in France in 1925. These were different from the earlier ones in the sense that I had now solved all the technical problems so that I could work in an extremely free, lyrical manner. They also had a very close personal association, since they were related to someone with whom I was in love at that time. Most of them, thus, are made to express the sense of an exaltation of the woman."[19]

The gestural freedom of these postwar *transparents* (fig. 6) and the totemic imagery at the heart of each of them suggest a relationship to the emerging totemic imagery and autographic brushwork of the young artists of the New York School; the central figures in the *transparents* compare intriguingly with the totemic figures in such contemporary works as Jackson Pollock's *Male and Female* (1942, fig. 7) and Mark Rothko's *Baptismal Scene* (1945, fig. 8). The cage-like structures and the textural detailing also connect the *transparents* to the emerging abstract expressionist sculpture in New York in the early 1940s (though most of it was fabricated by brazing and welding rather than cast). In particular the late 1940s and 1950s work of Seymour Lipton, Ibram Lassaw, Herbert Ferber (fig. 9), and Theodore Roszak (as in *The Migrant*, 1950, fig. 10) have an affinity to this work by Lipchitz, but it seems unlikely that any of these younger artists either influenced or were influenced by his *transparents*. Rather, the affinity shows the considerable currency for totemic images

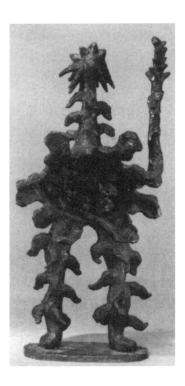

Figure 6. Jacques Lipchitz, *The Pilgrim*, 1942. Bronze
(unique), H. 75.6 cm.

and this kind of structure and gesture at this time in New York. All of the *transparents* were modeled directly in wax, making each bronze unique and heightening its spontaneous autographic quality, but none combined welding with casting as some of the Americans did.

One area where Lipchitz could well have had a direct influence on these younger American artists is in their mutual interest in animal themes, especially from mythology, and in the crossover human-animal forms, like the minotaur. Picasso, of course, was the principal source for minotaur imagery, and Lipchitz always kept a close eye on Picasso, too. But for Lipchitz, "the minotaur is Hitler," for example, giving this form a specificity it never had for Picasso. Lipchitz also explored the psychological in a manner that Picasso did not: " . . . a Hitler in each of us whom we must destroy."[20] Furthermore, in an interview with Paul Dermée in 1920 (published in the *Esprit Nouveau*, Paris), Lipschitz gave a Freudian twist to his use of such animals: "I said, 'I would like to make monsters, but monsters that seem to be natural; as if nature had made them.' . . . The work of art should go from the unconscious to the conscious and then finally to the unconscious again, like a natural, even though unexplainable, phenomenon."[21]

The younger Americans also used the psychoanalytic terms that had begun showing up in Lipchitz's work as well in the 1940s. The prevalence of concern about the war made this even more apparent. "For Roszak and others of his generation like David Smith and Seymour Lipton," Joan Marter writes, "bird forms assumed more ominous associations. In the postwar period, the traditional use of flying birds to symbolize spirituality was altered as birds became associated with fighter bombers. Images of prehistoric flying reptiles such as the pterodactyl served as metaphors for the destructive, predatory activity of warplanes."[22]

At the end of 1951 (on the eve of the devastating January 1952 fire in his Chelsea studio), Lipchitz had begun work on a whimsical series of twenty-nine *Variations on*

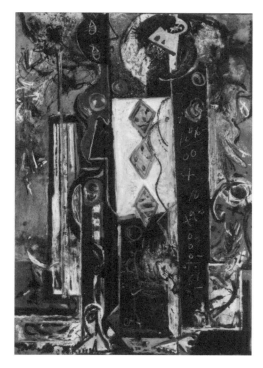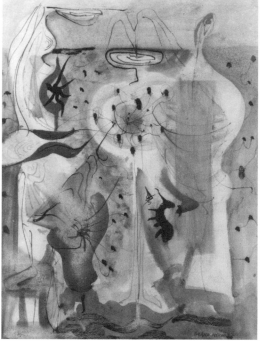

Figure 7. Jackson Pollack, *Male and Female*, 1942. Oil on canvas, 1.85 × 1.25 m, Collection Philadelphia Museum of Art, Gift of Mr. and Mrs. H. Gates Lloyd.

Figure 8. Mark Rothko, *Baptismal Scene*, 1945. Watercolor on paper, 50.5 × 35.6 cm, Collection of Whitney Museum of American Art, New York.

a Chisel (1951–52). These works are all built around a figuratively suggestive found object—the blade of a wood chisel without its handle. This leaves exposed the hat-like spiked end that fits into the wooden handle. Lipchitz improvised, modeling wax around these appropriated elements into narrative, figural vignettes and making unique casts of them. Here the parallel to David Smith's appropriation of tools, particularly in works from his welded *Agricola* series of this time, is obvious, although Smith was already incorporating farm implements into his sculpture in the early 1930s (as in *Saw Head*, 1933). Lipchitz might have known these works by Smith in reproduction, but, more to the point, both Lipchitz and Smith knew the welded sculpture of Picasso and Julio González from around 1930.

Whatever their sources, the 1951–52 chisel pieces represented a further technical liberation in Lipchitz's approach to sculpture in New York. This was followed by an even more original and dramatic development in direct expressivity with his so-called *semiautomatics*, thirty-three sculptures of 1955–56. "I would just splash or squeeze a piece of warm wax in my hands," he explained, "put it in a basin of water without looking at it, and then let it harden in cold water. When I took it out and examined it, the lump suggested many different images to me. Automatically a particular image would emerge several times and this I would choose to develop and clarify."[23] *Semiautomatics*, like *Gypsy Dancer* (plate 66), presage the tactile freedom of Willem de Kooning's sculpture of 1969–74, and at least one David Smith—Smith's *Europa and the Calf* (1956–57, fig. 11), which intriguingly relates not only to Lipchitz's subject matter in its title but also in general outline to the Europa imagery of Lipchitz and to the experimental freedom of the process in the *semiautomatics*.

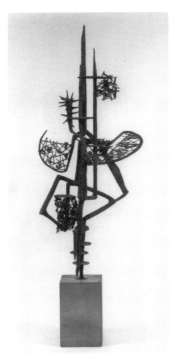

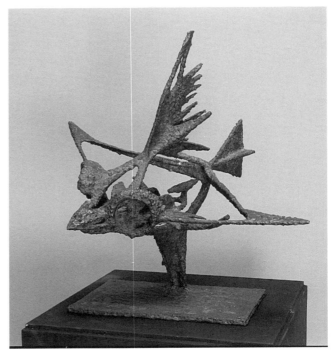

Figure 9. Herbert Ferber,
The Flame, 1949.
Brass, lead, and soft solder,
base, 103.1 × 64.5 × 64.5 cm,
Collection of Whitney Museum of
American Art, New York

Figure 10. Theodore Roszak, *The Migrant*, 1950.
Steel brazed with copper, 72.3 × 81.9 × 61.5 cm,
Krannert Art Museum and Kinkead Pavilion,
University of Illinois at Urbana-Champaign.

In a series of fourteen works of 1958–59 under the general title *À la limite du possible* (To the Limit of the Possible) and in the subsequent *Images of Italy* (1962–63), he loosened his technique still more by casting a broader range of found materials, including leaves, roots, and woven baskets. Alan G. Wilkinson points to the title of the first group as a reference to testing the outer technical limits of bronze casting,[24] and, to be sure, Lipchitz's technical virtuosity in these works is what affords him the expressive spontaneity that defines these unique compositions. There is also an unmistakable reference in these works to Picasso's casting of the 1950s; works by Lipchitz such as *The Japanese Basket* (1958, in the series *À la limite du possible*) and *The Beautiful One* (1962, from *Images of Italy*, plate 67) are cousins to Picasso's *Little Girl Skipping* (1950–52) and his *Goat Skull and Bottle* (1952–53).

Lipchitz's experience with monumental scale in sculpture is perhaps the other area in which one might find a direct impact on the younger American generation from his presence in New York in the 1940s and 1950s. He began enlarging the scale of some projects in the early 1930s. At eighty inches, the *Standing Bather* (1923–25), commissioned for Albert C. Barnes, was the largest sculpture that Lipchitz had made up to that time. "The large *Figure* is important to me," he pointed out. " . . . From this point forward, I think I began to be concerned more explicitly with this question of monumentality . . ."[25]

The *Joy of Life* (1927) is over seven feet high; the *Prometheus Strangling the Vulture* (1937) for the Paris World's Fair stood thirty feet high (it was in plaster!). In 1943 Lipchitz was commissioned to make a monumental sculpture for the Ministry of

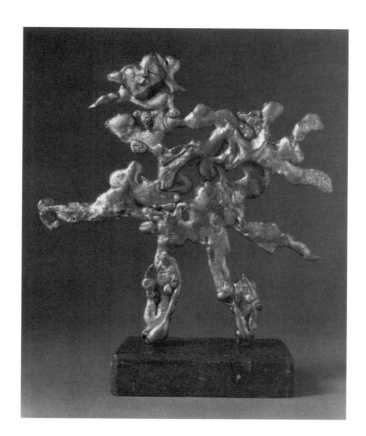

Figure 11. David Smith, *Europa and Calf*, 1956–57. Poured bronze on stone base, 28.8 × 24 × 9.5 cm, Smithsonian American Art Museum, Museum Purchase

Education in Rio de Janeiro on the theme of *Prometheus Strangling the Vulture* which, he said, stood for "the victory of light over darkness, of education over ignorance."[26] In 1958 he made *The Spirit of the Enterprise* for Fairmont Park in the center of Philadelphia and then in 1964 he began work on a sculpture for the roof of the entrance canopy of the Columbia University Law School on the theme of *Bellerophon Taming Pegasus*. By the later 1950s he must have been seen as someone with significant experience in this field of large-scale sculpture.

It is known that the one important young American artist with whom Lipchitz maintained an ongoing conversation about art was the minimalist sculptor Tony Smith. Smith returned to New York from California in 1945 and had close relationships with Barnett Newman, Jackson Pollock, and Mark Rothko; sometimes they asked him to help hang their shows in the 1940s because of his eye for installation. No one knows precisely what he and Lipchitz might have talked about when they met, but Smith and Lipchitz did get together regularly in the 1940s and 1950s.

Smith's widow recalled that "Tony Smith respected Lipchitz"[27] and thought that perhaps one of the things they discussed was scale in sculpture. One of Smith's greatest contributions involved the delicacy with which he calibrated the scale of his works in relation to their sites, undercutting the conventional notion of monumentality and making his sculptures remarkably responsive to their architectural or natural setting. "Why didn't you make it larger so that it would loom over the observer?" someone asked Smith about *Die*, the now famous, six-foot-high, black, steel cube of 1962. "I was not making a monument," he replied. "Then why didn't you make it smaller so that the observer could see over the top?" "I was not making an object."[28]

The notorious first encounter between the German (but School of Paris) émigré, Hans Hofmann, and the young Jackson Pollock in 1942 highlights the clash in perspective between the Americans and the European moderns like Lipchitz who had come there from Paris. At this first meeting, Hofmann reportedly told Pollock: "You don't work from nature. You work by heart. This is no good. You will repeat yourself." To this, Pollock—in the midst of the first cycle of genuinely great paintings in his career (*Male and Female*, *Guardians of the Secret*, *She-Wolf* . . .)—retorted "I am nature. . . . Put up or shut up. Your theories don't interest me."[29]

Hans Hofmann never lost his European modernist orientation and neither did Jacques Lipchitz. Hofmann had emigrated in the fall of 1931 to New York City and from the middle 1930s through the late 1950s, taught young American painters (and the critic Clement Greenberg!) the formal subtleties of European modernism: nuances of painterly handling and color (based on his first-hand experience with fauvism and the work of Vasily Kandinsky), an analytical approach to pictorial structure (from his study of Paul Cézanne and cubism) and a spirituality (as he found it in Kandinsky's romantic abstraction). Hofmann taught a formal and aesthetic approach; to him art had nothing to do with politics or social consciousness.

Jackson Pollock's response to Hofmann was more than simply an impulsive outburst of Oedipal rebellion. He had been studying Picasso, in particular, and European modernism generally in painstaking detail and would remark less than two years later, in 1944: "I accept the fact that the important painting of the last hundred years was done in France. . . . The fact that good European moderns are now here is very important, for they bring with them an understanding of the problems of modern painting. I am particularly impressed with their concept of the source of art being the unconscious."[30] Where Pollock differed fundamentally in perspective with Hofmann and even with Picasso was in his particularly American existentialism. With regard to the unconscious as a source, for example, the European surrealists sought to use automatism as a means of opening the mechanisms and content of the unconscious to scrutiny, whereas Pollock sought to redefine automatism as a device for recording the immediacy of the individual's subjective experience of the unconscious with a reference point decidedly in the present. This is a long-standing American theme.

Walt Whitman's famous poem "Crossing Brooklyn Ferry" centers not on the things but on the experience of traversing the space; like Pollock, what matters is the act of moving across the surface and across time. In his 1849 essay, "Nature," Ralph Waldo Emerson underscored the experience of reinvention, of beginning again,[31] which has consistently differentiated the American from the European perspective. It is a leitmotif of American culture: "We actually began, so to speak, from scratch, as if painting were not only dead but had never existed,"[32] Barnett Newman wrote about his generation of painters in the New York school of the 1940s. David Smith's friend, the artist Herman Cherry, talked in the late 1940s about Smith's "quality of anti-taste," his "rough sensibility" and his anti-aestheticism in contradistinction to the stylistic refinement of recent European art.[33] Indeed the painter John Graham had taken Smith to meet Lipchitz in Paris before the war and Smith had found him aloof—they had no rapport at all.

In sum, Lipchitz began his career in the United States when the great collector Albert Barnes began commissioning work from him in the 1920s. He had his first large American exhibition at the Brummer Gallery in New York in 1935, and Alfred Barr bought the very important *Figure* (1936) for the Museum of Modern Art shortly after it was made. Between Barr and Barnes, Lipchitz's reputation began to take root firmly on this side of the Atlantic well before he emigrated in 1941. Immediately after his emigration, Joseph Brummer introduced him to Curt Valentin who gave him a show in his Buchholz Gallery in 1942. By 1945, Lipchitz was sufficiently well known to be interviewed by the curator of the Museum of Modern Art in the prestigious *Partisan Review*. Valentin also showed the sculptors Herbert Ferber, Theodore Roszak, and Seymour Lipton in 1942, and they must have all seen one another's work. In 1954, Lipchitz was awarded a retrospective at the Museum of Modern Art. His work sold well by this time, but he was also a shrewd connoisseur as well and helped support himself by buying and selling art in collaboration with his brother Rubin (who remained in Paris) and a Paris art restorer. From Lipchitz's notes, he seems to have had a remarkable collection that even included paintings by Nicolas Poussin, Titian, Jean-Auguste-Dominique Ingres, and Georges Seurat.

So Lipchitz, we have to conclude, remained a fundamentally European artist despite residing in America. Nevertheless, his work evolved in significant and profound ways during his residence in the United States. In particular, he took the classical language of modeled sculpture perhaps further in the direction of spontaneous, gestural expressionism than anyone before him, and he infused a rich pantheon of classical and biblical subjects with a deeply personal spirituality that made the genre newly relevant and vital again, as it continued to make his own life whole and vital for himself.

1. Belle Krasne, "Sculpture at Modern," *Art Digest* (February 15, 1950): 15.

2. James Johnson Sweeney, "An Interview with Jacques Lipchitz," *Partisan Review* 12, no. 1 (Winter 1945): 86.

3. Albert E. Elsen, Modern European Sculpture 1918–1945: *Unknown Beings and Other Realities* (New York: Braziller, 1979), 28.

4. Christopher Green, "Lipchitz and Gris: The Cubisms of a Sculptor and a Painter," in *Lipchitz: A World Surprised in Space* (*Un mundo sorprendido en el espacio*), exhibition catalogue (Madrid and Valencia: Museo Nacional Centro de Arte Reina Sofía and IVAM, Centro Julio González, 1997), 207.

5. Maurice Raynal, *Lipchitz* (Paris: 1920), n.p., cited in Green, "Lipchitz and Gris," 206.

6. Jacques Lipchitz with H. H. Arnason, *My Life in Sculpture*, Documents of Twentieth Century Art (New York: Viking Press, 1972), 95.

7. Ibid., 74.

8. Ibid., 77.

9. Bruce W. Bassett, dir., *Portrait of an Artist: Jacques Lipchitz*, film (Chicago: Home Vision, 1977).

10. Sweeney, "An Interview with Jacques Lipchitz," 89.

11. J. F. Yvars, "Profile of Lipchitz," in *Lipchitz: A World Surprised in Space* (*Un mundo sorprendido en el espacio*), 204.

12. Ibid., 211.

13. Bassett, dir., *Portrait of an Artist: Jacques Lipchitz*, film.

14. Lipchitz, *My Life in Sculpture*, 140.

15. Ibid., 140.

16. Ibid., 143.

17. Ibid., 82–85.

18. Ibid., 148–51.

19. Ibid., 159.

20. Ibid.

21. Ibid., 195.

22. Joan Marter, *Theodore Roszak: The Drawings* (New York: The Drawing Society, 1992), 21.

23. Lipchitz, *My Life in Sculpture*, 193–94.

24. Alan G. Wilkinson, "The Life and Art of Jacques Lipchitz," in *Lipchitz: A World Surprised in Space* (*Un mundo sorprendido en El espacio*), 220.

25. Lipchitz, *My Life in Sculpture*, 90.

26. Ibid., 164.

27. Jane Smith, telephone conversation with the author, April 2001.

28. Tony Smith, cited in Morris, "Notes on Sculpture," pt. 2; reprinted in Gregory Battcock, *Minimal Art: A Critical Anthology* (New York: Dutton, 1968), 228, 230.

29. Cited in Cynthia Goodman, *Hans Hofmann*, (New York: Abbeville Press), 49.

30. B. H. Friedman, *Energy Made Visible*, (New York: McGraw-Hill, 1972) 62.

31. Ralph Waldo Emerson, "Introduction," *Nature*, 1836 (revised 1849), in *Ralph Waldo Emerson: Essays and Lectures,* notes and selections by Joel Porte (New York: The Library of America, 1983), 7.

32. Barnett Newman, 1967, cited in Harold Rosenberg, (New York: Abrams, 1978), 27–28.

33. Hilton Kramer, "Month in Review," Arts (October 1957): 49.

CATALOGUE

All works of art which appear in Alan G. Wilkinson's, *The Sculpture of Jacques Lipchitz: A Catalogue Raisonné*, 2 volumes (London: Thames and Hudson, 1996, 2000) are referenced by number at the end of each photo caption. For example, plate 2 appears on page 37 of *Catalogue Raisonné* vol. 1 as No. 6 and is cross-referenced here as: Wilkinson, 1996 No. 6.

The initials of the Art History graduate student contributors appear at the end of each of their essays. Their names are listed in full on page 151.

EARLY WORK, 1911–13

Jacques Lipchitz's proto-cubist work, which he produced from 1911 to 1913, represents his classical, more traditional concerns. Lipchitz was maturing as an artist, and the work from this period provides evidence of his thorough artistic training, which involved academic studies from live models.[1] The simplified and direct form of Egyptian and archaic Greek sculpture also interested Lipchitz throughout his career. Between 1911 and 1913, Lipchitz's sculpture bears a similarity to the work of Charles Despiau, a well-known classical French artist who worked in Auguste Rodin's studio as a marble carver from 1907 to 1914.[2] Lipchitz's sculpture *The Little Italian* (1911–12), which was praised at the 1912 *Salon national des beaux arts* exhibition, conveys clarity and naturalism similar to the work of Despiau. Lipchitz's most famous work from this early period is his bronze sculpture *Woman and Gazelles* (1911–12), which presents the classical nude female body in a simplified and naturalistic manner. The work was honored at the 1913 *Salon d'automne* and received further attention when it was reproduced in such periodicals as *Art et Décoration* in 1913.[3] He also experimented with charcoal and pencil drawings at this time, creating such works as *Coupe de fruits* (1912) and *Coupe de pommes* (1912–13). He chose customary still-life subject matter, naturalistically rendering fruit in a bowl placed on a table. These compositions were more traditional than later cubist still lifes that employed elements of the contemporary café, such as the newspaper. The two drawings explore different angles of presentation: *Coupe de fruits* from the side and *Coupe de pommes* from slightly above. The angled and relatively flat presentation of the tabletop in *Coupe de pommes* lends the composition a slight element of destabilization. These works recall Paul Cézanne's still lifes, in which the artist maintained an illusion of a realistic presentation, yet expressed the tension existing among individual objects as a coherent visual experience. To construct the full and rounded forms of the fruit and bowl, Lipchitz uses naturalistic light and shading. Although he eventually departed from this more traditional style in his experimentation with cubism and his later *transparents*, Lipchitz was never interested in complete abstraction and always maintained a connection to organic life in his work.

Lipchitz first encountered cubist works in Montparnasse in 1911. Initially he rejected the style, preferring his more traditional approach to sculpture, although he maintained a detached curiosity. By 1913, Lipchitz had started to incorporate elements of the cubist style into his work.[4] His brief return to more naturalistic forms in the early 1920s is credited to his problematic financial situation as well as to his contemporaries' renewed interest in neoclassicism. After his break with his art dealer, Léonce Rosenberg, Lipchitz turned to portraiture to provide a steadier income.

Lipchitz in 1922

Lipchitz's neoclassicist portraiture of the early 1920s parallels other artists' use of classical illustration and subject matter. Pablo Picasso, for example, painted classical figures around 1904–5 and experimented again with classicism from 1917–21. The neoclassicism of the 1920s is often described as a nationalist art bound in French tradition, springing from World War I and from a need to reestablish order among chaos. For individual artists, however, the motivations behind the return to classical form are diverse, and the assumption that classicism is simply an expression of a return to reason and order has subsequently been revised.[5] Although the term classicism is a broad category and refers to a variety of artistic methods, Lipchitz's classicism incorporates the basic principals of harmony, naturalism, idealism, clarity, and simplicity. Lipchitz's interest in neoclassicism and idealization resurfaces in his portraits of the 1920s, and his desire to depict classical mythological themes and religious narrative remains consistent throughout his career.

PW

1. Elizabeth Cowling and Jennifer Mundy, *On Classical Ground: Picasso, Léger, de Chirico and the New Classicism 1910–1930* (London: Tate Gallery, 1990), 145.

2. Ibid, 286.

3. Irene Patai, *Encounters: The Life of Jacques Lipchitz* (New York: Funk and Wagnalls, 1961), 109.

4. Ibid., 92–93.

5. Cowling and Mundy, *On Classical Ground*, 267.

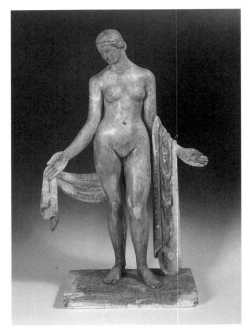

1

Jacques Lipchitz

Draped Woman (Fragment from Woman and Gazelles)

1911-12
Plaster
H. 80 cm

Krannert Art Museum and
Kinkead Pavilion,
University of Illinois at
Urbana-Champaign
Gift of Jacques and Yulla
Lipchitz Foundation

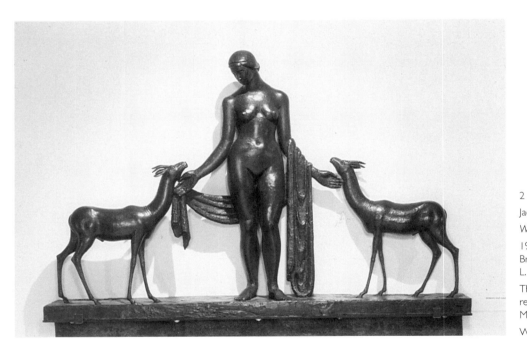

2

Jacques Lipchitz

Woman and Gazelles

1911-12
Bronze
L. 116.8 cm

The Estate of Jacques Lipchitz
represented by
Marlborough Gallery

Wilkinson, 1996 No.6

3

Coupe de Fruits
1912
Pencil on paper
31.1 x 47.0 cm

The Estate of Jacques Lipchitz represented by
Marlborough Gallery

4

Jacques Lipchitz
Coupe de Pommes
1912-13
Charcoal on paper
27 x 31.1 cm

The Estate of Jacques Lipchitz represented by
Marlborough Gallery

5

Jacques Lipchitz
Nature Morte (Pommes et Couteaux)
1913
Pencil on paper
27.9 x 19.1 cm

The Estate of Jacques Lipchitz represented by
Marlborough Gallery

LIPCHITZ AND RIVERA IN SPAIN:
AN ENTRY INTO CUBISM

It was the trip to Spain and all the impressions that I gathered there which
made me take the final step toward Cubism.
—Jacques Lipchitz, *My Life in Sculpture*

Jacques Lipchitz and Diego Rivera's trip to Spain in 1914 coincides with the two
artists' most decisive formal development: their transition into cubism. At the time
both artists were also emerging from a predominantly figural and illusionist style and
entering into a period of experimentation where flattening and breaking down the
pictorial and sculptural space became common elements in their work. Although
scholars like H. H. Arnason have clearly established that Lipchitz's presence in Spain
marked a turning point in his career, no one has properly explained how his expe-
rience there plunged him into cubism. After 1915, both the sculptor and the painter
went into radically different directions—with Lipchitz pushing further toward
abstraction and Rivera increasingly moving toward a social realist style—neverthe-
less, their brief yet critical personal and artistic exchange in Spain revealed several
parallel visual explorations in their work. Though Lipchitz and Rivera had been
friends prior to their trip to Spain, their presence there represented a period of
intense artistic and intellectual exchange.

From 1913 to 1915, Lipchitz and Rivera engaged in vigorous artistic exercises that
would lead them to their cubist phase. Rivera's work from 1913 to 1914 clearly illus-
trated this sudden shift from figuration to abstraction via cubism.[1] Likewise, Lipchitz
demonstrated an equally speedy and adventurous transition during those same
years. His *Horsewoman with a Fan* (1913), for instance, betrayed the sculptor's early
interest in round volumetric form and classicism, while a year later, works like
Toreador already exhibited the angular and geometric forms that would character-
ize his later cubist oeuvre. With little evidence of the precise stylistic process by
which they arrived at cubism, we are thus compelled to think that their stay in Spain,
which began in 1914 and extended to the beginning of 1915, permitted them to
develop the ideas they had previously picked up from the Parisian avant-garde. In
addition, the presence of many other modern artists and writers in Spain in the
mid-1910s, such as María Blanchard, Angelina Beloff, Robert and Sonia Delaunay, and
Ramón Gómez de la Serna, allowed Lipchitz and Rivera to initiate a direct dialogue
with them as well as benefit from their influence.

The process by which Lipchitz and Rivera made the transition from figural work to
geometric abstraction was not an exclusively formal or stylistic one. Both artists
took advantage of their stay in Spain to familiarize themselves with the country's
artistic patrimony. This orientation included a visit to the Prado Museum where
Lipchitz and Rivera, each on their own terms, became captivated by the paintings of
El Greco. Lipchitz went so far as to claim that it was his encounter with this Spanish
master's work that led him onto the cubist path. As he would later recall: "I could
see at once the relations of El Greco's powerful, expressive, angular paintings to
Cubism."[2] Rivera, in turn, drew directly from this Spanish master's visual vocabulary
by making a series of portraits and figural compositions that included slender and
elongated figures, a style that also revealed his interest in the work of contempo-

rary Basque painter Ignacio Zuloaga (1870–1945). For instance, Rivera's painting *Los Viejos* (1912), which depicts a group of four elderly Spanish men inhabiting a Toledan landscape, was an image that owed much to the visual vocabulary of both El Greco and Zuloaga.

During his time in Spain, Lipchitz took an interest in Spanish types, a phenomenon that can be seen not only in his *Toreador* but also in several drawings from 1914 such as *Spanish Woman with a Fan*. For the sculptor, however, these Spanish types were not figures that possessed any cultural or social importance; instead they were bodies devoid of an individualized identity and therefore open to formal manipulation and experimentation. Many of these characters were based on actual individuals he met or saw, yet his figures had only a negligible relationship to anyone in particular. For instance, *Toreador* was inspired by his friendship with Spanish bullfighter Joselito yet it was not, as Lipchitz would clarify, "in any sense a portrait."[3] The same would hold true for his *Sailor with Guitar* (1914), a figure he sculpted after observing the repeated dances of a sailor living on the coast of Mallorca. The movement of this sailor gave the artist the opportunity to view his figure from several perspectives, thereby providing an unexpected exercise in analytical cubism.[4] In the same year, Rivera explored a similar motif with his *Sailor at Lunch* (1914), a cubist painting that can be seen as a two-dimensional counterpart to Lipchitz's *Sailor with Guitar*. Both used an elongated rectangular form to define the sailor's head and constructed the figure through the assemblage of geometric forms. At the time, both artists had also come under the powerful influence of Pablo Picasso, whom Rivera had introduced to Lipchitz in 1913.[5]

While Rivera would abandon cubism in 1917, Lipchitz would continue experimenting with it well into the 1920s. Their time in Spain, nevertheless, proved to be an intensive period of experimentation with cubist forms; it endowed them with an improved technical proficiency in their respective media, and with an increased confidence in their contribution to the development of modern art.

GL

1. Christopher French, "Diego Rivera: Five Years of Cubism," *Artweek* 15 (October 20, 1984): 1.

2. Jacques Lipchitz with H. H. Arnason, *My Life in Sculpture, Documents of Twentieth Century Art* (New York: Viking Press, 1972), 18.

3. Ibid., 19.

4. Ibid., 18.

5. Bert Van Bork, *The Artist at Work: Jacques Lipchitz* (New York: Crown Publishing, 1966), 8.

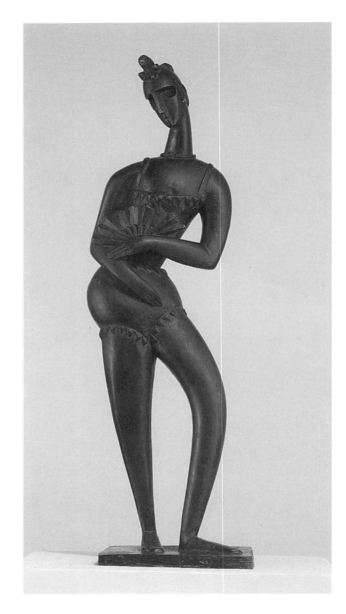

6

Jacques Lipchitz

Horsewoman with Fan

1913

Bronze

H. 67.6 cm

The Estate of Jacques Lipchitz represented by Marlborough Gallery

Wilkinson, 1996 No.12

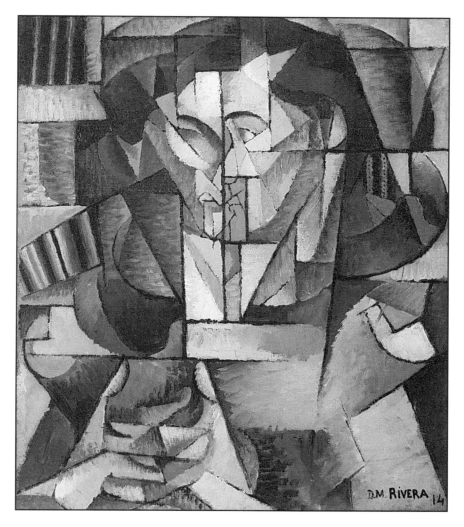

7

Diego Rivera

Jacques Lipchitz (Portrait of a Young Man)

1914

Oil on canvas

65.1 x 54.9 cm

The Museum of Modern Art, New York

Gift of T. Catesby Jones

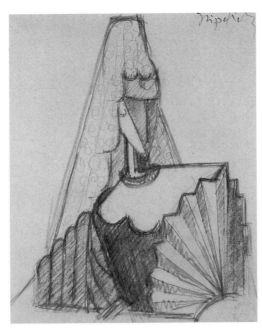

8

Jacques Lipchitz

Spanish Woman with Fan

1914
Graphite and colored pencils on paper
20.4 x 15.8 cm

Marlborough International Fine Art Est.

9

Jacques Lipchitz

The Waitress (La Serveuse)

1914
Charcoal and sanguine crayon on paper
41.4 x 26 cm

The Estate of Jacques Lipchitz represented by
Marlborough Gallery

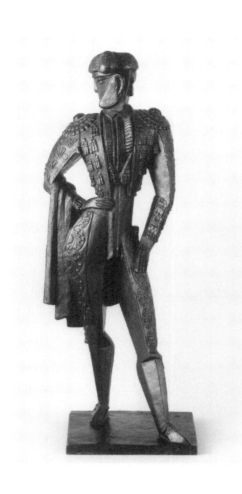

10
Jacques Lipchitz
Toreador (also known as *The Matador*)
1914
Bronze
H. 80 cm
The Minneapolis Institute of Arts
Gift of Mr. And Mrs. John Cowles
Wilkinson, 1996 No.19

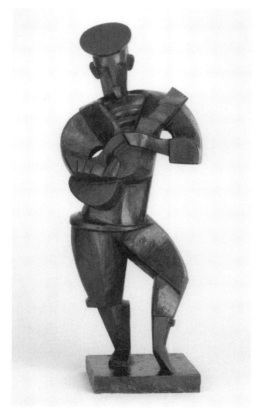

11
Jacques Lipchitz
Sailor with Guitar
1914
Bronze
H. 76.2 cm
Philadelphia Museum of Art
Gift of Mrs. Morris Wegner in memory of her husband
Wilkinson, 1996 No.21

12

Jacques Lipchitz

The Waitress (La Serveuse)

1914

Pencil on paper
17.2 × 12.1 cm

The Estate of Jacques Lipchitz represented by
Marlborough Gallery

13

Jacques Lipchitz

Spanish Servant Girl

1915

Blue pencil on paper
29.8 × 18.2 cm

The Estate of Jacques Lipchitz represented by
Marlborough Gallery

THE PARIS AVANT-GARDE MILIEU

Although Jacques Lipchitz was born in Lithuania, he spent most of his adult life in Paris from 1909 until his move to America in 1941. At the beginning of the twentieth century, Paris was a rich artistic milieu where avant-garde artists actively interacted with writers and poets. Lipchitz and his friends exchanged ideas with such literary figures as Max Jacob, Jean Cocteau, Pierre Reverdy, Guillaume Apollinaire, Vincente Huidobro, Juan Larrea, and Gertrude Stein. As Lipchitz recalled, "This period during the First World War was a very exciting time in Paris, with artists, philosophers, and poets continually discussing and arguing about the work with which they were involved."[1]

In the 1910s, a new and revolutionary style of painting and sculpture emerged in Paris-cubism. By exploring multiple points of view and moments in time within a single work, cubism challenged traditional theories of perspective.[2] Painters such as Pablo Picasso, Georges Braque, and Juan Gris, as well as sculptors like Lipchitz, Raymond Duchamp-Villon, and Henri Laurens, explored cubist ideas. According to Lipchitz, "At this period, cubism was so much in the air that everyone was borrowing from everyone else. We all saw one another's works and the results were some kind of collective art."[3]

Lipchitz maintained that the ideas of cubist sculpture were essentially different from those of cubist paintings. In fact, Lipchitz and Picasso discussed the differences between painting and sculpture with regard to Picasso's *Glass of Absinthe* (1914). While Picasso incorporated color into his sculpture, Lipchitz desired a purer form of sculpture, untainted by paint. With the exception of a few experiments with color reliefs in the late 1910s, such as *Bas Relief* and *Still Life* (1918), Lipchitz focused on the interplay of solids and voids and the effects of light, consistently expanding his sculptural vocabulary.

In addition to their creative ties, many of the avant-garde artists were personal friends, and they spent time together and introduced each other to fellow artists. For example, Max Jacob introduced Lipchitz to Amedeo Modigliani, and Lipchitz, in turn, introduced Modigliani to Chaim Soutine. Diego Rivera introduced Lipchitz to Picasso. Many of these artists, including Modigliani, Soutine, and Marc Chagall, shared a common Jewish heritage with Lipchitz.

EYJ and AMK

1. Jacques Lipchitz with H. H. Arnason, *My Life in Sculpture*, *Documents of Twentieth Century Art* (New York: Viking Press, 1972), 39.

2. A. M. Hammacher, *Jacques Lipchitz* (New York: Abrams, 1975), 11.

3. Lipchitz, *My Life in Sculpture*, 12.

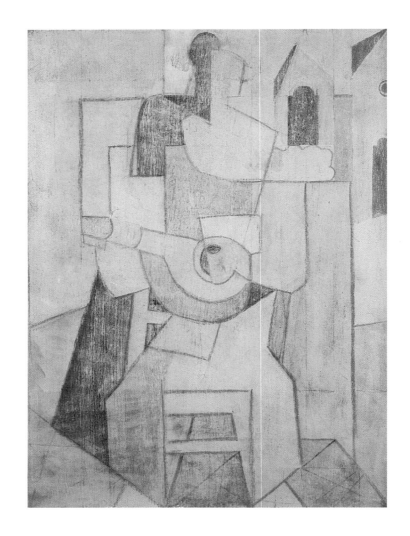

14
Jacques Lipchitz
Harlequin and Guitar
1914-15
Crayon and watercolor on cardboard
45.5 x 32.5 cm
Private Collection, New York

15

Diego Rivera

Table on a Café Terrace

1915
Oil on canvas
60.6 x 49.5 cm

The Metropolitan Museum of Art, New York
The Alfred Stieglitz Collection

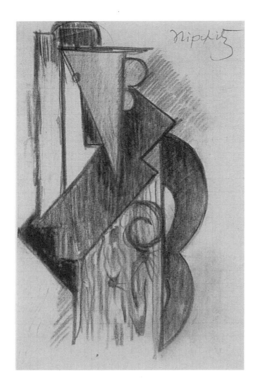

16

Jacques Lipchitz

Etude pour une sculpture (etude cubiste)

1915

White Chalk on Paper

21.2 x 13.4 cm

Marlborough International Fine Art Est.

17

Jacques Lipchitz

Seated Figure

1915

Bronze

H. 87 cm

The Estate of Jacques Lipchitz represented by Marlborough Gallery

Wilkinson, 1996 No.40

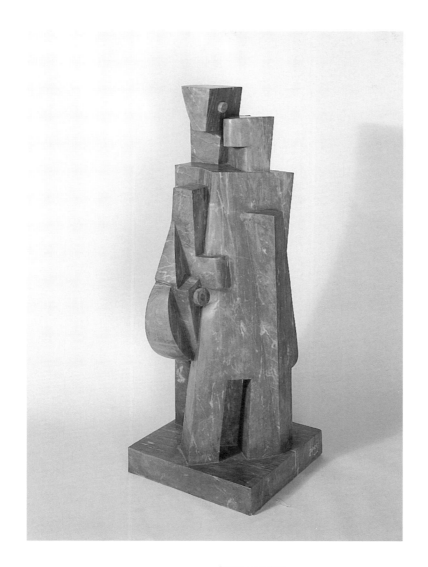

Jacques Lipchitz

Man with Mandolin

1916 (carved 1971)
Marble
H. 121.9 cm

Private Collection, New York

Wilkinson, 1996 No.55

JUAN GRIS AND LIPCHITZ

Jacques Lipchitz met Juan Gris in 1916 through the art dealer Léonce Rosenberg. Their friendship lasted for eleven years until Gris's death in 1927. From 1916 to 1920, the two artists worked together closely to explore the various possibilities of integrating cubist subject matter and geometric abstractions into both their sculpture and painting. Their creative exchanges formed the basis of their mature styles in the 1920s.[1]

Lipchitz's *Seated Figure* (1915) demonstrates a deductive composition, reducing the human form into complete geometric shapes, and yet it retains a powerful sense of the figure as a volume in space. His drawing *Étude pour une sculpture* (*étude cubiste*) (1915, see plate 16) indicates the spatial concept he used to create cubist sculpture.[2] The drawing's subdued tones suggest the varied positions of the planes in space, with white the closest, gray in the middle distance, and black the farthest back.[3] At this time, his idea of sculpture emphasized pure geometric abstractions.

Juan Gris
Lamp
1916
Oil on canvas
81 x 64.8 cm

Philadelphia Museum of Art
The Louise and Walter
Arensberg Collection

Inspired by Gris, Lipchitz created some painted relief sculptures, such as *Bas Relief* and *Still Life* (1918). His *Bas Relief* resembles Gris's *The Lamp* (1916); they share the same application of colored dots surrounding the still-life objects. With the varied elevations of the relief surface, Lipchitz's *Still Life* revealed his increasing use of rounded, volumetric, and multifaceted forms. The representation of multiple perspectives relates to Gris's concept of time; by recalling the viewer's memory of form, these works suggest the action of moving around the subject. In this way, Lipchitz's experimental reliefs also manifest his ambition to incorporate the concept of time into his sculptural space. He integrated Gris's curvilinear abstractions, unifying the painter's experiments with time and his spatial concept of sculpture.

As early as 1916, Gris's *The Lamp* and *Newspaper and Fruit Dish* exemplified his attempt to construct more stable sculptural compositions by fusing figure and ground into a cohesive whole. The almost flat picture planes not only create a tightly composed pictorial harmony but also manifest simplified geometric structures, signaling a synthesis of painting and sculpture. Additionally, each composition consists of an amalgamation of unrelated objects that cohere as a whole structurally, yet signify a conceptual openness that allows for a multilevel interpretation of the relationship between the objects and their setting. This representation complicates the identity of objects and demonstrates the process of their metaphysical transformation. Gris's painting thus enters a new phase that is perceptually structured and conceptually unbounded.

After 1916, Gris, like Lipchitz, was interested in using the ancient Greeks' Golden Mean to produce ideal proportions.[4] From 1917 to 1918, with Lipchitz's technical help, Gris created his painted sculpture *Harlequin* by using mathematically calculated rectangles to construct the figure's body parts in an established ideal ratio in which each element harmoniously corresponded to the whole. This application of the Golden Mean demonstrated Gris's breaking away from analytical cubism toward a more deductive composition that emphasized the logical relationships between the elements.

19
Juan Gris
Portrait of Madame Lipchitz
1918
Pencil and color pencil on paper
47.5 × 30.5 cm
Musee National d'Art Moderne,
Centre Georges Pompidou, Paris, France

These years, from 1916 to 1920, were significant for both Lipchitz and Gris. Lipchitz described his relationship to Gris in *My Life in Sculpture*: "When I speak of possible influences from a painter like Gris on my sculpture, I am not talking about a one-way street. We were all working so intimately together that we could not help taking motifs from one another."[5] Yet, as the sculptor clarified, "This is not simply imitation: we were all working with a common language and exploring the vocabulary of that language together."[6]

LLT

1. Christopher Green, "1916–1921: Platonic Absolutes?" *Juan Gris* (London: Whitechapel Art Gallery in association with Yale University Press, 1992), 53.

2. Jacques Lipchitz and H. H. Arnason, *My Life in Sculpture, Documents of Twentieth Century Art* (New York: Viking Press, 1972), 31.

3. Ibid.

4. Christopher Green, "Lipchitz and Gris: The Cubism of a Sculptor and a Painter," in *Lipchitz: A World Surprised in Space (Un mundo sorprendido en el espacio)*, exhibition catalogue (Madrid and Valencia: Museo Nacional Centro de Arte Reina Sofía and IVAM, Centro Julio González, 1997), 206.

5. Lipchitz, *My Life in Sculpture*, 52.

6. Ibid., 40.

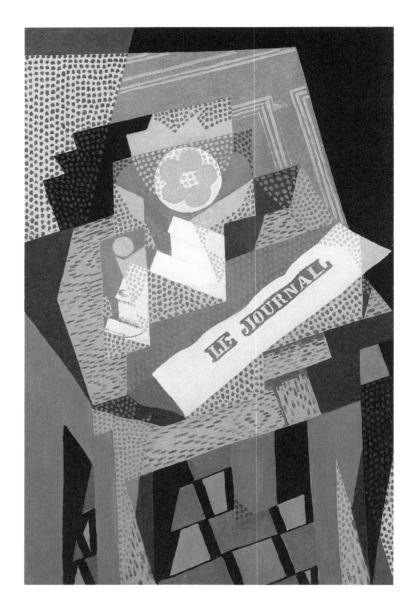

20
Juan Gris
Newspaper and Fruit Dish
1916
Oil on canvas
92 x 60 cm
Yale University Art Gallery, New Haven, CT
Gift of Societe Anonyme

21

Diego Rivera

Still Life

1916
Oil on canvas with built-up relief effects
54.8 x 46 cm

St. Louis Art Museum
Gift of Mr. Morton. D. May

MODIGLIANI AND LIPCHITZ

Amedeo Modigliani

Portrait of Jacques and Berthe Lipchitz

1916
Oil on Canvas
80.7 x 54 cm

The Art Institute of Chicago,
Helen Birch Bartlett
Memorial Collection

Berthe Kitrosser, Lipchitz's first wife, was a Russian poet. After their marriage, Lipchitz commissioned a portrait of the two of them in an effort to help Amedeo Modigliani monetarily. Modigliani began this project by rapidly creating a number of drawings of Jacques and Berthe separately and finished the painted portrait in an afternoon. Lipchitz encouraged Modigliani to continue working on the portrait for two weeks, longer than Modigliani ever worked on a single painting. Of the preparatory drawings, six are documented; all are remarkable for their simplicity and elegance.[1] Although Lipchitz liked the preliminary drawings, he did not care for the finished portrait, *Portrait of Jacques and Berthe Lipchitz* (1916), a painting in the collection of the Art Institute of Chicago. Years later, in an effort to buy back his own work from his dealer, Lipchitz traded Modigliani's painting for his own stone sculptures, which he destroyed as soon as he had them back.

Modigliani and Lipchitz were close friends, having met in 1912 or 1913.[2] Both artists shared a common Jewish heritage and moved within the same circle of poets and artists in the Paris avant-garde. Lipchitz had a deep respect for Modigliani's talent and spirit, which he expressed in the book *Modigliani* (1954) and the article "I Remember Modigliani" for the February 1951 issue of *Artnews*. The two artists disagreed about the role of modeling in sculpture, however. Modigliani, who was working with sculpture in 1912, believed "there was too much modeling in clay, 'too much mud.' The only way to save sculpture was to start carving again, direct carving into stone."[3] In contrast, Lipchitz rarely worked in stone; instead he created clay sketches for larger cast bronze sculptures. Lipchitz and Modigliani remained friends until Modigliani's death from tuberculosis in 1920 at the age of 36.

EYJ and AMK

1. See Neal Benezra, "A Study in Irony: Modigliani's *Jacques and Berthe Lipchitz*," *Museum Studies* 12, no. 2 (1986): 188–99. Benezra states: "Although Lipchitz recalled around twenty preliminary drawings, only nine have been documented" (191). In a footnote, however, he admits that J. Lanthemann's *Modigliani: Catalogue Raisonné* (Barcelona, 1970) only accounts for six of these drawings. The location is presently unknown for two of these six.

2. Jacques Lipchitz's own accounts are conflicting concerning whether he met Modigliani in 1912 or 1913. In his 1954 biography, *Modigliani*, Lipchitz states, "Max introduced us—it was in the Luxembourg Gardens in Paris in 1913." Later in the book, however, Lipchitz also recalls that he met Modigliani in the same year that Modigliani's sculptural heads were exhibited in the *Salon d'automne*. This exhibition took place from October to November 1912.

3. Jacques Lipchitz, *Modigliani* (New York: Abrams, 1954), unpaginated.

22
Amedeo Modigliani
Portrait of Berthe Lipchitz
1916
Pencil on paper
54.6 × 38.1 cm
Private Collection, New York

23
Amedeo Modigliani
Portrait of Jacques Lipchitz
1916
Pencil on paper
43.2 × 26.7 cm
Private Collection

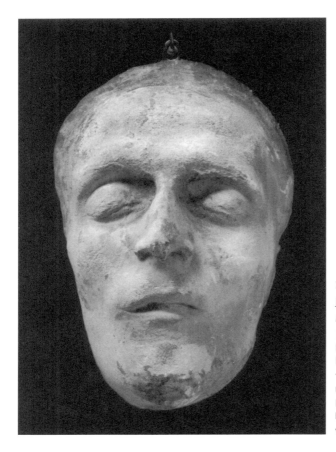

24

Jacques Lipchitz

Death Mask of Modigliani

1920
Plaster
H. 22. 9 x 12.7 cm

The David and Alfred Smart Museum of Art
University of Chicago
Bequest of Joseph Halle Schaffner, in memory of his
beloved mother, Sara H. Schaffner

Wilkinson, 1996 No.116

While Modigliani lay dead in the hospital, Kisling and Moricand tried to make a plaster mask of his face and made a very bad job of it. Not knowing how to remove the plaster, they had shattered it into a thousand pieces, and it was in that state that they brought it to me, all in fragments with hair and flesh still adhering to it. I worked very patiently and hard to put all these pieces together, and where parts were missing I filled in myself. The mask was finally completed and we made twelve copies for the heirs. There is a good bit of Lipchitz in that mask.

Jacques Lipchitz, "I Remember Modigliani," Artnews 49, no. 10 (February 1951): 65

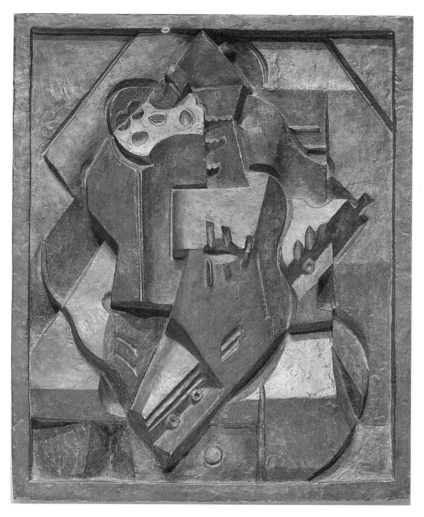

25

Jacques Lipchitz

Still Life

1918
Bronze
68.9 x 55.2 cm

The Estate of Jacques Lipchitz represented by
Marlborough Gallery

Wilkinson, 1996 No.80

26

Jacques Lipchitz

Instrument de Musique

1918

Sanguine crayon on paper

13 x 20 cm

The Estate of Jacques Lipchitz represented by
Marlborough Gallery

27

Jacques Lipchitz

Etude pour un Pierrot

1918-19

Pencil on paper

31.1 x 21 cm

The Estate of Jacques Lipchitz represented by
Marlborough Gallery

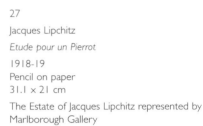

28

Jacques Lipchitz

Etude pour un bas-relief

1919

Charcoal on paper

38.1 x 31.1 cm

The Estate of Jacques Lipchitz represented by
Marlborough Gallery

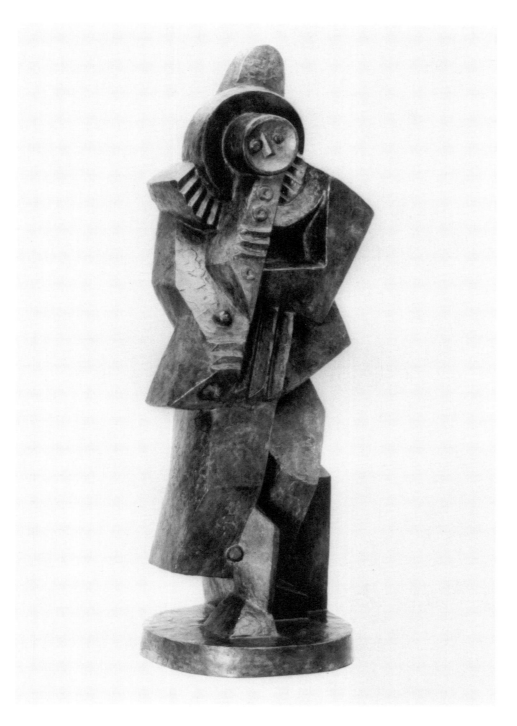

29

Jacques Lipchitz

Pierrot with Clarinet

1919
Cast Bronze
H. 74.9 cm

The David and Alfred Smart Museum of Art
University of Chicago
The Joel Starrels, Jr. Memorial Collection

Wilkinson, 1996 No.84

30
Jacques Lipchitz
Baigneuse (Etude de Femme Debout)
1920
Pen on paper
21 x 13 cm
The Estate of Jacques Lipchitz represented by
Marlborough Gallery

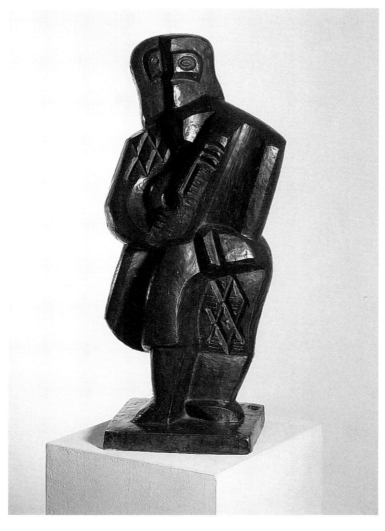

31
Jacques Lipchitz
Harlequin with Mandolin
1920
Bronze
H. 64.8 cm
The Estate of Jacques Lipchitz represented by
Marlborough Gallery
Wilkinson, 1996 No.110

LIPCHITZ AND GERTRUDE STEIN

Within the artistic community in Paris, artists introduced each other to dealers, collectors, and patrons whom they relied upon for creative and financial support. A prominent American writer as well as a passionate collector, Gertrude Stein (1874–1946) was a patron of the arts who lived primarily in Paris among the avant-garde artists from 1903 until her death. Stein played an invaluable role in the Paris avant-garde art scene, befriending Pablo Picasso, Georges Braque, and Henri Matisse and collecting their works. Although Stein never collected sculpture, she became friends with Jacques Lipchitz whom she allowed to make a portrait bust of her on two separate occasions.[1] Lipchitz created simplified, classically rendered portrait busts early in his career, but his later portraits after World War I (such as *Gertrude Stein*, 1920, and especially *Gertrude Stein*, 1938) are examples of his interest in realism. In his autobiography, *My Life in Sculpture*, Lipchitz described his 1920 portrait of Gertrude Stein:

> I think it was about this time that I met Gertrude Stein and went frequently to her receptions, where I liked not only the beautiful paintings on the walls but also the excellent food. I became quite good friends with her and found her a most interesting woman.... Although she had a great collection, unfortunately I could not interest her in sculpture.... After the war, in 1920, I made her portrait, hoping she would buy it, but she never did. In this, I was particularly impressed by her resemblance to a fat, smooth, imperturbable Buddha, and it was this effect that I tried to get.... I hollowed out the eyes deeply but did not indicate the pupils, so that they give an impression of shadowed introspection which emphasized the characterization I was making.... A number of years later, in 1938, I met Gertrude after a long interval and found that she had lost a great deal of weight. She looked now like a shriveled old rabbi, with a little rabbi's cap on her head. I was so struck by the contrast that I asked if I could make another portrait of her. I made two different sketches, one with the cap and one without. She preferred the one without the cap, perhaps because it looked more feminine, but I liked the other one better. I did not carry the second portrait beyond the sketch stage because of the interruption of the Second World War ... I liked the later sketches very much, particularly that with the cap. They have a strongly lifelike appeal. The massive, self-confident Buddha has become a tired and rather tragic old woman.[2]

Gertrude Stein, in turn, created a "portrait" of "Lipschitz" in 1926.[3]

EYJ and AMK

1. Stein also posed for Pablo Picasso's *Portrait of Gertrude Stein* (1905–6), presently in the New York Metropolitan Musuem of Art. Stein acquired Picasso's portrait, but she did not commission or purchase either of Lipchitz's portrait busts.

2. Jacques Lipchitz with H. H. Arnason, *My Life in Sculpture, Documents of Twentieth Century Art* (New York: Viking Press, 1972), 23, 60-63.

3. Gertrude Stein preferred to use "Lipschitz" (the correct spelling of his family name), which had been misspelled by a French official when he was registered. Information from A. M. Hammacher, *Jacques Lipchitz* (New York: Abrams, 1975), 212.

32
Jacques Lipchitz
Gertrude Stein
1920
Bronze
H. 35.2 cm
Yale University Art Gallery,
New Haven, Connecticut
Gift of Curt Valentin

Wilkinson, 1996 No.115

LIPSCHITZ

Like and like likely and likely likely and likely like and like.

He had a dream. He dreamed he heard a pheasant calling and very likely a pheasant was calling.

To whom went.

He had a dream he dreamed he heard a pheasant calling and most likely a pheasant was calling.

In time.

This and twenty and forty-two makes every time a hundred and two thirty.

Any time two and too say.

When I knew him first he was looking looking through the glass and the chicken. When I knew him then he was looking looking at the looking at the looking. When I knew him then he was so tenderly then standing. When I knew him then he was then after then to then by then and when I knew him then he was then we then and then for then. When I knew him then he was for then by then as then so then to then in then and so.

He never needs to know.

He never needs he never seeds but so so can they sink settle and rise and apprise and tries. Can at length be long. No indeed and a song. A song of so much so.

When I know him I look at him for him and I look at him for him and I look at him for him when I know him.

I like you very much.

Gertrude Stein, *Portraits and Prayers* (New York: Random House, 1934), 63–64.

33

Jacques Lipchitz

Portrait of Mlle. Coco Chanel

1921
Plaster
H. 34.3 cm

Krannert Art Museum and Kinkead Pavilion
University of Illinois at Urbana-Champaign
Gift of Jacques and Yulla Lipchitz Foundation

Wilkinson, 1996 No.122

THE DRAWINGS

34

Jacques Lipchitz

Etude de Femme
(*Femme Orientale*)

1923

Blue ink on paper
27.9 x 18.1 cm

The Estate of Jacques Lipchitz
represented by
Marlborough Gallery

To return to my own sculpture and the period about 1915, I have always made drawings related to my sculptures both before and after the sculpture. These could be sketches preliminary to the clay maquette or drawings after the sculpture. In the latter case, they did help to clarify my ideas about sculptural themes on which I was working and to suggest possible variations. Nevertheless, all my drawings are related to my sculpture. I never make drawings as independent works of art. Compared to the cubist painters, my cubist drawings always tend to be more constructed and less pictorial, extending into space in the manner of a sculptor or an architect. When I drew I was thinking about the pronounced planes and I used color to indicate the positions of the planes in space, with the white closest, the gray in the middle distance, and the black farthest back as though it were in shadow. The drawing to me was a kind of blueprint, a sculptural indication or reminiscence. I am not interested in making beautiful or finished drawings but rather in making something from which I can build in stone or clay, or as I said, in which I restudy a finished sculpture and develop my ideas in relation to it. I have always drawn a great deal, developing ideas for sculpture. I characteristically make many sketches, put them up on the wall, and keep studying them. In later years many of my drawings and gouaches have become more finished and collectors have acquired them as separate works of art. But I still find that if I push a drawing too far, make it too finished, I cannot make a sculpture from it because everything is solved and I do not need to make the sculpture. Although in later years I have sold drawings after the sculpture was made, for a long time I simply burned them after they had served their purpose. The earliest drawing that have survived were principally those taken by my dealer, who bought them at price of one hundred francs for three.

Jacques Lipchitz, *My Life in Sculpture, Documents of Twentieth Century Art*
(New York: Viking Press, 1972), 31-32.

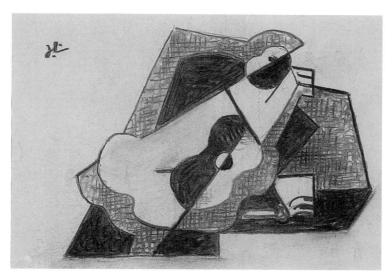

35
Jacques Lipchitz
Still Life (Guitar)
c. 1922
Charcoal on paper
H. 24.1 × 34.3 cm
Initialed upper left

Modernism Gallery, San Francisco

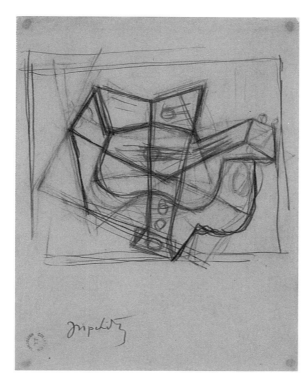

36
Jacques Lipchitz
Etude pour un Bas-Relief
1923
Pencil· on paper
20 × 27 cm

The Estate of Jacques Lipchitz represented by
Marlborough Gallery

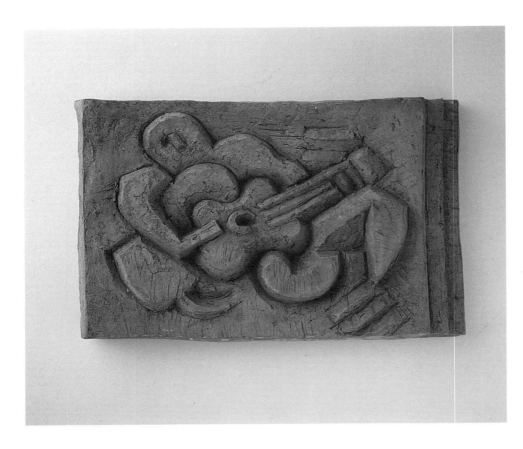

37
Jacques Lipchitz
*Figure with Guitar; Maquette
No. 2*
1923
Plaster
H. 14.6 cm

Krannert Art Museum and
Kinkead Pavilion
University of Illinois
at Urbana-Champaign
Gift of Jacques and Yulla
Lipchitz Foundation

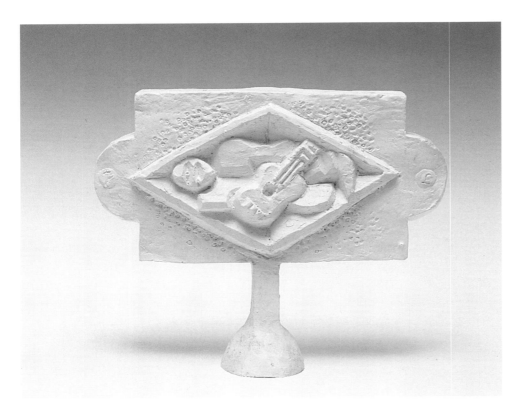

38
Jacques Lipchitz
Reclining Figure with Guitar
1923
Plaster
H. 20.3 cm

Krannert Art Museum and
Kinkead Pavilion
University of Illinois
at Urbana-Champaign
Gift of Jacques and Yulla
Lipchitz Foundation

A COLLECTOR AND A WORKMAN:
LIPCHITZ AND NON-WESTERN ART

From his arrival in Paris in 1909 until the end of his life in 1973, Jacques Lipchitz passionately collected non-Western sculpture and artifacts. His collection included works from many different cultures, with a significant presence of African, Oceanic, and ancient pieces. In his autobiography, *My Life in Sculpture*, Lipchitz explained: "mainly I bought sculpture of all cultures from which I could learn something."[1] The mask from the Toma Peoples of Guinea, which Lipchitz purchased in Paris before 1935,[2] provides evidence of his lifelong interest in African art. In 1910, Lipchitz paid his first visit to the Trocadero Museum in Paris, with its impressive array of artifacts from around the world. His interest in non-Western artwork was part of a larger trend among the avant-garde artists. Indeed, such notable figures as Pablo Picasso, Amedeo Modigliani, Henry Moore, Constantin Brancusi, and members of the German *Die Brücke* and *Der Blaue Reiter* groups were among the artists who explored non-Western art. These artists were particularly interested in investigating the formal elements of non-Western works. African, Oceanic, and ancient works satisfied the artists' impulse to return to "pure" experience unaffected by formal artistic training. Many of these avant-garde artists viewed non-Western and ancient works as authentic because of their distance from the increasingly industrialized society in Europe.[3]

Jacques Lipchitz in New York, c. 1961-66

Lipchitz was well aware of the impact non-Western art had on the cubist vocabulary, yet he resisted acknowledging the relationship between his collection and his art. In a 1945 interview with J. J. Sweeney in *Partisan Review*, Lipchitz stated: "I distinguish in myself two men: a collector and a workman. If the collector likes a work of art that need not influence the workman; nor should the workman's resistance to earlier works of art interfere with the collector's interests."[4] Lipchitz preferred to define his relationship to the pieces in his collection as "encounters" rather than influences. In 1960, the Museum of Primitive Art in New York held an exhibition of Lipchitz's collection. In the introduction to the exhibition catalogue, Lipchitz elaborated on the role his collection played in his creative process. He wrote: "I was not exactly looking for a direct influence or a source of inspiration, but only to enlighten and enrich my creative spirit. And so I found out that not one single attitude, not one single technique is new . . . Every morning, before going to work, I look at all that surrounds me, and feel the whole of humanity with me. I am never alone, never lost, and given, with a sense of humility, the courage for my every day's work."[5]

Whether or not Lipchitz's collection directly influenced his work, his own descriptions of his "encounters" make clear that his collection played a vital role in his career as a "workman" and in his creative process.

SLE and NCR

39
Mask
Toma People, Guinea
Formerly collection of
Jacques Lipchitz
Private Collection,
New York

1. Jacques Lipchitz with H. H. Arnason, *My Life in Sculpture*, *Documents of Twentieth Century Art* (New York: Viking Press, 1972), 41.

2. Virginia-Lee Webb, *Perfect Documents: Walker Evans and African Art, 1935* (New York: Abrams, 2000), 60.

3. Artists, critics, and historians have used the term *primitivism* to describe Eurocentric representations and interpretations of non-Western subjects and artifacts. Originating in mid-nineteenth-century Europe, the term alluded to the presumably less civilized and uncultivated "other" in relation to the culturally advanced West. The term *primitivism* is problematic because it implies a judgment that other cultures are less civilized than their European counterparts. For more on this topic, see Perry Gill, "Primitivism and the 'Modern,'" in Perry Gill et al., eds., *Primitivism, Cubism, Abstraction: The Early Twentieth Century* (New Haven: Yale University Press, 1993), 9–34. Also see the entry on "Primitivism" in *Twentieth-Century Art* (New York: The Museum of Modern Art, 1984) and James Clifford, *The Predicament of Culture: Twentieth-Century Ethnography, Literature and Art* (Cambridge, Mass.: Harvard University Press, 1988).

4. James Johnson Sweeney, "An Interview with Jacques Lipchitz," *Partisan Review*, 12, no.1 (Winter 1945), 85.

5. Jacques Lipchitz, "Introduction," in *Primitive Art from the Lipchitz Collection* (Jacques, Yulla & Lolya) (New York: The Museum of Primitive Art, 1960), 7.

40

Face Mask, used in funerary dance performed by
Junior Grade Blacksmith initiates of the Poro Society

Senufo People, Côte d'Ivoire.

Wood
H. 37 x 21 cm

Anonymous Loan
Krannert Art Museum and Kinkead Pavilion
University of Illinois at Urbana-Champaign

41

Standing Male Ancestor Figure

Fang Peoples, Ugoas Subgroup
N'gaoga, southeast of the Ogowe River, Gabon

Wood, pigments
H. 36.5 cm

Anonymous Loan
May Department Store, St. Louis, Missouri
Krannert Art Museum and Kinkead Pavilion
University of Illinois at Urbana-Champaign

42

Male Figure

Baule People, Côte d' Ivoire

Wood
H. 29.2 cm

Gift of Faletti Family Collection
Krannert Art Museum and Kinkead Pavilion
University of Illinois at Urbana Champaign

TRANSITION FROM CUBISM TO THE TRANSPARENTS

In 1925 Jacques Lipchitz began to keep his experimental drawings. Two of these drawings are included in this exhibition: *Untitled*, a recent donation to the Krannert Art Museum collection, and *Untitled*, from a private collection in New York, previously undated. They are believed to have been completed between 1927 and 1929.[1] These two drawings are undeniably similar in their formal qualities and stylistic tendencies. The triangular shape at the top of both creates a threshold that functions as both a window and a mirror, an ambiguity common in the work of Pablo Picasso. The figure simultaneously passes through the space and is reflected by the mirror, a doubling also evident in the biomorphic compositions of Jean Arp. In the Krannert piece, it is difficult to decipher the figure's attributes. The elliptical form of the figure's face could function as either an eye or a mouth, while the circular elements on the body could be simultaneously read as breasts or eyes. These two drawings complicate Lipchitz's spatial relations in his late cubist period and push his work to a new level.

In the mid to late 1920s, Lipchitz began making sculptures in a distinctly new style, referred to as *transparents*. Constructed from bronze and embodying a style that broke from late cubism, the *transparents* were characteristically playful, imaginative, and engaged in an exploration of light and space. Though they did not sell well at the time, they were very popular with contemporary progressive artists and critics, such as Pablo Picasso, Julio González and Juan Gris.[2] Although Lipchitz always considered himself a sculptor first and foremost, he consistently made drawings both before and after completing a sculptural work. In his autobiography, he explained: "all my drawings are related to my sculpture. I never make drawings as independent works of art."[3] These drawings allowed Lipchitz to work out new ideas pictorially and to experiment with variations on previous sculptures. Significantly, there is no recorded evidence of a sculpture derived from the two drawings mentioned above. "I characteristically make many sketches, put them up on the wall, and keep studying them . . . But I still find that if I push a drawing too far, make it too finished, I cannot make a sculpture from it because everything is solved and I do not need to make the sculpture."[4]

Multiple artistic movements coexisted throughout the Parisian avant-garde milieu in the mid to late 1920s, such as late cubism, surrealism, and purism. Jeanne Bucher, known for exhibiting works by late cubist and surrealist artists, was Lipchitz's art dealer in Paris from 1926 to 1941. Due to Bucher's frequent exhibitions, Lipchitz had considerable exposure to both movements. Although Lipchitz clearly felt akin to Picasso and other cubists, he denied any relation to the surrealists. Interestingly, Lipchitz was celebrated in both the illustrated magazine *Minotaure*, the orthodox surrealist publication favored by André Breton, and *Documents*, a dissident journal most closely associated with Breton's nemesis, George Bataille. The writers in these Parisian magazines expressed the opposing ends of the surrealist discourse, yet both admired Lipchitz's work, declaring his sculptures "free of the air of the world"[5] and symbolic of the "struggle of life."[6]

A significant influence upon Lipchitz at this time was the architect, Le Corbusier. In 1926, Lipchitz and his wife, Berthe, moved into an innovatively designed house by Le Corbusier at Boulogne-sur-Seine. It may be assumed that living and working in

Le Corbusier
Boulougne-sur-Seine: villas
Lipchitz and Miestchaninoff,
1923

the space created by Le Corbusier had a significant influence upon Lipchitz's sculptural style and evolving sense of space.[7] Lipchitz's *transparents* are transitional works that are distinctly his own creation; they move beyond the realm of late cubism and share stylistic tendencies with Le Corbusier and his experiments with space in architecture.

Lipchitz's two *Untitled* drawings are closely related to his controversial sculpture from 1928–29, *The Cry*, originally entitled *The Couple. The Cry/Couple* is an example of Lipchitz's advanced transparent sculptures. Lipchitz experimented with optical ambiguities in this work, which doubles as a dramatic crying figure and an embracing couple. Lipchitz constructed a metamorphosis where violent and erotic subject matter were represented in the same work. These innovative *transparents*, taking form in experimental drawings and sculptures, were a significant contribution to the evolution of modern art. In his introduction to Lipchitz's autobiography, H. H. Arnason summarizes their importance:

> During the mid-1920s the artist experimented with a revolutionary series of linear sketches, almost drawings in bronze, to which he gave the name of "transparents." These were some of the first completely open constructions in the history of modern sculpture, pieces in which solids and voids were reversed—open space defined the forms outlined in linear bronze drawing. The transparents were a beautiful revelation to the artist, a new concept of sculpture that helped to clarify his subsequent ideas on its very nature.[8]

NCR

1. In 1925 a framer told Lipchitz that his drawings were master drawings worthy of collecting, before then, he burned the drawings after completing his related sculptural works. Jacques Lipchitz with H. H. Arnason, *My Life in Sculpture*, *Documents of Twentieth Century Art* (New York: Viking Press, 1972), 32.

2. Ibid., 32.

3. Ibid., 31.

4. Ibid., 32.

5. Jacques Baron, "Jacques Lipchitz," *Documents*, no. 7 (1929): 17–22.

6. Maurice Raynal, "Dieu—Table—Cuvette," *Minotaure*, no. 3–4 (1930): 39–41.

7. A. M. Hammacher, "Jacques Lipchitz, 1891–1973: A Concise Survey of His Life and Work," in Alan G. Wilkinson, ed., *The Sculpture of Jacques Lipchitz: A Catalogue Raisonné* (New York: Thames and Hudson, 1996), 16.

8. Lipchitz, *My Life in Sculpture*, xxxii.

43

Jacques Lipchitz

Untitled

Circa 1927-1929

Colored chalk on paper

29.8 x 40.6 cm

Private Collection, New York

44

Jacques Lipchitz

Untitled

Circa 1927-1929

Charcoal on paper

44.5 x 60.3 cm

Krannert Art Museum and Kinkead Pavilion
University of Illinois at Urbana-Champaign
Gift of Jacques and Yulla Lipchitz Foundation

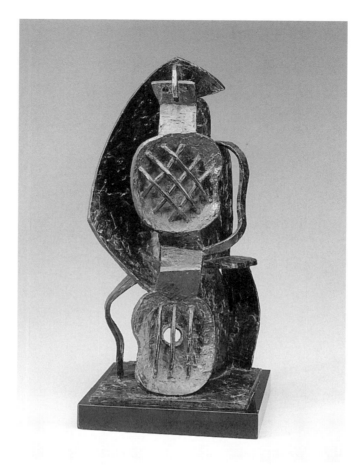

45

Jacques Lipchitz

Harlequin with Guitar

1926
Bronze (unique)
H. 33.7 cm

Indiana University Art Museum,
Bloomington, Indiana

Wilkinson, 1996 No.189

Gift of
Dr. and Mrs. Henry R. Hope

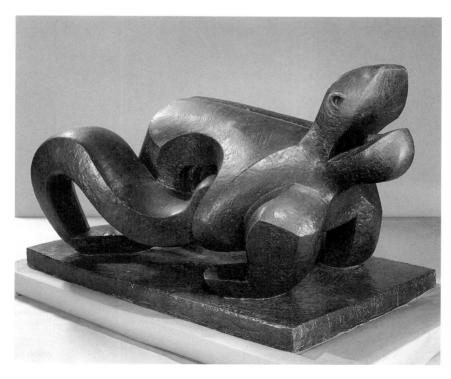

46

Jacques Lipchitz

The Cry
(*The Couple*)

1928-29
Bronze
92.1 x 161 x 95 cm

The Estate of Jacques Lipchitz
represented by Marlborough
Gallery

Wilkinson, 1996 No.223

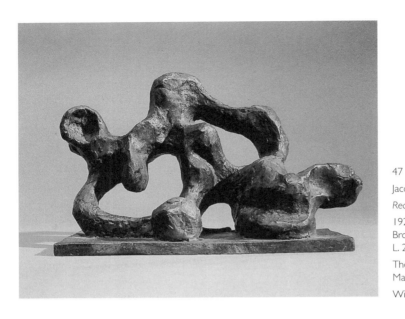

47
Jacques Lipchitz
Reclining Figure
1929
Bronze
L. 22.9 cm
The Estate of Jacques Lipchitz represented by
Marlborough Gallery
Wilkinson, 1996 No.226

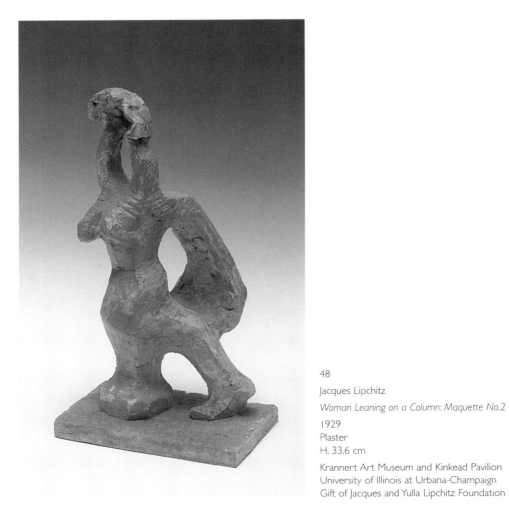

48
Jacques Lipchitz
Woman Leaning on a Column: Maquette No.2
1929
Plaster
H. 33.6 cm
Krannert Art Museum and Kinkead Pavilion
University of Illinois at Urbana-Champaign
Gift of Jacques and Yulla Lipchitz Foundation

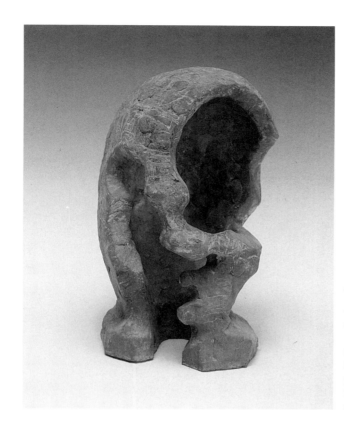

49
Jacques Lipchitz
Head: Maquette No. 2
1932
Plaster
H. 22.8 cm

Krannert Art Museum and Kinkead Pavilion
University of Illinois at Urbana-Champaign
Gift of Jacques and Yulla Lipchitz Foundation

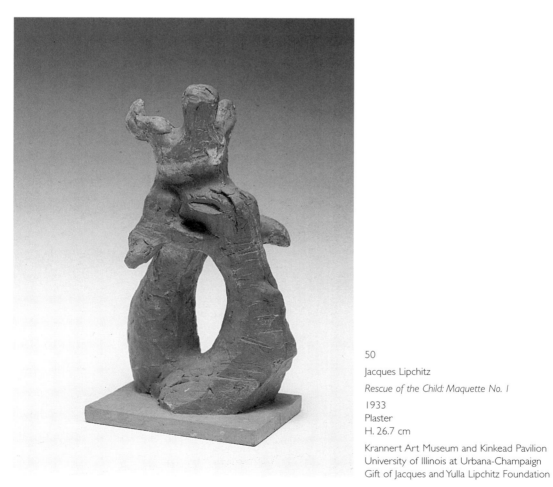

50
Jacques Lipchitz
Rescue of the Child: Maquette No. 1
1933
Plaster
H. 26.7 cm

Krannert Art Museum and Kinkead Pavilion
University of Illinois at Urbana-Champaign
Gift of Jacques and Yulla Lipchitz Foundation

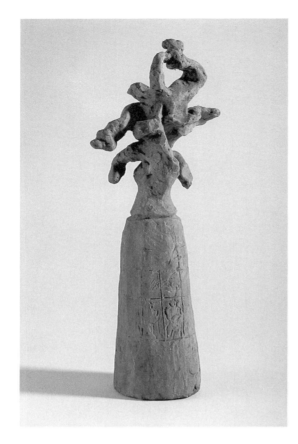

51
Jacques Lipchitz
Study for a Monument, 1934
Plaster
H. 34.3 cm

Krannert Art Museum and Kinkead Pavilion
University of Illinois at Urbana-Champaign
Gift of Jacques and Yulla Lipchitz Foundation

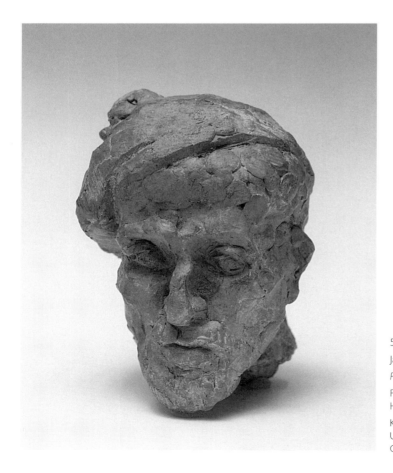

52
Jacques Lipchitz
Portrait of Gericault, 1933
Plaster
H. 13.3 cm

Krannert Art Museum and Kinkead Pavilion
University of Illinois at Urbana-Champaign
Gift of Jacques and Yulla Lipchitz Foundation

MYTHOLOGICAL THEMES

Classical myths were an important source of subject matter for Jacques Lipchitz from the late 1920s through the rest of his career. Lipchitz explored numerous classical mythological themes, repeatedly returning to the narratives of Prometheus, Pegasus and Bellerophon, and the Rape of Europa. For Lipchitz these mythical themes often expressed a struggle between light and dark, resulting in thematic dichotomies. The different sides of these struggles would then symbolize opposing values.

In 1937, Lipchitz constructed *Prometheus Strangling the Vulture* for the Paris World's Fair (see page 11). Prometheus symbolized light and science, while the vulture stood for darkness and ignorance. In the myth, the gods punish Prometheus, the Titan who brought fire to mankind, by chaining him to a rock while a vulture tears eternally at his liver. Lipchitz transforms the myth, however, by representing Prometheus unchained and strangling the vulture. Rather than a mere victim of the vulture and the gods, Prometheus becomes instead an active participant in an ongoing struggle. As Lipchitz explains, "It was conceived as a struggle, not a simple conquest, in which light, education, [and] science were struggling against darkness and ignorance which had not yet been conquered."[1]

Pegasus, another reoccurring thematic icon, is illustrated with Bellerophon in various preliminary prints that culminated in a monumental sculpture for Columbia Law School in 1969. Lipchitz first dealt with the subject of Pegasus in a relief designed for the Rockefeller guesthouse in 1950, focusing on Pegasus's role in the Birth of the Muses. In revisiting the subject matter in the late 1960s, he reinterpreted the myth, relating it to the struggle between man and nature, law and disorder.

> Bellerophon is a symbol of man dominating nature. In the myth, Bellerophon was a human being who fell in love with the daughter of Zeus. When he asked for her hand, Zeus was not happy about it and gave him terrible deeds to do, hoping that he would perish, but Bellerophon, an intelligent man, tamed Pegasus, the winged horse who represents the wild forces of nature, and with the help of Pegasus he was able to accomplish all the tasks that were required of him.[2]

Once again, Lipchitz applies a thematic dichotomy in which Pegasus symbolizes disorder and Bellerophon exemplifies reason, justice, and law.

Three different variations on the *Rape of Europa*, from 1938, 1941, and 1971, provide further examples of Lipchitz's tendency to rework the meaning assigned to mythological subjects. Lipchitz describes *Rape of Europa* (1938), as sensual and even

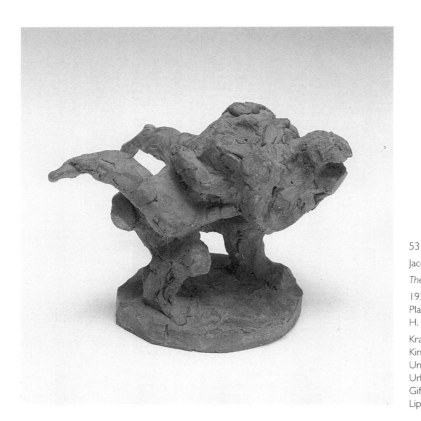

53
Jacques Lipchitz
The Rape
1933
Plaster
H. 12.7 cm

Krannert Art Museum and
Kinkead Pavilion
University of Illinois at
Urbana-Champaign
Gift of Jacques and Yulla
Lipchitz Foundation

tender. In the classical myth, Zeus, who is disguised as a bull, captures the nymph Europa and swims away with her to Crete. In 1941, however, Lipchitz radically transforms the meaning of the myth, identifying Hitler and fascism with the bull, while Europa rises up with a dagger to kill the bull. Lipchitz was well aware of these shifts in meaning:

> The general forms of the bull and Europa probably derive from the earlier bull and condor, although, as is so frequently the case with my sculpture, the conflict and terror of this earlier version is here transformed into erotic love. I used the theme of Rape of Europa later in quite a different context, the Europa as a symbol for Europe and the bull as Hitler, with Europe killing Hitler with a dagger. This reverses the concept to one of terror, whereas in the original sculptures of Europa the entire theme is tender and erotic love; the bull is caressing Europa with his tongue.[3]

These three examples do not represent the full extent of Lipchitz's mythological works, but they are characteristic of his philosophical belief in universal values. Furthermore they elaborate on the evolution and trajectory of his formal, stylistic tendencies.

SLE and NCR

1. Jacques Lipchitz with H. H. Arnason, *My Life in Sculpture, Documents of Twentieth Century Art* (New York: Viking Press, 1972), 139.

2. Ibid., 214, 217.

3. Ibid., 140.

54
Jacques Lipchitz
Pastorale
1933
Gouache
61.0 × 45.4 cm
The Estate of Jacques Lipchitz represented
by Marlborough Gallery

55
Jacques Lipchitz
Study for Sculpture
1938
Charcoal
63 × 48.1 cm
The Estate of Jacques Lipchitz represented
by Marlborough Gallery

56

Jacques Lipchitz

Theseus & Minotaur

c. 1942

Brush India Ink and pencil on paper

31 cm x 23.5

Private Collection

57

Jacques Lipchitz

Rape of Europa II

1938
Bronze
H. 61 cm

The David and Alfred Smart Museum of Art
University of Chicago
The Joel Starrels, Jr. Memorial Collection

Wilkinson, 1996 No. 343

THE MINOTAUR ICONOGRAPHY

Classical mythological themes have provided rich symbolism for expressing personal experiences and responding to the sociopolitical climate. Many twentieth-century European artists, such as Pablo Picasso, Jacques Lipchitz, Paul Klee, Max Ernst, André Masson, Giorgio de Chirico, to name a few, turned to mythological themes to cope with such events as the Spanish Civil War, the rise of fascism, and World War II.

Lipchitz and Picasso met through Diego Rivera in Paris in 1913. They soon became friends, and their mutual influence, both formal and thematic, is apparent in their works. Mythical themes, particularly the bull and the Minotaur, frequently appear in the works of Lipchitz and Picasso, especially by the 1930s and 1940s.

In employing the iconography of the bull and the Minotaur, neither Lipchitz nor Picasso was interested in the narrative content of the myths of the Rape of Europa or of the Minotaur per se. They used the vocabulary of myth because of its universal currency to express desires and experiences in veiled symbolic terms. Lipchitz and Picasso reinvented these classical myths, embedding them in lived experience and employing their symbols through visual bricolage, piecing together the different narratives to suit their own personal or political expressive needs.

According to the myth of the Minotaur, Poseidon gave Minos a bull to sacrifice. Instead of sacrificing the bull, Minos kept it for himself, and, in retaliation, Poseidon made Paisiphae, Minos's wife, fall madly in love with the bull. Their offspring was the half-man, half-bull Minotaur. Rather than killing the monster, Minos employed Daedalus to build a confinement from which it was impossible to escape. The Minotaur was imprisoned in this labyrinth. Every nine years, seven maidens and seven youths from Athens were sacrificed to the Minotaur. Theseus, son of the king of Athens, was able to slay the Minotaur and escape the labyrinth with the help of Daedalus and of Ariadne, Minos's daughter.

Picasso often used bull imagery and was interested in depicting scenes from the Spanish bullfights. This early imagery is straightforward. The bull stands as a symbol of strength and virility. In the late 1920s, however, his bull imagery changes formally and symbolically into that of the Minotaur. Picasso's use of the Minotaur is generally personal and ambivalent. The Minotaur is a humanized figure both brutish and sensual. He is the result of unnatural passion, a violation of norms. The Minotaur is both a violent being and a victim. In *Minotauromachy* (1935), this ambivalence is especially clear; Picasso combines the Rape of Europa, the bullfight, and the Minotaur myth. In this instance, the monster is not violent but protects himself against the light from the young girl's candle, perhaps a metaphor for the conflict between light and dark, good and evil. The horse baring the Europa-like Torera is also present in *Minotauromachy*. Picasso returns to the image of the bull and the horse in his highly politicized *Guernica*, which was exhibited along with Lipchitz's *Prometheus* at the 1937 Paris World's Fair.

Lipchitz chose to depict the myths of both the Rape of Europa and Theseus and his use of the Minotaur is similar to Picasso's. The 1938 versions of the *Rape of Europa* have personal and romantic significance for Lipchitz, and they are much less violent than later versions. Between 1938 and 1941, Lipchitz's treatment of the myth

58
Pablo Picasso
"*Mort d'Orphée*" from "*Les Métamorphoses d'Ovide*"
1930
Etching on Japan paper
31.1 × 22.2 cm
St. Louis Art Museum
The Sidney S. and Sadie Cohen Print Fund

became overtly political, and he altered the iconography from that of the bull to the Minotaur. The 1941 version of the *Rape of Europa*, executed the same year he left Europe for the United States, is his most intensely political statement. In it, Europa not only resists the Minotaur, the symbol of the evil of fascism, but she turns to stab her abductor. Lipchitz explained that "Europa is fighting against her rapist (Hitler) and trying to kill him. There are a number of drawings of this, very intense in feeling, almost like prayer, in which Europa is overcoming the monster . . . Europa has become specifically modern Europe threatened by the powers of evil and fighting for her life against them."[1]

Lipchitz continued his political statement in his *Theseus and the Minotaur* (1942). In this work, Lipchitz's symbolism engaged another level of meaning. The bodies of Theseus and the Minotaur seem to meld, suggesting that the evil Theseus/Europe must overcome is both internal and external. Lipchitz executed a study of this sculpture about which he wrote: "The Minotaur is Hitler and I was thinking about de Gaulle as Theseus. . . . When I made a sculpture like 'Theseus' or the second version of the 'Rape of Europa,' I was in a sense making a magical image, like a witch doctor who makes the image of an enemy whom he wishes to destroy. . . . Through my sculpture I was killing Hitler."[2] In Lipchitz's 1943 and 1944 versions of the myth, the Minotaur resists more actively, reflecting the struggle on both sides during the war. Lipchitz did not return to the Theseus theme after the war.

The myth of the Minotaur provided both Lipchitz and Picasso with an expressive symbolism that allowed them to cope with and protest against the political turmoil within Europe.

SKS

1. Cited in Ziva Amishai-Maisels, *Depiction and Interpretation: The Influence of the Holocaust on the Visual Arts* (Oxford: Pergamon Press, 1993), 200.

2. Jacques Lipchitz with H. H. Arnason, *My Life in Sculpture, Documents of Twentieth Century Art* (New York: Viking Press, 1972), 159.

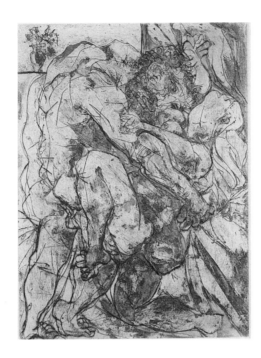

59
Pablo Picasso
Rape Beneath the Window
1933
Aquatint, etching and drypoint
27.8 x 19.8 cm
Private Collection, Urbana

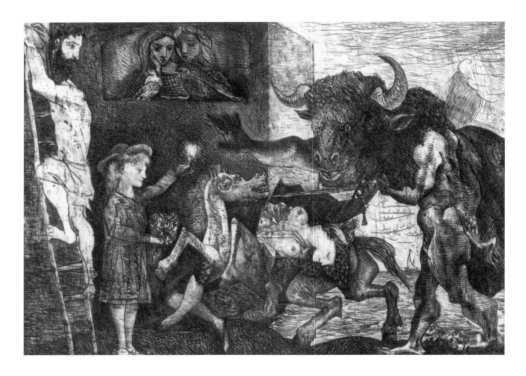

60
Pablo Picasso
The Minotauromachy
1935
Etching
57.15 x 77.15 cm
St. Louis Art Museum
Bequest of Horace M. Swope

61
Jacques Lipchitz
Study for Pegasus and Bellerophon

c. 1963 - 1973
Lithograph
63.5 x 45.7 cm

Krannert Art Museum and
Kinkead Pavilion
University of Illinois
at Urbana-Champaign
Gift of Jacques and Yulla
Lipchitz Foundation

62
Jacques Lipchitz
Study for Pegasus and Bellerophon

c. 1963 - 1973
Lithograph
76.2 x 56.5 cm

Krannert Art Museum and
Kinkead Pavilion
University of Illinois
at Urbana-Champaign
Gift of Jacques and Yulla
Lipchitz Foundation

THE U.S. YEARS

In 1940 Lipchitz and his wife, Berthe Kitrosser, were forced to flee Paris as Hitler's troops occupied the city. They found refuge first in Toulouse and then in New York. Lipchitz describes his escape:

> We left Paris in May of 1940 with the German invasion of France. Friends of mine, the Chareaus, came one evening and said that Hitler was coming and they would not leave Paris without us. They left their car for us; they were marvelous, they saved me at the moment when Hitler was at the outskirts of Paris, because I was terrified and so paralyzed I could not make a move. I had been to a friend, a doctor, and had obtained some poison from him, because I felt that I would rather die than fall into Hitler's hands. My wife was so courageous. We went first to some friends in Vichy, taking nothing with us. A few days later, Paris was occupied and my brother joined us with his fiancée. . . . Finally we found ourselves in the free zone of France and I decided to stay in Toulouse, where I could work. . . . Through the assistance of the Museum of Modern Art in New York I was later able to get to the United States.[1]

In New York, Lipchitz found himself among many other exiles and émigrés including those pictured with him in the 1942 photograph taken for the *Artists in Exile* exhibition at the Pierre Matisse Gallery (see page 56). Although surrounded by other exiles, Lipchitz never found in New York the kind of artistic community he had valued so much in Paris. Nevertheless, Lipchitz described the move to America at the age of fifty as a liberating chance to begin again. "It was like starting my life all over again. Despite my concern, curiously enough I also felt a certain exhilaration; I felt young and strong, as though I were just beginning my career once more."[2]

In America Lipchitz's work became increasingly monumental in size, especially with the commisioned works that he created to narrate mythological and biblical themes, such as *Prometheus Strangling the Vulture*, *Notre Dame de Liesse*, *Bellerophon Taming Pegasus*, and his last work, *Our Tree of Life*. Yet Lipchitz carried out some of his most experimental work on a smaller scale. During his first years in New York, he nostalgically returned to some of his earlier works; he revisited the *transparents* in creating *Myrrah*, which was part of a series entitled *Twelve Transparents* and shown at the Buchholz Gallery in 1943.

Following a fire in his studio in 1952, Lipchitz began a series of sculptures that he made quickly, one a day, using a chisel as his starting point. Alan G. Wilkinson, in his book, *Jacques Lipchitz: A Life in Sculpture*, attributes a new found spontaneity to this series, *Variations on a Chisel* (1951–52).[3] These quick sculptures were the predecessors to his *semiautomatics*. In the mid-1950s he created a series titled *32 Semiautomatics*, of which *Gypsy Dancer* is an example. Lipchitz described the first

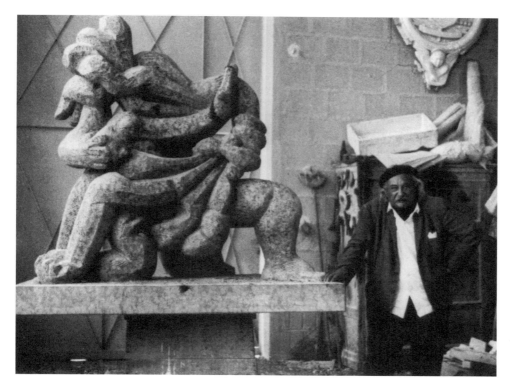

Jacques Lipchitz with *Hagar*
1971
Stone (unique)
H. 182.9 cm

part of this technique as "automatic" because he suppressed any conscious decisions about the piece. To begin the sculpture, he put warm wax in water, shaping it blindly with his fingers and then allowing it to harden in colder water. He then looked at the figure and decided what form it suggested. Only at this second stage did he consciously work with the sculpture. *The Beautiful One* (1962) was part of another series, *Images of Italy*, which Lipchitz also considered *semiautomatic*. In contrast to the *semiautomatics* of the 1950s, however, with this series Lipchitz had a more deliberate idea of what form he wanted each piece to take before he began working.[4]

Until his death in 1973 on the island of Capri, Lipchitz blended new opportunities with the ideas he developed in both Europe and America. The move to America invigorated Lipchitz with a new freedom to explore more experimental work and provided him with the confidence to create on a larger scale, but his work from this later period is still conceptually connected to his earlier work and he continued to return to themes and techniques he had developed in the past.

SLE

1. Jacques Lipchitz, *My Life in Sculpture*, *Documents of Twentieth Century Art* (New York: Viking Press, 1972), 140–43.

2. Ibid., 144.

3. Alan G. Wilkinson, *Jacques Lipchitz: A Life in Sculpture*, exhibition catalogue (Toronto: Art Gallery of Ontario, 1989), 142.

4. Lipchitz, *My Life in Sculpture*, 209.

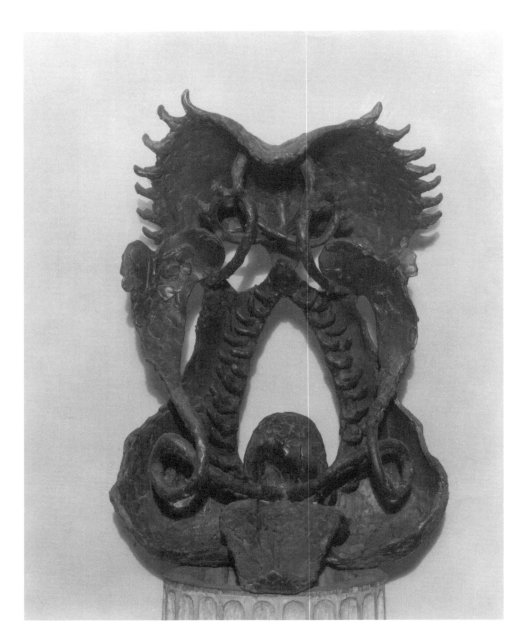

63
Jacques Lipchitz
Myrrah
1942
Bronze (unique)
57.9 cm
The Estate of Jacques Lipchitz
represented by Marlborough
Gallery
Wilkinson, 2000 No.369

64
Jacques Lipchitz
Untitled II
Circa 1947-48
Mixed media on paper
15.2 x 12.1 cm
The Estate of Jacques Lipchitz represented by
Marlborough Gallery

65
Jacques Lipchitz
Untitled VIII
Circa 1947-48
Mixed media on paper
15.2 x 12.1 cm
The Estate of Jacques Lipchitz represented by
Marlborough Gallery

66

Jacques Lipchitz

Gypsy Dancer

1955-56
Bronze (unique)
H. 28.6 cm

The Estate of Jacques Lipchitz
represented by
Marlborough Gallery

Wilkinson, 2000 No.514

67

Jacques Lipchitz

The Beautiful One

1962
Bronze (unique)
H. 31.7 cm

The Estate of Jacques Lipchitz
represented by
Marlborough Gallery

Wilkinson, 2000 No.586

68

Jacques Lipchitz

Sketch for the Monument for Duluth

1963

Plaster

H. 58.4 cm

Krannert Art Museum and Kinkead Pavilion
University of Illinois at Urbana-Champaign
Gift of Jacques and Yulla Lipchitz Foundation

69

Jacques Lipchitz

Sketch for John F. Kennedy

1964

Plaster

H. 46.3 cm

Krannert Art Museum and Kinkead Pavilion
University of Illinois at Urbana-Champaign
Gift of Jacques and Yulla Lipchitz Foundation

The Kennedy monument on which I worked in 1964 was a related but some-
what different problem. First of all a student organization in London asked me
to make a sculpture of Kennedy after his death and, since I had great admira-
tion for the President, I made it, even though it was a posthumous bust. Then
I was asked to make a larger version for Newark, New Jersey. I had never seen
the President, but I had a model who was supposed to look very much
like him and Pierre Salinger sent me photographs. Members of the Kennedy
family came and made suggestions about my sculpture. Nevertheless, I was
never satisfied with it and I will never do such a posthumous sculpture again.

Jacques Lipchitz, *My Life in Sculpture, Documents of Twentieth Century Art* (New York: Viking Press, 1972), 213.

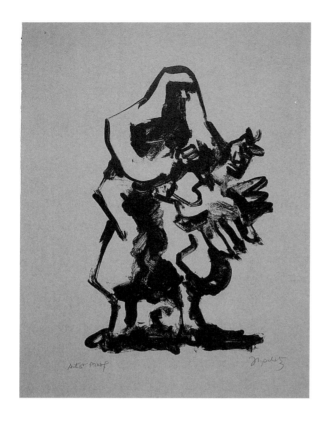

70

Jacques Lipchitz

Sketch for Sacrifice

c. 1963-1973
Lithograph

Krannert Art Museum and Kinkead Pavilion
University of Illinois at Urbana-Champaign
Gift of Jacques and Yulla Lipchitz Foundation

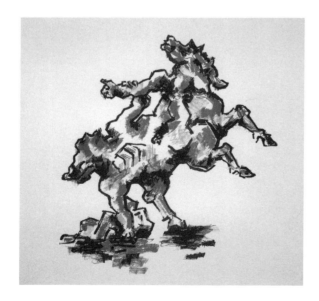

71

Jacques Lipchitz

*Sketch for Variation on the theme of
the Rape of Europa*

c. 1963-1973
Lithograph

Krannert Art Museum and Kinkead Pavilion
University of Illinois at Urbana-Champaign
Gift of Jacques and Yulla Lipchitz Foundation

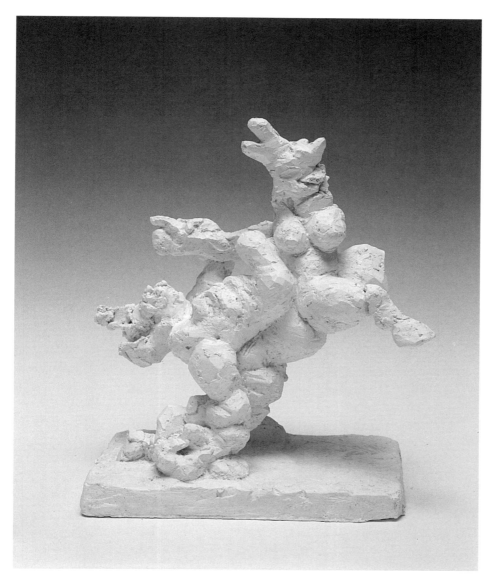

72

Jacques Lipchitz

Variation on the theme of the Rape of Europa

1969
Plaster
H. 24.8 cm

Krannert Art Museum and Kinkead Pavilion
University of Illinois at Urbana-Champaign
Gift of Jacques and Yulla Lipchitz Foundation

THE FUNCTION OF THE MAQUETTES

While studying at the academy, a young Jacques Lipchitz began making preliminary clay "sketches" in three dimensions to serve as studies for large sculptures. He continued this practice throughout his career. Using this method, Lipchitz could quickly record (and alter) ideas for his larger works. Because of their fragility, many of these rough sketches have not survived. Later in his career, however, Lipchitz began to cast these sketches in terra-cotta or bronze to ensure their permanency. Lipchitz described the function of his maquettes in *My Life in Sculpture*:

> Here I would like to say something further about my habit of working from small sculpture sketches. Sketches of this type, known as maquettes or in Italian as *bozzetti*, are as old as the history of sculpture, and in the traditional training of the academy I learned to work in this manner. As I have said, I believe it is the best way for a sculptor to work, even better than making preliminary drawings, because he can fix his idea quickly in the clay and then change it easily. In effect, the idea grows under his fingers in three dimensions as the final sculpture will appear. I made many such clay sketches when I was a student, but almost all of these have disappeared or were destroyed, since I had no means of fixing them in a durable material. In fact, in those days, I thought of them only as preliminary ideas and did not realize their importance to me. More of these maquettes were broken up in 1915, when during an emotional crisis I destroyed many early works. Then, many others disappeared from my Paris studio after I left France or were destroyed in the terrible fire in my New York studio in 1952. However, I still have more than one hundred and fifty of these preliminary sketches, which I have made permanent in terra cotta and bronze, and I would like to refer to them from time to time as I am discussing the development of my sculpture. . . . In the surviving maquettes it is possible to see the first ideas for many of my completed sculptures, very quickly and roughly sketched out. There are also sketches of ideas that I made and then did not develop until years later, sometimes in a radically different form.[1]

AMK

1. Jacques Lipchitz with H.H. Arnason. *My Life in Sculpture, Documents of Twentieth Century Art.* (New York: Viking Press, 1972), 23-24

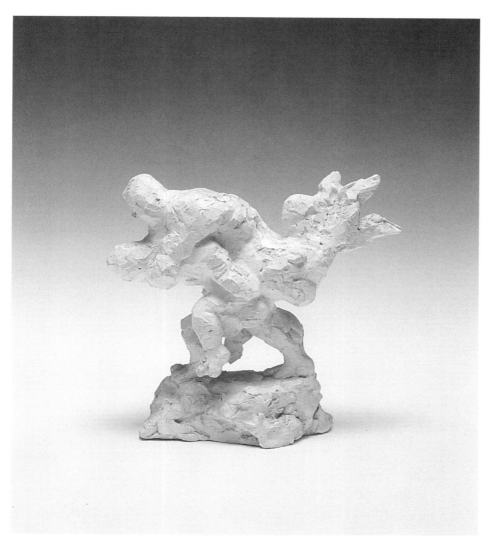

73

Jacques Lipchitz

Variation on the theme of the Last Embrace

1970-72
Plaster
H. 18.4 cm

Krannert Art Museum and Kinkead Pavilion
University of Illinois at Urbana-Champaign
Gift of Jacques and Yulla Lipchitz Foundation

LIPCHITZ AND HIS DEALERS

Léonce Rosenberg

The majority of Jacques Lipchitz's early cubist work was constructed with the support of Parisian art dealer Léonce Rosenberg (1877–1947). Lipchitz signed a contract with Rosenberg on May 5, 1916, and was exclusively represented by him until 1920.[1] Rosenberg's gallery exhibited the work of other cubist artists such as Pablo Picasso, Georges Braque, Juan Gris, and Diego Rivera. It was at Rosenberg's gallery that Lipchitz met Juan Gris, who would become a friend and important influence. Between 1916 and 1920, Rosenberg included Lipchitz in several group exhibitions with the other cubist artists. Lipchitz's most prominent exposure during his contract with Rosenberg was his one-man show in 1920.

Pablo Picasso
Portrait of Léonce Rosenberg
1915
Lead pencil on paper
46 x 33.5 cm
Private Collection

Rosenberg admired cubism for its conceptual content more than its physical form. He felt that cubism was progressively modern, referring to a new social dynamism influenced by the machine.[2] In 1916, Rosenberg unofficially declared Picasso the leader of the cubist group. By 1918, however, Picasso felt great hostility toward the dealer due to his insistence on rigid artistic formulas and his inability to sell the works he bought.[3] Rosenberg had acquired his contracts from Daniel-Henry Kahnweiler, the first dealer interested in cubism, who left Paris during the war due to his German citizenship. In the postwar period, Kahnweiler and Rosenberg were professional rivals and provoked conflict among their artists. Both Kahnweiler and Rosenberg only handled art that they bought from artists tied to them by contract. In 1920, Kahnweiler persuaded Braque and Gris to abandon Rosenberg's gallery for his Galerie Simon. Soon after the war, most of the cubist artists, excluding Lipchitz, left both Kahnweiler and Léonce Rosenberg for Léonce's brother, Paul Rosenberg, who was a dedicated supporter and successful businessman.[4]

One positive aspect of Lipchitz's relationship with Rosenberg was the financial security Lipchitz enjoyed under his contract, which enabled Lipchitz to employ a stone carver as an assistant. Lipchitz first made his sculptures in clay and later converted them into stone. Because the contract bound Lipchitz solely to Rosenberg, he gave everything he produced to the dealer. By 1919, Lipchitz was interested in experimenting with new ideas in sculpture, but Rosenberg insisted he continue his cubist work, as it was the most lucrative. As Irene Patai explains, "Rosenberg could not refrain from injecting his own theories into a discussion of Lipchitz' work and was constantly harking back to his period of extreme abstraction."[5] Lipchitz's reputation had developed as a cubist, and Rosenberg did not want his buyers to loose interest. In 1920, Rosenberg organized Lipchitz's first one-man exhibition. Some of Lipchitz's strongest cubist pieces were shown in this exhibition, including *Seated Figure* (1915) and *Pierrot with Clarinet* (1919). Maurice Raynal wrote an important essay on Lipchitz's work for the catalogue.

Lipchitz's desire to experiment further with his art contributed to the demise of his relationship with Rosenberg. When they mutually agreed to part in 1920, Rosenberg enforced the terms of Lipchitz's contract, and the artist had to buy back many of his own works, despite his difficult financial situation. From 1920 to 1922, Lipchitz's career was unstable due to his break with Rosenberg. To support him-

self, he turned to classical portraiture.[6] By 1922, Dr. Albert Barnes, an American collector, had begun supporting Lipchitz by buying and commissioning works.[7] In the same year, Lipchitz received a major commission from Barnes to create stone reliefs for his art gallery outside Philadelphia.[8] The artist continued to accept a variety of commissions from Barnes until Jeanne Bucher began representing his work in 1926.

Jeanne Bucher

Jeanne Bucher (1872–1946) began her career as an art dealer in 1925 with an exhibition of work by Juan Gris, André Masson, and Georges Braque. More open-minded in her artistic tastes than Léonce Rosenberg, Bucher represented Lipchitz from 1926 to 1941, showing his work at her Galerie de la Renaissance.[9] An eclectic dealer, Bucher maintained an older collection of purist work by Fernand Léger and cubist work by Juan Gris and Pablo Picasso. She also supported artists like Piet Mondrian and Lipchitz who moved away from cubist principles.[10] Along with her promotion of post-cubist departures in painting and sculpture, Bucher also dealt in surrealist art and exhibited such artists as Giorgio de Chirico, Marc Chagall, Max Ernst, Wassily Kandinsky, and Paul Klee.

Bucher was a great friend and supporter of Lipchitz in Paris, and her support continued after he moved to America. While simultaneously maintaining his independence and his contacts with other galleries, Lipchitz exhibited his early *transparents* at Bucher's gallery. His *transparents*, created between 1925–30, radically changed the structure of his work. From solid, simplified forms, Lipchitz shifted to open, lyrical structures that incorporate space as a defining element; from cubist abstraction, he turned to the more naturalistic modes of expression, moving from straight lines to curvilinear figures. Because Bucher also handled surrealist artists, Lipchitz's work was often linked to theirs, which he disliked. The only surrealist that attracted Lipchitz's attention was Max Ernst.[11]

Bucher held multiple exhibitions of Lipchitz's work. She organized a group exhibition of Lipchitz with Marcel Gromaire, Jean Lurçat, Jules Pascin, and Louis Marcoussis in May and June 1925. In March and April 1927, Bucher showed Lipchitz's sculptures together with Picasso's paintings at her gallery. Lipchitz also participated in a group exhibition with such artists as Braque, Klee, Gris, and de Chirico in April–May of 1929. In January 1930, Lipchitz's sculptures were displayed with the works of ten painters from her gallery. The largest exhibition of Lipchitz's work took place in 1930 when Bucher organized a retrospective of 100 of Lipchitz's works at the Galerie de la Renaissance. Little was sold from this exhibition. The artist attributed his lack of sales to the economic depression and discrimination. He felt that foreign artists were not well received in Paris at this time.[12] The exhibited works at this particular show included *The Couple* (1928–29) and *Mother and Child* (1930). In 1934, Lipchitz met Alfred Barr at Bucher's gallery. Later that year, Barr purchased Lipchitz's *Figure* (1930) for the Museum of Modern Art. Bucher also introduced Lipchitz to Joseph Brummer, an American collector, who held a one-man show for Lipchitz in America in 1935.

During the difficult period of the 1930s and 1940s, Bucher provided important moral as well as financial support for Lipchitz. At the beginning of World War II, Lipchitz received negative press about his artwork and was the target of racist com-

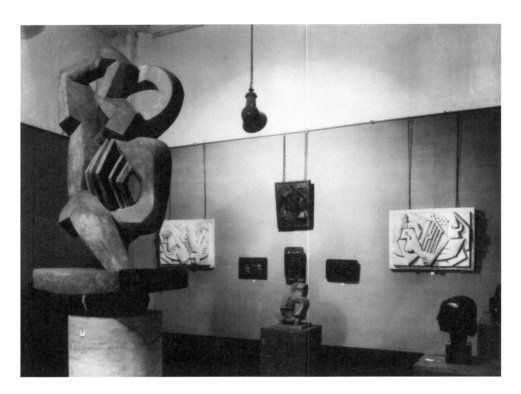

Jacques Lipchitz's first large retrospective exhibition held at Jeanne Bucher's *Galerie de la Renaissance*, Paris, 1930.

mentary. Bucher successfully organized his flight from Paris to Toulouse in 1940. With the help of the American Emergency Rescue Committee, Lipchitz immigrated to America in the summer of 1941. To protect Lipchitz's sculptures from being seized, Bucher buried many of them. Later, she sold them and sent the earnings to Lipchitz in New York.[13]

Curt Valentin

German art dealer Curt Valentin (1902–54) emigrated from Berlin to New York in 1936 and established his gallery on West 46th Street in 1937 as a casual forum for writers, museum directors, artists, collectors, and teachers. Originally titled the Buchholz Gallery after a Berlin company, he renamed it the Curt Valentin Gallery in 1951. In the 1930s, few American dealers were interested in modern sculpture; Valentin became the most important of this small group.[14] Numerous European artists gained recognition in America by exhibiting their work with Valentin. He was particularly important in introducing German art to an American public accustomed to French art. His gallery exhibited prints, drawings, paintings, and sculptures of many different styles and included such artists as Ernst Barlach, Honoré Daumier, Auguste Rodin, Henry Moore, and Amedeo Modigliani. Lipchitz was introduced to Curt Valentin in 1941. Captivated by Lipchitz's sculptures and drawings, Valentin became his art dealer the same year.

Lipchitz constructed *Flight* (1940) and *Arrival* (1941) as sculptural reflections on his experience of exile. These two sculptures were included in the solo exhibition

Valentin organized for Lipchitz at the Buchholz Gallery in January and February 1942.[15] Much of Lipchitz's work at this time incorporated tragic biblical or mythological themes as a reflection on the oppression he experienced in Europe.

In December and January 1942–43, Valentin organized a one-man exhibition of Lipchitz's sculpture at his gallery. This exhibition and Valentin's publication of Lipchitz's work had a profound effect on such American sculptors as Herbert Ferber, Theodore Roszak, and Seymour Lipton.[16] Valentin published *Twelve Bronzes by Jacques Lipchitz* in 1942. This text, which included sixteen plates, was followed in 1944 by *The Drawings of Jacques Lipchitz*, a portfolio of twenty plates.[17] Valentin held another one-man exhibition for Lipchitz in 1951.

Valentin died in August 1954. Beginning in 1961, Lipchitz was represented by the Otto Gerson Gallery in New York, which later became the Marlborough-Gerson Gallery and is presently called the Marlborough Gallery. Valentin was the artist's last official art dealer. After 1954, Lipchitz independently developed his artwork for nearly two decades until his death in 1973.

PW

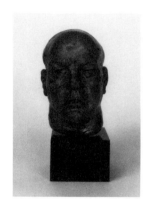

Jacques Lipchitz
Portrait of Curt Valentin
1941-42
Bronze (unique)
H. 38 cm.
The Museum of Modern Art, New York
Gift of Mrs. Henry Pearlman in memory of her husband.
Wilkinson, 2000 No. 354

1. *Lipchitz: A World Surprised in Space* (*Un mundo sorprendido en el espacio*), exhibition catalogue (Madrid and Valencia: Museo Nacional Centro de Arte Reina Sofía and IVAM, Centro Julio González, 1997), 206.

2. Ibid., 44.

3. Michael C. Fitzgerald, *Making Modernism* (New York: Farrar, Straus, and Giroux, 1995).

4. Ibid.

5. Irene Patai, *Encounters: The Life of Jacques Lipchitz* (New York: Funk and Wagnalls, 1961), 194

6. Elizabeth Cowling and Jennifer Mundy, *On Classical Ground: Picasso, Léger, de Chirico and the New Classicism 1910–1930* (London: Tate Gallery, 1990), 145.

7. Jacques Lipchitz and H. H. Arnason, *My Life in Sculpture*, Documents of Twentieth Century Art (New York: Viking Press, 1972).

8. Cowling and Mundy, *On Classical Ground*, 45.

9. Malcolm Gee, *Dealers, Critics, and Collectors of Modern Painting: Aspects of the Parisian Art Market between 1910 and 1930* (New York: Garland Publishing, 1981), 76.

10. Ibid., 76–77.

11. Lipchitz, *My Life in Sculpture*, 94.

12. Cowling and Mundy, *On Classical Ground*, 291.

13. A. M. Hammacher, *Jacques Lipchitz* (Otterlo: Rijksmuseum Kröller-Müller, 1994).

14. Lipchitz, *My Life in Sculpture*.

15. Stephanie Barron, *Exiles and Emigrés* (Los Angeles: Los Angeles County Museum of Art, 1997), 121.

16. Marlborough-Gerson Gallery, *Artist and Maecenas: A Tribute to Curt Valentin* (New York: Marlborough-Gerson Gallery, 1963).

17. Ibid.

LIPCHITZMO

What is he really like, this man of genius? He is Russian, and his name is Lipchitz. His face has a manly and exotic beauty and—strangest of all—the underlying traits of an old spider. It has the pallor of one who has recently returned from the dead. In Lipchitz's features there is considerable spiritual refinement; it seems as though he was born a prince, *the last prince of all*, and that he is one no longer. Nevertheless, he will always turn out to be the sole and unacknowledged representative of the House of Lipchitz, a house in worse condition than any other in the world, that began in Egypt, and that has since been selecting, polishing, and smoothing itself until it could turn out its conclusive type.

Lipchitz is a man of unlimited kindness and intelligence. He passed through Spain like an émigré who entered for the few days of his unavoidable migration, both a strange country and modest places, ones that could not have expected him for they had never dreamed of such excessive glory.

He understood everything here, but he needed to go to Paris again. It was there that I saw him once more.

I will not forget that little Parisian house, lit by an oil lamp with a broad-brimmed shade, where Lipchitz was settled, amid some extraordinary odds and ends, with a beautiful Russian writer, ideally suited to him, a woman with the sweetest of voices who both welcomed and took her leave of you in an ineffable manner.

Next to that house, in the same patio—a gloomy patio, like those in Russia, perhaps—was the house chapel: the first-floor studio of the sculptors, who were upstaged by the gravity of their works and were remote from that light and sky in which painters' studios are bathed. In that patio there was an awful workshop for photoengraving and toward the back something like a storage room for furniture.

When the bell of his studio rang, Lipchitz would appear, or his wife would greet us from their house's tiny window. (It is worth noting that the bell of Lipchitz's studio was one of those large bells that has a handle hanging down and a counterweight on the other end; one of those bells that turned like a windmill's sail, swaying violently; one of those poor, obliging, spunky, unruly bells that not only tolled but made loud, ringing gestures inside houses, anguished gestures in empty ones.)

There were such beautiful things in that studio! The most recent ones, above all, gave me the impression that the ideal had been brought to a state of resolution; not a seductively female ideal, but one with the seductive purity of idea itself. Indeed, for Lipchitz sculpture is a formula, an A + B + C, a trigonometric subtlety, as far from what is "nice" as from what is "beautiful" (which is as debased and as showy as what is nice). Lipchitz manages to create only things that are high and true, with true and essential dimensions. The only reality that exists for Lipchitz is what, in reality, is already another work of reality, super-reality, miracle work, even though all its features might nevertheless have come from nature itself. His doctrines, which are truly pure, give a natural and authentic spirituality to the blocks of stone on which he works. Sculpture for Lipchitz is a construction. To shape plastic gestures into sculptural form is a stupidity and a cliché, as is bunching together trivial, form-like shapes that are breaks, cracks, and partial bits from which so much is lacking.

Alongside the stupid and pretentious opinions of other sculptors—profane opinions of those who knead and finger their creations, their men and their women, like the men and the women they are—how supreme and distant is Lipchitz's work, so remote from that despicable act of foolishly rooting in matter! Lipchitz's conception, his sculpture's immaculate conception, is the true rebirth that arises after hundreds of centuries of futile contemplations, vicious circles, clumsy treatments of sculptoral matter.

When I beheld Lipchitz's things in their yellow stone, as though made from the interlocking of beveled tiles, set squares, rulers, and long strips of stone; when I saw his austere, completely austere, manner of representation, I was amazed at the heroism of the man—one who can be aiming at the highest quality in all, and yet could pay as little heed to the masses' astounding lack of appreciation of his work as to the fact that it inspires in them a desire to lynch him.

One day he told me: with a plane that rises or grows and that is surrounded by whatever additions it needs, and by edging it in just the right proportions, one can capture human sadness or whatever sentiment one desires.

He also told me: I want to be the master of my material. And in fact, in his treatment of wood, of stone, of all the elements, he is like a great artisan from a unique guild.

On another day he said: for me, the best that exists is a pyramid.

He would also say: "I was sad until the day Providence inspired those 'aerial, transparent' things in me, things that can be seen and can move us with all their features on display at once. Today I fly with that airplane *heavier than air*, which is sculpture itself."

While standing in front of Lipchitz's work, how many times have I seen how plain, airy, unsurpassed forms can go to heaven, to search for their paradise! Lipchitz is right: the body can yield so many forms!

The sacred soul of Lipchitz leaves aside the tomfoolery that in the work of the masters turns round and round upon itself, but which in him heads off in luminous direc-

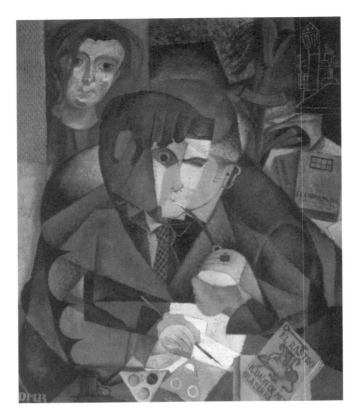

Diego Rivera
*Portrait of Ramón Gómez
de la Serna*
1915
Oil on canvas
109 × 90 cm.

Private Collection

tions by relying on light—something sculpture had never counted on before, just as no one in painting had reckoned on space in its entirety.

Do understand that sculpture is a thing that centers and captures light for its own ends. When would that ever have occurred to you, distinguished dimwits! How true it is that when one sees the principal works of major sculptors, one sees that light is separating them into their elements, and that they are not yet ready to apprehend the intellect of light!

The recent works of Lipchitz, while standing quite low to the floor, resemble very high skyscrapers rising up to the heavens with their constant elegance.

Sculpture is the beach or cliff on which art dies.

That sentence, I know, will mean that my ideas will be suppressed—just as the regicide's shout is silenced.[1] But I utter them to proclaim my own anarchic faith in another ideal.

In that wretched mausloeum of art, Lipchitz stands out.

Translated by John C. Wilcox

Originally published in Spanish as a chapter in *Ismos* (Madrid: Biblioteca Nueva, 1931), 233–38.

1. Allusion to the opposition during the 1920s to King Alfonso XIII of Spain, who abandoned his throne in 1931 and went into exile in Italy.

COMMENTARY

In 1931 Ramón Gómez de la Serna published a book that marked the history of the avant-garde in Spain. Titled *Ismos* (Isms), it drew upon his observations about artists, writers, performers, and popular personalities who visited the *tertulía* that he held at the Café Pombo beginning about 1915. The foundation for *Ismos* was set in Gómez de la Serna's *Pombo* of 1918. *Pombo* documented the history, not only of the Café Pombo, but also of the café as a vital component of the development of modernity in Madrid. Michael Ugarte has described the literary meetings, or *tertulía*, that were held at Pombo as both a place and an event, for it was both a location in the city (Café Pombo) and a "happening" where ideas were exchanged in an atmosphere of lively debate and friendship.[1] Among the artists described by Gómez de la Serna, first in *Pombo* and then in *Ismos*, were: Jacques Lipchitz, Diego Rivera, María Blanchard, and Angelina Beloff. Gómez de la Serna first met some of these artists in Paris; others he came to know as a result of their visits to the café. The lives and work of these artists and others became intertwined with Gómez de la Serna's anecdotal histories. He continually revisited his descriptions and expanded or modified the details of his encounters in subsequent publications, like his *Retratos Completos* of 1963.

The description that Gómez de la Serna presents of Jacques Lipchitz is quite similar in both *Pombo* and *Ismos* and covers Lipchitz's character, his lifestyle, and his home in Paris. He also recounts the sculptor's trip to Spain and the evolution of his work. In *Ismos*, Gómez de la Serna updated his observations, since more than twelve years separated the publication of the two works, and he added photographs of several pieces, including a reproduction of *Toreador*. For Rivera, Gómez de la Serna greatly expanded his description in *Ismos* to include several pages dedicated to paintings such as Rivera's portrait of him, which hung in the controversial *Exposición de Pintores Íntegros* in March 1915. For both Lipchitz and Rivera, as for many other artists included in *Ismos*, Gómez de la Serna made of their work something larger than the particularities of their practice by converting their individual style into an "ism": "Lipchitzmo" and "Riverismo." About the artist Marie Laurencin, who also spent the war years in Spain, he titled a chapter "Ninfismo." He also dedicated sections to historical figures like Jean-Auguste-Dominque Ingres: "Ingrismo." Whether old or new, foreign or national, Gómez de la Serna wrote a selective account of modernity that both corresponded to the history of the avant-garde as it was being written internationally and to his own circumstantial observations.

The proliferation of *isms* in Gómez de la Serna's book bordered on the absurd. Yet, as one of the leading supporters of the avant-garde in Spain during the twentieth century, he played a serious role in introducing what were often foreign personalities and terms to a Spanish audience. Most often in *Ismos*, Gómez de la Serna combined biography with art criticism. He created an intimacy between the reader and his cast of characters (famous, infamous, and unknown) by weaving together accounts of their visits to Café Pombo, his descriptions of their homes and studios, and his observations about their appearance and behavior. At the same time, he made of them something awe inspiring and heroic in their determination to participate in the creation of new art. Thus, for Gómez de la Serna, Lipchitz was "born a prince" whose work rose "up to the heavens with their constant elegance." He confronted the masses with their resistance to challenging work, often assaulting them in his prose. As this excerpt demonstrates, Gómez de la Serna was above all else a great admirer of the artists he met, and he paid them homage by writing highly personal views of their contributions, crafted with his own mix of seriousness and humor.

Jordana Mendelson

1. Michael Ugarte, *Madrid 1900: The Capital as Cradle of Literature and Culture* (University Park: Pennsylvania State University Press, 1996), 116.

Joaquin Torres-García

LIPCHITZ: LE SCULPTEUR COSMOGONIQUE

A great creator of form and of life, with life and form working together in perfect balance. By *form*, I mean abstract form, and by *creator*, I mean one who does not imitate Nature. Prodigious and powerful forms, brought marvelously to life. Construction and architecture add up to Beauty. Universal life is played out in plasticity. The tempo, the music, it is all an affirmation of our times, a new order of things. Modern man is powerful indeed. The multifariousness of a source that never runs dry, one that endures and endlessly produces, not mere sculptors' dreams, but something more grounded, more basic.

Lipchitz got his start, as did most sculptors, in the academy. It was later that he began to see, and once he had made his break, he never returned to a simple imitation of nature. His oeuvre contains a short but distinct cubist period, but one whose new rhythms and expression, unmistakably his own, would mark his work to come. This is the artist's originality, his personality, which was to grow into the powerful works of today, flawless, clear, and perfectly executed.

Happy is the man who has fathered such works! And such youth, the youth of life! Lipchitz has a clear understanding of nature, the immense power that resides in all beings, the cosmic force that is life itself, intelligence in the broadest sense, the force of ideas. But ideas, creative intelligence, must not be confused with mere instinct, unworthy of praise. Yes, he did understand nature, he saw that it was force veiled by form (and that form was but a mask), and that what is essentially force and idea could assume other forms, other states of the same being.

On the other hand, sculpture imposed upon him certain rules, the interplay of surface and rhythm, of shadow and light, the nature of materials, all coming together in an aesthetic reverie and a creative opportunity. Both of these must have been operative and at hand—one imagines that he thought long and hard, hesitated, felt his pulse quicken. How did this miracle, this fusion of the two, come about? Sculpture had to embrace life (and more than life, the idea of being) to bring about true creation. For a being is one thing in Nature but quite another when it comes to sculptural creation, and Lipchitz intuited this deeply. Neither Rodin, nor Bourdelle, neither Maillol nor Despiau had understood. Yet it was this that had to be understood.

Art is total creation, not imitation. An expression of proportion and rhythm will always be more interesting, and more profound (provided such expression springs from the vitality of nature) than any mere representation of a life that has no basis in reality. But in the case of Lipchitz, matter is brought to life through an enhancement of its own nature and thereby represents nothing but itself.

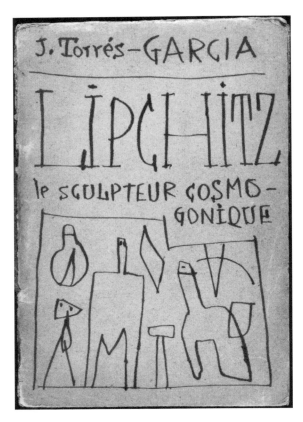

Cover of the manuscript "Lipchitz, le Sculpteur cosmogonique"
by Joaquin Torres-García

Library, The Getty Research Institute
(960087)

Lipchitz remarked to me one day: "Granted, we are all descendants of Picasso. He was the one who opened the way for the whole movement, but that's not the whole story." Though it is true that an assembly of more or less abstract forms (infused with life by some hint of nature) was already something quite remarkable, an ushering in of new life, it still came up short. We saw where other sculptors working in the cubist idiom usually ended up falling into decorative triviality whenever they attempted to break from it. The whole thing was terribly tricky, but stasis would have been even more deadly. Again, it was Lipchitz who understood this.

Take heart! We must enter the fray. Are the quasi-disciplined people who now accept cubism, as if it were some new academism, going to be scandalized once again? One step forward, one step backward? It is hard to say. We are once more in a confused state, and no one is going to be grateful to the sculptor. But that matters little. He is the giant who must undertake this task, to create a new order of powerful beings engendered by powerful thinking, independent beings who will claim a space for themselves, boldly and forcefully. For one day, when we come to despise the notion of overly convenient art, we will understand that man cannot settle for small discoveries, that the voice of man must be heard. Then the monster will no longer be a monster but rather something normal, even logical, as natural as any other object. This mother and child, with time, will look as familiar to everyone as an Assyrian stone.

Anyone who has followed Lipchitz in his most overtly cubist sculpture, as well as his more figurative kind, such as that housed at the Barnes Foundation, was certainly

disappointed to see him exit from the cubist scene (as was the case with Brancusi) and make a return to nature. I must confess that I was a bit disconcerted myself and eventually came around, though it took me several viewings of his sculptures. I have often said, along with many others, that the cubist movement was a revolutionary movement, one that would lead to something definitive and normalized. (Normality does not imply naturalism.) To remain within the cubist fold would have meant dwelling in a state of perpetual instability, in violation of the laws of equilibrium. It had to be abandoned, and many attempted to do so, but the process was not an easy one, and all, or nearly all lapsed into vulgarity or extravagance.

Return to normality, even back to nature, but how? Crossing the boundary imposed by cubism in order to move beyond, was this still possible? And yet it had to be done at all costs, or perish. It was time that man spoke to man. Enough with experiments, with dada. The great historical periods of art had to be matched, the long lineage of art in time had to be pursued, but without repeating a single form of expression from that line. In a word, one had to create.

The monsters started to appear. Colossal in size and formidable in strength. When a woman gives birth, it is to a tiny infant, but when it is a man who delivers . . . What planet did these beings come from? They form a family, proving they must have mothers and fathers, even a country, but what country? Or have I been sleeping for the past few centuries, to awaken only now? Man must no longer be as I once knew him, he must be vastly more civilized—but what civilization am I going to find? Here is an artist who is a century ahead of his time, a bold pioneer who has ventured into uncharted regions.

Man is strange and mysterious. Though small, weak, almost insignificant on the scale of other creatures of Nature, he can become immeasurably grand, so grand that he is said to contain within himself the whole universe. Put simply, man is great or small depending on whether he is conscious of his being. Deep within his soul, he may even be able to read the secrets of divine ideation, though in his ignorance of what he possesses, he is capable of lapsing into the worst kind of coarseness. Consciousness is capable of running the entire gamut, up and down. This is why, at any given moment, man can become worse than an animal, or stretch beyond man himself. Artists undoubtedly produce unexpected insights, often stunning for outsiders. What is as normal and sensible for artists as anything else in nature often proves incomprehensible, even monstrous, for the crowd.

Interior of the manuscript "Lipchitz, le Sculpteur cosmogonique" by Joaquín Torres-García

Library, The Getty Research Institute (960087)

This progress is situated neither in time nor in space but at different levels of existence. One day this doctrine will be admitted as observable fact. To confine oneself to a purely physical order of things, however real it may be, is to limit the problem of existence to a single aspect. Man's thirst throughout time for things metaphysical is perfectly natural. We know (without really knowing) that this life as it presents itself in reality is but one of a thousand forms that life can assume. If our capacities of perception were different, then reality would be different as well. Limiting oneself to mere representations of the phenomena of existence is to remain on the surface, without getting down to what is essential, what is at the heart of things, what really matters. Lipchitz did see what is essential, and taking into account the laws imposed upon him by sculpture, created a form in which to express it. The so-called monster.

In short, though Lipchitz, within the cubist movement, was creator of a new structure at the level of sculpture, and a prodigious inventor of form, his creative drive was not to stop there but followed through logically, according to plan, to the furthest possible point: to the creation of truly independent beings with a life of their own, set into their corresponding framework. All the great periods of art have experienced a similar evolution, a sign of true artistic creation on the human scale, without which art would amount to nothing but pure aestheticism. The artist is hence a true father, for he has begotten real creatures. It is all about taking various facets of an object and combining them harmoniously, establishing connections that create a sculpted unity, in short, synthesizing, making out of reality a unified whole, a set of rhythms, as in architecture or music. Within this new framework, forms have a value in themselves that is not a value of mere representation.

Art is thereby reinstated in its true role, which is not to imitate but rather to freely create. This was the task that Lipchitz first set for himself, until a new aspect of art occurred to him, a more human aspect that, as I have just mentioned, does not confine itself to purely aesthetic concerns. I am not implying that the Lipchitz oeuvre as a whole has ever been devoid of humanity. On the contrary, the human is featured prominently in all his work, yet this aspect remained attached to him like a foetus to its umbilical cord, for it could not yet live independently. Things are quite different now. Grand and powerful forms have emerged, infused with intense life, forms that recall beings that possess the same desires that propel us, humans. But this is only a starting point, and as such would represent little. The artist's intuition penetrates ever more deeply to reveal what is intranslatable, resistant to any form of language, something that only form, by some miracle, can display before our eyes. Any attempt to describe such work in words is a vain enterprise indeed. Undoutedly, the artist himself would be equally incapable of providing the explanation, since his work is a product of the subconscious, conceived through a force rooted in the depths of his being, at a level no longer that of the individual but of universality.

We are living in truly exciting times, where artists dare to take on the legacy of Antiquity. Despite the positivism of our era, the wellspring of art has not run dry, for it is eternal. Fortunately, we have these artworks as testimony, giving us hope that all is not lost. In this mechanistic century, we can still generate our mythology, live our faith (same as it has always been), and continue the lineage, a direct line from eternity that will carry on infinitely and that has served as a guide to those who have lived in truth. This is the heart of the matter, in the end; it is not simply about making sculpture. Our personal task has never been anything other than this—and only this could have lent us support.

And that is the reason we now seek to draw public attention to the recent work of Lipchitz. In this divine ideation that is Creation, the form of each being who is sound of body and mind is no less odd than any form an artist could invent. It is just that our habit of seeing it (and the logic that we assume to govern the unity of a being) has rendered it familiar to us—in other words, it has become commonplace. Roosters or fish are no more or less an oddity than any one of Lipchitz's creations. That nature should have stopped at that point in its combinations does not mean that artists must do the same, for the artist strives essentially to express the same thing as nature has through archetypes of its multicycled existence.

Metaphysical reality, which is the very essence of life if we leave aside matters of representation, is based upon the pure forms of knowledge that govern and order everything according to the immutable laws of thought. There is nothing monstrous, then, in these beings, which we can love just as we would any other and which have taken on a new form only to lead us more directly to what is essential. Indeed, this work of Lipchitz is there to sharpen our consciousness, to awaken it to a truer reality after its long sleep, induced by force of habit in the world of appearances. This is why so-called civilized man, in order to escape his materialistic environment (for we all have a need for the metaphysical), must regain his balance among men who are still living the life of the soul—primitive men, so-called savages, who still relate directly to the world.

On this score, we are far indeed from the cubist concept of things, so narrow and local, a kind of harlequin's costume made up of a thousand pieces drawn haphazardly from all quarters, and which, like Futurism and Dadaism, served only to derail Naturalism which is and always will be the negation of art. Unfortunately, many have remained there, and will continue to remain there, lacking the means to detach themselves from the local environment, so narrow and ugly, a kind of decomposition, in fact. Because deep down, they have neither the requisite capacity nor the strength nor the cultural wherewithal. These artists did not really create the movement, but rather it was circumstances that shaped them instead. People started calling them geniuses before they even realized what was happening. They are like the nouveaux riches of art. It would have been out of the question for Lipchitz to remain there. He broke away because he wished to be counted, not among those who exploited the fashions of the moment, but rather among those who have a faith and live by that faith, the timeless tradition of Man, whatever the era.

Though Lipchitz proudly claims Picasso as his father, as have so many other artists, it is equally valid to affirm that Picasso was directly influenced by Lipchitz, whose forms as animate beings provided the basis for Picasso's painting during a certain period, by way of sculpture. As it turned out, these supposedly serene paintings were realizations of actual sculptures. Picasso was to profit enormously from this influence. Thanks to Lipchitz, Picasso was able to break away from the local influence to become greater and simpler. In any case, one observation can be made: with Picasso, the monster remained a monster, while with Lipchitz, the monster, if you will, is a living being in nature.

It is easy to establish what each of these great artists contributed of his own substance. Nevertheless, by setting up a comparison between them, we can conclude that Picasso remains subjective (he is always the protagonist of the beings he creates), where with Lipchitz, always objective, we observe the forces of nature (lively intelligence, in the broadest possible sense) personified, objectified, with the artist as father-creator only. Where Picasso always works from instinct, Lipchitz creates out of a more universal conception of life.

Translated by Jane Kuntz

The unpublished manuscript, written in French, is held by The Getty Research Institute, Los Angeles, California

COMMENTARY

Joaquín Torres-García and Jacques Lipchitz met in Paris, probably in 1930, as both artists exhibited at Galerie Jeanne Bucher.[1] From their correspondence,[2] we know it was an intense friendship, although their personal contact was not long; at the end of 1932 Torres-García left Paris for Madrid. In 1934, he returned to his native Montevideo. From there they stayed in touch, corresponding until 1936. In South America, Torres-García launched a crusade to acquaint his compatriots with the latest developments in modern art; he gave several lectures in Montevideo and Buenos Aires about Lipchitz and wrote another essay that includes some of the ideas found in "Lipchitz: Le Sculpteur cosmogonique," as well as additional personal anecdotes.[3]

Lipchitz: Le Sculpteur cosmogonique is full of admiration, almost awe, for Lipchitz's work and personality. Torres-García, who was small, fragile, and extremely thin, must have been very impressed by Lipchitz's large frame, as he implied that the power of Lipchitz's persona was transmitted to his works. Torres-García writes about Lipchitz fathering powerful monsters and describes his sculpture as "mastodons" to convey their raw energy. The word *cosmogonic* (the origin or creation of the world or universe) endows Lipchitz with god-like powers; by describing his sculptures as "independent beings," he compares them to the creatures born of Mother Nature. Torres-García saw that Lipchitz, as a true artist, understood the language of pure forms. Coincidentally, the Chilean writer Vicente Huidobro, who was a friend of both Lipchitz and Torres-García, also portrayed Lipchitz as a supernatural being. In a prose poem he described him as four meters tall, with wings and an aureole around his forehead, and "cosmogonic fingers."[4]

Torres-García's regard for his friend's superhuman might was expressed in a 1936 lecture, when he recounted a story that Lipchitz had told him about the dangers of a thoughtless curse. Before moving to a house designed by Le Corbusier, Lipchitz lived in a modest cottage with a small garden containing a large old tree of which he was very fond. One day without any warning the landlord cut it down. Lipchitz was outraged and without thinking twice he cursed the man, wishing that he be felled like the tree. That same night the landlord died of an accident with his mechanical saw.

In this essay, Lipchitz's works of the late 1920s are exalted, as if he needed support in this new phase after his very successful cubist period. If Torres-García acknowledges that Lipchitz's new figurative pieces at first "disconcerted" him, he "eventually came around" to understand their greatness. For Torres-García believed that an artist must constantly search and experiment: "evolve or perish." Torres-García was consistent in his point of view, for in 1917 in Barcelona he wrote a manifesto titled *Art—Evolution*, in which he explained that the need to change was a process in accord with the course of life, with "the plasticity of time."[5] He viewed cubism and futurism as something temporary: a means "to derail naturalism." Once that had been achieved, artists had to move beyond to find something more lasting and substantial.

This view of the avant-garde is characteristic of Torres-García's outlook, for he thought that it was intrinsically necessary that the latest would eventually be con-

demned as passé. Therefore, he aimed to create an art form that would remain timeless while reflecting its moment.

An additional interest that they shared was the art of ancient civilizations. Both artists were looking for inspiration to reintegrate the extra-aesthetic quality of tribal art in their own work. Lipchitz collected pre-Columbian and tribal art, as well as Spanish old master paintings, and Torres-García was familiar with the collections at the Museé de l'homme.

What also makes this essay so intriguing is that at the time he wrote it, Torres-García had achieved his distinctive style, which he called Constructive Universalism—a synthesis of the opposing elements that form humankind's physical and metaphysical world. By placing symbols within a geometric structure, he sought to include an orderly view of the universe in his canvases. His painting followed a very different, almost contrary course to Lipchitz's art, which after his cubist phase changed to fluid, rounded forms, a "tumultuous labyrinth of curving lines." In spite of the vast differences between the work of the two artists, Torres-García expressed profound appreciation and respect for Lipchitz's work.

At the turn of the century, Pablo Picasso and Torres-García frequented the legendary café Els 4 Gats in Barcelona, and in Paris they had numerous friends in common. Thus Torres-García's references to Picasso are especially illuminating. Torres-García thought Picasso's fame prevented a realistic appraisal of his true merits. Although he acknowledged Picasso's importance and masterful command of painting, Torres-García saw flaws in the genius. He recounted how in Paris it was said, "you could discuss even God but not Picasso."[6] He knew Picasso's ability to borrow from other artists and turn their originality into something of his own, as Picasso did with the sculpture of Julio González. Torres-García was a witness to Picasso's discussions with Julio González about his iron sculpture. His recounting of González's interpretations of Picasso's drawings contradicts the general view that it was Picasso who influenced González's sculpture. In *Lipchitz: Le Sculpteur cosmogonique* he asserts that it is Picasso who took ideas from Lipchitz.

Torres-García's concept of the artist as a father of his creations was also echoed by Lipchitz. Many years later, in discussing his own work, Lipchitz compared making art to "Procreation—the animals have procreation, and they are driven by this powerful thing that pushes them to make the species survive. But human beings have art . . . , the immortality of art . . ."[7]

Cecilia de Torres

1. In 1930, Jeanne Bucher organized a retrospective exhibition of 100 of Lipchitz's sculptures at the Galerie de la Renaissance. In January 1931, Torres-García had a one-man show at the Galerie Jeanne Bucher.

2. J. F. Yvars and Lucía Ybarra, eds., *Cartas a Lipchitz y algunos inéditos del artista* (Madrid: Museo Nacional Centro de Arte Reina Sofía, 1997), 81.

3. J. Torres-García, *Universalismo constructivo* (Buenos Aires: Editorial Poseidón, 1944), 521.

4. Vicente Huidobro, "Jacques Lipchitz," in Yvars and Ybarra, *Cartas a Lipchitz y algunos inéditos del artista*, 13.

5. J. Torres-García, *Art—Evolució (a manera de manifest)*, Un enemic del Poble, Barcelona, November 1917, in Jaime Brihuega, comp., *Manifiestos, proclamas, panfletos y textos doctrinales, Las vanguardias artísticas en España*, 1910–1931, 2d ed. Cuadernos Arte Cátedra (Madrid: Ediciones Catedra, 1982), 96.

6. Torres-García, *Universalismo constructivo*, 441.

7. Jacques Lipchitz, "Conversation with Cranston Jones, 1958," *The Oxford Companion to Twentieth Century Art* (Oxford, Eng.: Oxford University Press, 1988), 330.

Chronology

1891 Chaim Jacob Lipchitz born in Druskieniki, Lithuania, on August 22.

1909 Moves to Paris at the age of 18.

1909–10 Studies at the École des Beaux-Arts with Jean-Autoine Ingalbert. Transfers to Académie Julian in order to study under Raoul Verlet, while also attending evening classes at Académie Coloarossi.

1912 Moves next door to Constantin Brancusi in Montparnasse.

1913 Exhibits *Woman and Gazelles* at the *Salon d' automne*. Diego Rivera introduces him to several significant cubist painters including Pablo Picasso.

1914 Travels to Spain with Diego Rivera and friends.

1915 Constructs his first mature cubist sculptures. Meets and later moves in with Berthe Kitrosser, a Russian poet.

1916 Amedeo Modigliani paints a wedding portrait of Jacques and Berthe. Léonce Rosenberg becomes Lipchitz's official art dealer. Becomes close friends with Juan Gris.

1918 Flees Paris with Berthe and Juan and Josette Gris to stay in the Touraine village of Beaulieu-lés-Loches in reaction to the threat of German bombing.

1920 Gains recognition in his first one-man exhibition at Rosenberg's *Galerie de l'effort moderne* in Paris. Maurice Raynal publishes the first monograph on his oeuvre. Lipchitz breaks his contract with Rosenberg and buys back his work with the support of friends. Completes a portrait of Gertrude Stein.

1922 Sells several sculptures to Dr. Albert C. Barnes in Paris and is also commissioned to construct stone reliefs for the façade of Barnes's mansion in Pennsylvania.

1924 Attains French nationality and officially marries Berthe Kitrosser.

1925 Moves into a house designed by Le Corbusier located in the Parisian suburb of Boulogne-sur-Seine. Begins experimenting with *transparents*.

1926 Begins showing at Jeanne Bucher's gallery.

1928–29 Learns of the death of his sister and father. Creates *The Couple*, later renamed *The Cry*.

1930 Jeanne Bucher holds Lipchitz's first large retrospective exhibition at the *Galerie de la Renaissance*, Paris, from June 13–28.

1931 Introduces the mythical character of Prometheus into his artistic vocabulary.

1933 Completes *Portrait of Gericault*.

1935 First important exhibition in the United States, held at the Brummer Gallery, New York.

1936–37 Commissioned to build the monumental plaster sculpture, *Prometheus Strangling the Vulture*, for the entrance to the Science Pavilion at the Paris World's Fair by the French government; wins the gold medal.

1938 Becomes reacquainted with Gertrude Stein and produces two portraits of her. Creates two versions of *Rape of Europa*.

1940	Flees Paris to Toulouse with Berthe as a result of the German occupation.
1941	Arrives in New York on June 13 to seek asylum in the United States. Begins selling work at the Buchholz Gallery shortly after meeting the gallery's dealer, Curt Valentin.
1942	Celebrates first one-man show in the United States at Curt Valentin's Buchholz Gallery, New York, from January 21 to February 14.
1943–44	Works on a commission, *Prometheus Strangling the Vulture*, from the Ministry of Health and Eduction, Rio de Janeiro. Introduced to fellow sculptor Yulla Halberstadt.
1946	Visits Paris with Berthe for the first time since World War II. Decides to permanently return to the United States, while Berthe decides to remain in Paris. They are divorced shortly afterward.
1948	Marries Yulla Haberstadt. Lolya Rachel, his first and only child is born. Changes residence to Hastings-on-Hudson, New York.
1952	Many works destroyed in studio fire on 23rd Street in New York.
1953	Constructs a new studio close to his residence in Hastings-on-Hudson.
1954	Retrospective exhibition held at the Museum of Modern Art, New York.
1957	Exhibits new series of semiautomatic sculptures at Fine Arts Associates.
1961–62	First represented by the Otto Gerson Gallery, New York (later the Marlborough-Gerson Gallery and presently Marlborough Gallery, Inc.). Commisioned to construct a monument to Daniel Greysolon, Sieur du Luth, the seventeenth-century French explorer.
1963	Visits Israel for the first time. Large retrospective exhibition at University of California at Los Angeles; San Francisco Museum of Art; Bever Art Museum; Forth Worth Art Center; Walker Art Center; Des Moines Art Center; Philadelphia Museum of Art.
1964	Exhibition of *Between Heaven and Earth* at Documenta International, Kassel, and Carnegie International, Pittsburg.
1965	John F. Kennedy sculpture installed in Military Park, Newark, New Jersey. Award for cultural achievement from Boston University and one-man exhibition there. Exhibition at opening of Jerusalem Museum, Israel.
1969	Receives the Einstein Commemorative Award of Merit from the Medical Center of Yeshiva University, New York, and the Medal of Achievement from American Institute of Architects.
1970–72	Extensive work on monumental sculpture commissions from Columbia Law School (*Bellerophon Taming Pegasus*).
1972	Publication of his autobiography, *My Life in Sculpture*, concurrent with major exhibition organized by the Metropolitan Museum of Art, New York.
1973	Passes away on May 27 on the island of Capri and is subsequently buried in Har Hamenuhot, Jerusalem. *A Tribute to Jacques Lipchitz: Lipchitz in America, 1941–1973*, held at the Marlborough Gallery, New York, in November.

Selected Bibliography

All citations listed below are in addition to the bibliography found in Alan G. Wilkinson's *The Sculpture of Jacques Lipchitz: A Catalogue Raisonné*, vol. 2 (London: Thames and Hudson, 2000). For additional material not listed below or included in the Wilkinson *Catalogue Raisonné*, see the Jacques Lipchitz archive at the Tate Gallery, London.

(organized chronologically)

Gómez de la Serna, Ramón. *Pombo*. Madrid: Imprenta "Messón de Paños," 1918.

Exposició d'Art francès d'Avantguarda. Catàlog. Barcelona: J. Dalmau, 1920.

George, Waldemar. "Bronzes de Jacques Lipchitz." *L'Amour de l'art*, 1926.

Vitrac, Roger. *Jacques Lipchitz: Vingt-neuf reproductions de ses oeuvres précedées d'une étude*. Paris: Nouvelle Revue Française, 1927.

Gómez de la Serna, Ramón. I*smos*. Madrid: Biblioteca Nueva, 1931.

Huidobro, Vicente. "Jacques Lipchitz." *Cahiers d'art* (1928).

Morris, George L. K. "Relations of Painting and Sculpture." *Partisan Review* 10, no.1 (January-February 1943): 63-71.

Torres-García, Joaquin. *Universalismo constructivo*. Buenos Aires: Editorial Poseidon, 1944.

Valentin, Curt. *The Drawings of Jacques Lipchitz*. New York, 1944.

"The Ideas of Art: Fourteen Sculptors Write." *The Tiger's Eye* 4 (June 1948): 80.

"Jacques Lipchitz 'Matador'" Bulletin (Minneapolis Institute of Arts) 42, no. 20 (May 16, 1953): 97-98.

Lipchitz, Jacques. *Modigliani*. New York: Abrams, 1954.

Lipchitz, Jacques. "Introduction." *The Lipchitz Collection*. New York: The Museum of Primitive Art, 1960.

Suárez, Luis. *Confesiones de Diego Rivera*. Mexico: Edciones Era, 1962.

Marlborough-Gerson Gallery. *Artist and Maecenas: A Tribute to Curt Valentin*. New York: Marlborough-Gerson Gallery, 1963.

Gómez de la Serna, Ramón. *Retratos Completos*. Madrid: Aguilar, 1963.

Grossman, Emery. *Art and Tradition*. New York: Thomas Yoseloff, 1967.

Favela, Ramón, *Diego Rivera: The Cubist Years*. Phoenix: Phoenix Art Museum, 1984.

Beloff, Angelina. *Memorías*. Mexico: UNAM, 1986.

Benezra, Neal. "A Study in Irony: Modigliani's Jacques and Berthe Lipchitz." *Museum Studies* 12, no. 2 (1986): 188-99.

Szabo, George. "A Study in Jealousy: A Drawing by Amedeo Modigliani." *Drawing 10* (January-February 1989): 105-7.

Cowling, Elizabeth, and Jennifer Mundy. *On Classical Ground: Picasso, Léger, de Chirico and the New Classicism 1910-1930*. London: Tate Gallery, 1990.

Kelleher, P. J., "Lipchitz Show at the Jewish Museum: Effort to Revise Artist's Reputation." *New York Observer* (January 24, 1991): 1.

Castillo, Tito. "Gratos recuerdos de Vicente Huidobro y Jacques Lipchitz," *Atenea: Revista de ciencia, arte y literatura de la Universidad de Concepción* (Chile), no. 467 (1993): 149-54

Stein, Gertrude. *A Stein Reader*. Ed. with an introduction by Ulla E. Dydo. Evanston, Ill.: Northwestern University Press, 1993.

Les Musées de la Ville de Strasbourg. *Jeanne Bucher: Une Galerie d'avant garde 1925-46*. Strasbourg: Les Musées de la Ville de Strasbourg, 1994.

Bonet, Juan Manuel, *Diccionario de las vanguardias en España, 1907-1936*. Madrid: Alianza Editorial, 1995.

Lichtenstern, Christa, "Jacques Lipchitz." *Canto d'Amore*. Basel : Öffentliche Kunstsammlung Basel/Kunstmuseum: Paul Sacher Stiftung, 1996. 154-58.

Saffron, Matthew. "Constructing a New Jewish Identity: Marc Chagall, Jacques Lipchitz." In Stephanie Barron with Sabine Eckmann, eds., *Exiles + Emigrés : The Flight of European Artists from Hitler*. Los Angeles: Los Angeles County Museum of Art ; New York: Abrams, 1997. 120-25.

Pütz, Catherine. "Catalogue raisonné Part 1" review, *Burlington Magazine* No. 1133 (August 1997): 557 ff.

Pütz, Catherine. 'Lipchitz' exhibition review, *Burlington Magazine* No. 1133 (August 1997) 568 ff.

Pütz, Catherine. (unpublished) PhD University of London 1999: *Cubist Sculpture and the Circularity of Time. The work of Jacques Lipchitz and Henri Laurens in interwar Paris*.

Pütz, Catherine. "Cubist Sculpture, Beginnings and Sources." *Kalias* 11, no. 22 (Valencia) (February 1999): 91-103.

Pütz, Catherine. "The Encounter and the Struggle: Lipchitz Maquettes 1928-1942." *Essays in the Study of Sculpture*. Leeds, Eng.: Henry Moore Institute, March 1999.

Pütz, Catherine. "An Early Sculpture by Jacques Lipchitz." *Burlington Magazine*, no. 1173 (December 2000): 777-79.

Pütz, Catherine. "Jacques Lipchitz." *The Encyclopedia of Sculpture*. Chicago: Fitzroy Dearborn Publishers, 2001.

Pütz, Catherine. "Letters to a Reconstructed Cubist." *The Sculpture Journal* 5 (2001): 97-102.

Contributors

Jonathan Fineberg is professor in the Department of Art History at the University of Illinois at Urbana-Champaign. He received his Ph.D. from Harvard University and his M.A. from the Courtauld Institute of Art in London. Fineberg's specialties are contemporary art, European modernism, and the social psychology of art. He is the author of *Art since 1940, Strategies of Being* (2000) and *The Innocent Eye: Children's Art and the Modern Artist* (1997).

Christopher Green is professor at the Courtauld Institute of Art, London. His specialty is European and American art and architecture of the twentieth century and French and British painting and sculpture between 1900 and 1945. Green is the author of *Art in France, 1900–1940* (2001), *Picasso's Les demoiselles d'Avignon* (2001), *Juan Gris* (1992), *Cubism and Its Enemies: Modern Movements and Reaction in French Art, 1916–1928* (1987).

Jordana Mendelson is assistant professor in the Department of Art History at the University of Illinois at Urbana-Champaign. Her publications include "Political Practice and the Arts in Spain," in Virginia Hagelstein Marquardt's *Art and Journals on the Political Front, 1910–1940* (1997) and *Margaret Michaelis: Fotografía, vanguardia y política en la Barcelona de la República* (1998). Mendelson is currently working on a book about documentary practices and the representation of rural culture in 1930s Spain.

David O'Brien is associate professor in the Department of Art History at the University of Illinois at Urbana-Champaign. He writes primarily about European art of the eighteenth and nineteenth centuries. O'Brien is author of *After the Revolution: Antoine-Jean Gros, Napoleon, and Official Painting*, (forthcoming in 2002).

Cathy Pütz is registrar and exhibitions coordinator at the Courtauld Gallery, Courtauld Institute of Art, London. She received her Ph.D. from the Courtauld Institute of Art in 1999; her speciality is cubist sculpture between the wars. Pütz has published widely on Jacques Lipchitz, in addition to Henri Laurens and Raymond Duchamp-Villon. Her six years of research on Lipchitz have uncovered previously unknown sculptures and major archival material, discussed for example in, "A New Perspective on Jacques Lipchitz" (1997) and "Letters to a Reconstructed Cubist" (*The Sculpture Journal*, 2001). She is also the assistant editor of *The Sculpture of Jacques Lipchitz, A Catalogue Raisonné*, vol. 2 (2000).

Cecilia de Torres is an internationally recognized authority on Joaquín Torres-García, and other artists of his circle, and is author of the *Torres-García Catalogue Raisonné*. Originator of the exhibition: *El Taller Torres-García – The School of the South*, Ms. de Torres has curated and contributed to numerous museum exhibitions here and abroad. The New York gallery that she opened in 1993, Cecilia de Torres Ltd., specializes in Constructivist works and artists of Geometric Abstraction.

Graduate student contributors from the University of Illinois at Urbana-Champaign:

Sarah L. Eckhardt, master's student in Art History

Eun Young Jung, master's student in Art History

Amy M. Kuhl, master's student in Art History

Guisela Latorre, Ph.D. candidate in Art History

Natasha C. Ritsma, master's student in Art History

Stacy K. Smith, master's student in Art History

Li-Lin Tseng, Ph.D. candidate in Art History

Phoebe Wolfskill, Ph.D. candidate in Art History